CONTENTS

W9-DFC-054

PREFACE

The Mesoamerican Hall of the American Museum of Natural History is one of the great educational resources of New York City. Millions of New Yorkers and other visitors from around the world have learned about the past of Mexico and neighboring countries in Central America from the beautiful works of art in its exhibits.

The Museum has been active in illuminating that past throughout this century. In presenting this history to the public, we have been concerned not only with archaeology and history, but also with demonstrating the intellectual and artistic achievements of Pre-Columbian Native American peoples. Many institutions and individuals assisted us in pursuing these goals. This catalogue and the exhibition it accompanies honor one of the foremost among them, the late Ernest Erickson, on the presentation of his collection of Mesoamerican Pre-Columbian art to the Museum by the Ernest Erickson Foundation.

For more than forty years, Mr. Erickson, a successful businessman born in Finland, devoted his time and resources to enriching the museums of New York, his adopted city. "His interests are in seeing and understanding early art forms wherever they occur," wrote Dr. Gordon Ekholm, curator of Mesoamerican Archaeology at the Museum, in 1969. Mr. Erickson shared his interests with the public by loaning works from his collections to The Brooklyn Museum and The Metropolitan Museum of Art, as well as to the American Museum of Natural History. Here, his collection forms the core of our permanent exhibition on the ancient cultures of Mesoamerica.

He was "one of the most enthusiastic and knowledgeable collectors in New York," in Dr. Ekholm's judgment, and his generous impulses led him to acquire works that would illustrate the history and scientific study of Mesoamerica in keeping with the guiding principles of this Museum. His collection has been serving its intended purpose for eighteen years, since the opening of the current Mesoamerican Hall in 1970.

"Pre-Columbian Art from The Ernest Erickson Collection" allows us to look at Mr. Erickson's collecting judgment with new eyes. In addition to the great breadth and quality of the art, the guiding intelligence and taste of the collector are revealed. Many of the finest pieces focus on the depiction of the human face and the human form. From the monumental ceramic sculptures of West Mexico to the finely modeled figurines of Veracruz and the Maya area, the Collection celebrates the variety and consummate skill with which men and women were depicted in Pre-Columbian art.

Mr. Abraham S. Guterman, President of the Ernest Erickson Foundation, a lawyer and a lifelong friend of Mr. Erickson, continues to fulfill the mission for which the Collection was assembled in presenting it to the Museum. The Museum's Board of Trustees is deeply grateful and honored to accept this gift on behalf of the public which it will enrich.

Robert G. Goelet, *President*

Pre-Columbian Art from

The

Ernest

Erickson

Collection

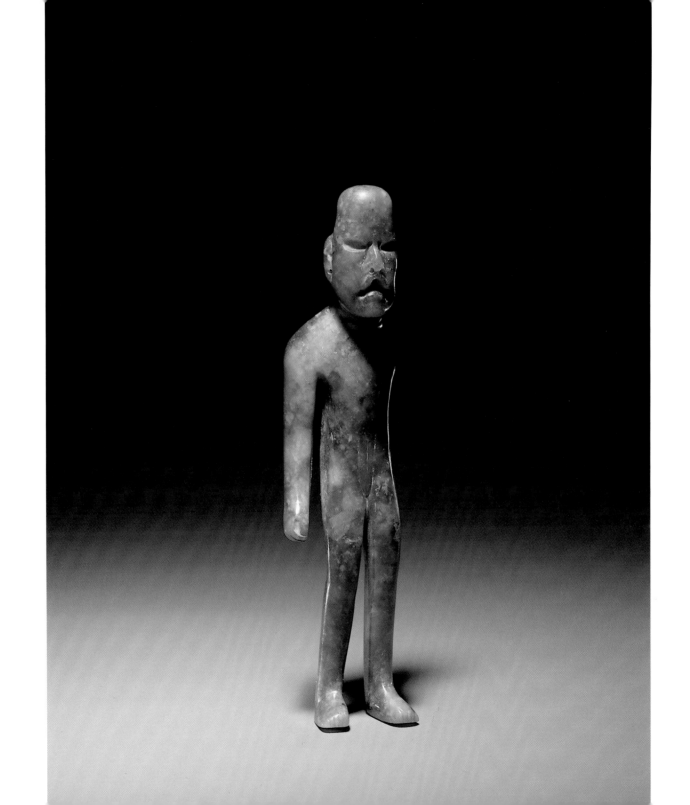

Pre-Columbian Art from

The
Ernest
Erickson
Collection

*at the American Museum
of Natural History*

N.C. Christopher Couch

Photographs by John Bigelow Taylor

American Museum of Natural History
New York, New York

This catalogue and the exhibition it accompanies are the result of efforts by many people. The entries on West Mexico were written with the generous assistance of Prof. Phil Weigand, Department of Anthropology, SUNY Stonybrook, and Celia García de Weigand. Help, support, and advice were also provided by William Weinstein and Barbara Conklin, Department of Anthropology, American Museum of Natural History; Prof. Esther Pasztory, Department of Art History, Columbia University; and Stacy Alyn Marcus, research assistant for the catalogue.

Printed for the exhibition

Pre-Columbian Art from
The Ernest Erickson Collection

American Museum of Natural History
June 15–August 15, 1988

Front cover: Helmet jaguar mask containing human face.
Late Classic, A.D. 600–800
Frontispiece: Standing male jade figurine.
Preclassic, 1200–500 B.C.
Back cover: Village model containing world tree.
Late Preclassic, 400 B.C.–A.D. 200

Library of Congress Catalog Card Number 88-071042
ISBN 0-913424-12-9

Design: Mark La Rivière, La Rivière · Hanson
Typesetting: Cosmos Communications Inc.
Printing: The Veitch Printing Corporation

American Museum of Natural History
Central Park West at 79th Street
New York, New York 10024

The Museum receives substantial support from a number of major sources. We are particularly grateful to the City of New York, which owns the Museum buildings and provides funds for their operation and maintenance, and to the New York State Council on the Arts, National Science Foundation, National Endowment for the Arts, National Endowment for the Humanities, Institute for Museum Services, 300 corporations, 60 private foundations, 490,000 members, and numerous individual contributors.

INTRODUCTION

Will I have to go like the flowers that perish?
Will nothing remain of my name?
Nothing of my fame here on earth?

 —Tecayehuatzin, prince of Huexotzinco, 1490
 (Leon-Portilla 1969:81)

The artistic achievements of Native Americans before the arrival of Columbus and the Europeans who followed him are primarily known to us from objects which have survived the ravages of time and conquest. Sculptures in stone, ceramic, and occasionally wood; products of the metalworkers' art; the remains of buildings and great cities—all testify to the skill of hundreds of generations of artists and craftsmen who produced works of genius and charm.

"Pre-Columbian Art from The Ernest Erickson Collection" focuses on works from Mesoamerica, an area encompassing most of Mexico and upper Central America. Here, from the beginnings of agriculture and village life in the third millennium B.C., related cultures and civilizations appeared, flourished, and declined until the Conquest in the sixteenth century. Its historical development is conventionally divided into three periods— Preclassic, Classic, and Postclassic. The Classic period is determined by the span of dates found inscribed in hieroglyphic writing on monuments and structures erected by the Maya, from ca. A.D. 300 to 900. These broad periods are each additionally subdivided into Early, Middle, and Late.

The earliest advanced civilization in Mesoamerica, the Olmec, developed on the Gulf Coast of Mexico. In the Middle Preclassic (1200 to 500 B.C.), the Olmec created earthen architecture and stone sculptures at major centers such as La Venta, Tres Zapotes, and San Lorenzo as well as sophisticated small-scale lapidary and ceramic works. Olmec sculpture appears to depict elite personages and a complex of deities; the most important is a "were-jaguar" (half human and half feline). Artists working in the Olmec tradition gave their figures a wide variety of poses, whether they were depicting a deity or a ruler. Their colossal heads must surely be identified as portraiture. Olmec-style objects are found throughout Mesoamerica, with particular and early concentrations in Guerrero, suggesting that the style may have originated there.

During the Preclassic period, complex cultural traditions were also developing in Central Mexico and Oaxaca and in West Mexico, toward the Pacific. The Preclassic-period Central Mexican figurines depict religious practitioners, ballplayers, and women (most commonly young women); apart from the less frequently found "acrobats," all have the reserved expressions and stereotyped postures characteristic of archaic sculpture.

The West Mexican ceramic sculptures from the Late Preclassic period (400 to 200 B.C.) show the life of the artists' communities in all its color and detail. Village models set on round bases reflect the plan of elite centers that were built on round platforms. The large ceramic sculptures of human figures, which in some cases are clearly portraits, were buried in elaborate shaft-and-chamber tombs. They may also have functioned as architectural sculpture, set in prominent places atop the monumental earthen structures.

The great Central Mexican site of Teotihuacán, the largest urban complex in Mesoamerica, reached its peak in the Middle Classic period (A.D. 400 to 700). However, its

beginnings date back to the Late Preclassic period, when building of the colossal 200-foot Pyramid of the Sun commenced. Mural painting was Teotihuacán's most important art form. The planned geometry of the city may be reflected in the stylized and geometricized human figures that appear in building frescoes; the frescoes seem to have been composed of parts or modules that were assembled as needed. Teotihuacán's influence spread throughout Mesoamerica; trade pieces and locally made ceramics in its style have been found as far south as the Maya area of Guatemala.

In the Gulf Coast lowlands, several traditions may be grouped under the term "Classic Veracruz." The development of a style of stone sculpture characterized by the use of scroll motifs was associated with the Mesoamerican ball game. Human and animal figures, abstracted or contorted, covered the geometric shapes of the equipment worn by ballplayers. Ceramic sculptures—from miniature to monumental—indicate a singular independence from the rest of Mesoamerica; they include, for example, wheeled toys—the only use of the wheel in Pre-Columbian America.

In Oaxaca, the Classic period saw the development of the major sculptural medium associated with the Monte Albán culture, the effigy urn. These sometimes life-size images of deities and rulers emphasize costumes that convey the figures' identity and status rather than the detailed depiction of the body that is merged with the vessel. In the Late Classic period (A.D. 600 to 900) the mountaintop city of Monte Albán was rebuilt, a huge undertaking that resulted in a tremendous central plaza surrounded by pyramidal structures.

The Maya civilization in eastern Mesoamerica reached its peak in the Late Classic period. Their civilization can be traced back to the Olmec, who may have invented hieroglyphic writing, the ball game, and the calendar—transmitted to the Maya through the Late Preclassic Izapan culture of the Pacific slope (200 B.C. to A.D. 200). Early Classic Maya art, in the public medium of the carved stelae and altars, is formal and iconographically complex, and it emphasizes rich costume and ornament rather than the human figure. The art of the Late Classic (A.D. 600 to 900) is exemplified by the stucco sculptures of Palenque, the stone carvings of Piedras Negras, and especially painted ceramic vessels and Jaina figurines; these elegant two- and three-dimensional human figures in refined poses embody the Maya ideal of beauty.

During the Early Postclassic A.D. 900–1200, the city of Tula, just north of the Basin of Mexico, came to control much of western Mesoamerica. Although the Toltecs were considered by the Aztecs to have been the creators of the arts, much of Tula's architecture and art has a rough and unfinished quality. The buildings and sculpture of Chichén Itzá, in the Maya region of Yucatán, generally thought to be derived from those of Tula, appear polished and accomplished by contrast.

The Aztec empire, centered at the capital of Tenochtitlán-Tlatelolco in the Valley of Mexico, unified much of Mesoamerica between A.D. 1400 and 1521, and appropriated and synthesized many earlier cultural and artistic developments. The Aztecs' sculptural and painting styles were in great part derived from those of the Mixtecs of Oaxaca and Puebla, whose complex iconography and crystalline tectonic figures were rendered more schematic in painting, more full and rounded in sculpture.

The material remains of Pre-Columbian cultures record only a portion of the lives and artistic achievements of these Native Americans. Their governmental structures, religious conceptions and ceremonials, poetry, dance, and song leave only echoes or no trace at all in the archaeological record. "Earth is the region of the fleeting moment," sang Tecayehuatzin, Aztec prince of Huexotzinco in a Nahuatl poem (Leon-Portilla 1969.81).

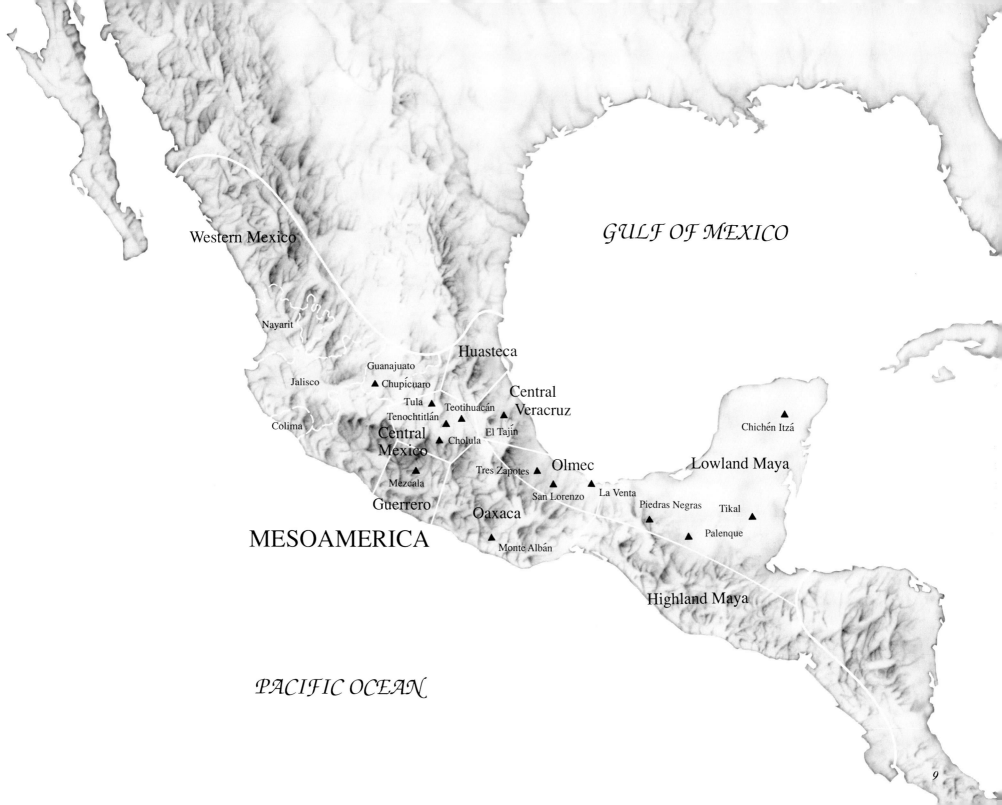

GULF OF MEXICO

Western Mexico

Nayarit

Huasteca

Guanajuato
▲ Chupícuaro

Central
Veracruz

Jalisco

Tula ▲
Teotihuacán ▲
Tenochtitlán ▲

Chichén Itzá ▲

Colima

El Tajín ▲
Central ▲ Cholula
Mexico

Lowland Maya

Olmec ▲
Tres Zapotes ▲
▲
Mezcala
San Lorenzo ▲ La Venta ▲

Guerrero

Oaxaca

Piedras Negras ▲
Tikal ▲

MESOAMERICA

▲
Monte Albán

Palenque ▲

Highland Maya

PACIFIC OCEAN

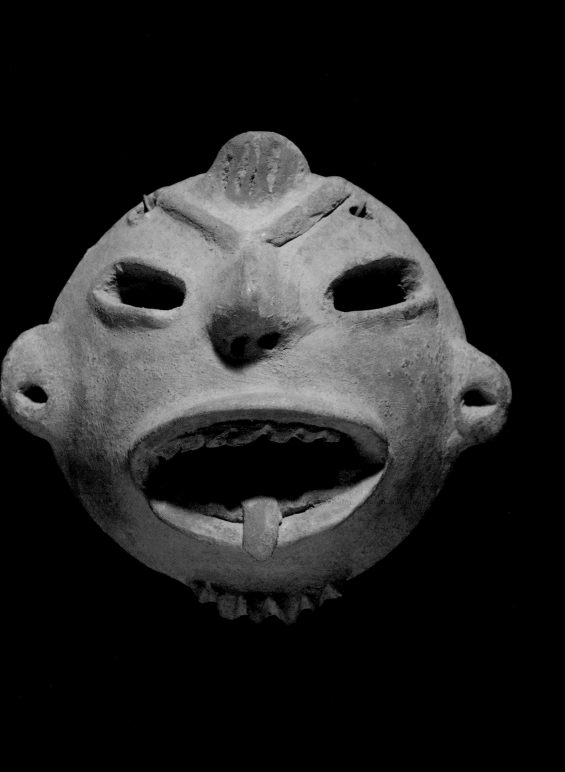

PRECLASSIC MEXICO

The first civilization of Mesoamerica apparently developed in the fertile, rainy, and tropical areas of present-day Veracruz and Tabasco along Mexico's Gulf Coast (Bernal 1969). There the Olmecs created ceremonial centers at La Venta, Tres Zapotes, and San Lorenzo; they built large pyramidal structures and carved stone monuments—iconographically complex altars and stelae and colossal stone heads that may represent secular or religious leaders. They were masters of the lapidary arts. Their trade routes extended south and west across much of Mesoamerica and enabled them to acquire hard fine-grained stones—usually jade or other green stones—often used in their sculptures. Locally made and imported objects in the Olmec style or incorporating Olmec iconography are found throughout much of Mesoamerica. Trade in exotic raw materials and the spread of Olmec symbolism indicate that local elite groups in other regions enhanced their own standing through emulation of the Olmec elite, adopting Olmec religious concepts, iconography, and artistic style (Flannery 1968). Some of the Collection's Olmec objects, such as the stone head of a dwarf (Figure 4), probably came from the Gulf Coast region, but most came from elsewhere. While the Olmec civilization was thriving in the coastal area, settled communities also flourished in the Central Mexican highlands. Here, in the heartland of Mesoamerican agriculture, complex mortuary and ceramic traditions developed at such sites as Tlatilco, Tlapacoya, and Las Bocas. The Collection includes several elegantly sculpted archaic female figurines and a ceramic mask (Figure 1)

from a Tlatilco burial ground. Also found in these Central Mexican graves—side by side with offerings in local styles—are Olmec ceramics, such as the beautiful white-slipped figurine from Las Bocas (Figure 3).

1 Funerary mask

Gray ceramic with red cinnabar;
broken and repaired
Height: 8.0 cm; *width:* 9.5 cm
Valley of Mexico, Tlatilco, west
side of Lake Texcoco
Middle Preclassic, 1200–500 B.C.
30.3/2277

Objects from Tlatilco graves indicate a flourishing culture in the Preclassic period. The graves were richly furnished with ceramic wares, including figurines, musical instruments, highly polished bottles and other vessels, and a variety of striking masks such as this one. The masks were apparently worn by ritual performers, as well as being part of the burial attire of the dead. Figurines shown wearing them indicate that they covered only the lower part of the face (Coe 1965:54 and cf. figs. 167, 168). This example features a crest of hair (also seen on some figurines), eyes and mouth pierced through, carefully modeled teeth, a projecting tongue, and a beard. Hair, tongue, and lips were colored with red cinnabar. Two holes for attachment are found at the top.

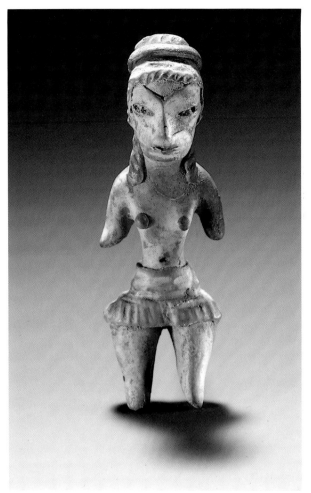

2 Young woman

Yellow ceramic with traces of red
paint
Height: 7.5 cm; *width:* 3.0 cm
Central Mexico, Tlatilco
Preclassic, 1200–500 B.C.
30.3/2280

Figurines of this type (D-1 in Vaillant's classification, 1935) are among the most beautiful small-scale ceramic objects produced in the Americas. Those depicting young women are the most numerous; characteristic are the wide hips, small waists, and elegantly stylized arms and legs. The predominance of female figurines may indicate an association with agricultural or human fertility, but a wide variety of other types, including male and androgynous figures—dancers, musicians, ballplayers, and others—suggests a broader range of uses (Coe 1965:25). The archaic qualities of Tlatilco figurines are particularly well exemplified by this example: the disproportionately large head with carefully delineated features, the frontality, and repose. The figurines are commonly nude, but this young woman wears a headband and a short skirt with striations that may represent a fringe.

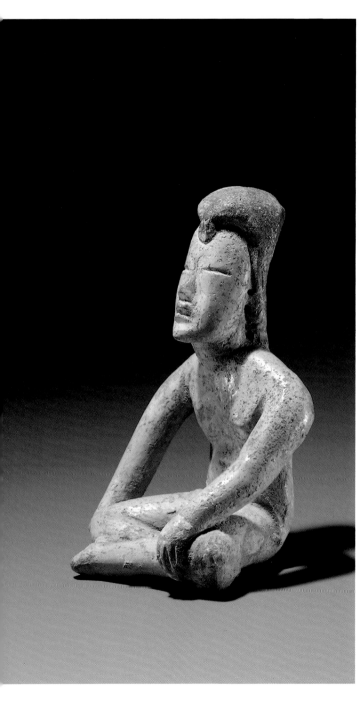

3 Male seated cross-legged

White ceramic with burnished
white slip, and red pigment
Height: 11.0 cm; *width:* 6.4 cm
Southeastern Puebla,
(from an Olmec site?)

Las Bocas style
Preclassic, 1000–500 B.C.
30.3/2270

Some of the finest ceramics that reflect the Olmec influence in Central Mexico come from the site of Las Bocas. Solid and hollow figurines made from a fine white clay with a white slip and often featuring red pigment show human figures in various poses. Most often they are seated cross-legged, but they also recline, lean on one arm, and stand. (The standing figures are more like other Preclassic figurines.) The lifelike quality of this figurine is enhanced by its upward gaze. The eyes are characteristically single shallow slits. The Olmec character is seen in the naturalistic pose and the downward-turned mouth of Figure 4. (Published: Coe 1965:117, no. 194; Ekholm 1970:40.)

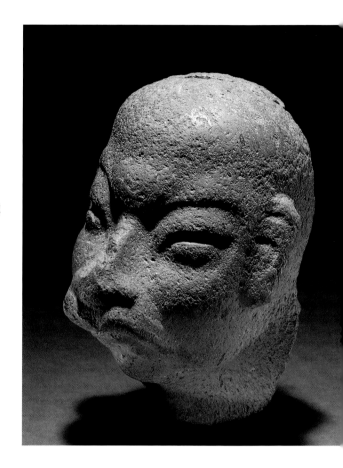

4 Head of a "chinless dwarf" statue

Brown stone with black inclusions
Height: 16.51 cm
Provenance unknown
Olmec style
Preclassic period, 1200–500 B.C.
30.3/2259

This head with downturned mouth is an example of large-scale Olmec stone sculpture that reached its greatest development in the southern part of the modern state of Veracruz. Many images of gods and humans combine an extraordinary naturalism with supernatural attributes. The most important deity images combine human and jaguar attributes; it has long been suggested that these were-jaguars are somehow related to rain and agricultural fertility (Covarrubias 1957). The downward-turned mouth of this sculpture may derive from such images. A number of chinless-dwarf statues carry ears of corn or have corn symbols carved on them (Joralemon 1976:52). Most such statues stare upward toward the heavens (Bernal 1969, pl. 61; Joralemon 1976, fig. 20f and 1971, fig. 19). A kneeling figure from the site of La Venta wears a jaguar mask and has the same upward gaze (Bernal 1969, pl. 32).

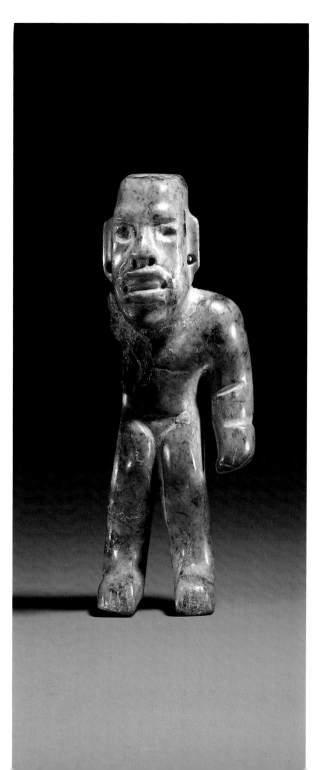

5 Standing male

Bluish-green serpentine; one arm broken off
Height: 6.8 cm
Veracruz, San Cristobal Tepatlasco

Olmec style
Preclassic period, 1200–500 B.C.
30.3/2258

This standing figure, reportedly from San Cristobal Tepatlasco, is an example of one of the most widespread types of Olmec lapidary work. These figures were traded over much of Mesoamerica and apparently highly prized. Carved from jade or other fine green stones, such pieces are characterized by a slight curvature of the legs that suggests the bend of knees, upright posture with arms at the sides, and the indication of a loincloth. They were created by sawing with string, polishing with sand, and drilling features such as the fine perforations in the ears and slight depressions for the nostrils. The left arm was sawed off in ancient times; this may be viewed as mutilation but was apparently a common practice and might better be referred to as "division" of a valued object. The most remarkable of such figures are those excavated at La Venta, where six celts, or chisel-like tools, and sixteen figures were discovered. The figures, arranged in an ordered confrontation or ritual group, had been intentionally buried as an offering. (Published: Ekholm 1970:37; Weaver 1972, frontispiece.)

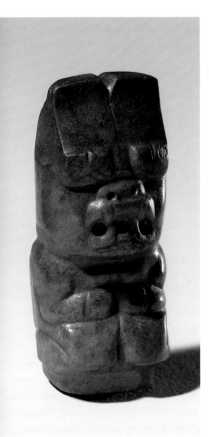

6 Figurine with jaguar mouth

Brown jade with incised glyphs
and "padded" eyes
Height: 7.94 cm
Olmec style
Preclassic, 1200–500 B.C.
30.3/2263

This small kneeling figure with folded arms, cleft head, eyes with crossed bands, and what appear to be fangs has been identified as the Olmec Dragon, the most important and frequently represented deity (Joralemon 1976). This deity (also referred to as God I) is associated with the earth, agricultural fertility, and rain. A number of two-dimensional representations show a maize plant growing from the cleft in the deity's head; the mouth was symbolic of caves, considered the source of moisture and rain; and the fangs may be identified as plant images or a combination of plants and fangs. A long, thin blade—subsequently broken off—originally extended from the base, making the whole rather like an icepick in shape. This instrument, by analogy with the practices of later Mesoamerican cultures, was used in autosacrifice, the ritual letting of blood in private or public devotions. (Published: Joralemon 1976, fig. 10w.)

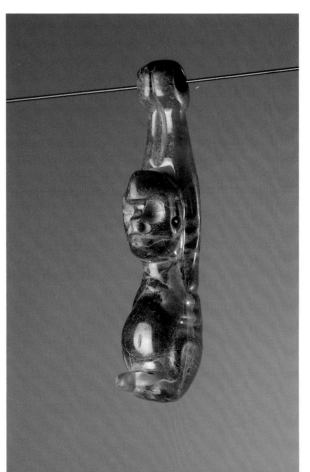

7 Monkey pendant

Deep sea-green jade; perforations
through nose, ears, and foot
Height: 6.2 cm
Olmec style
30.3/2262

Naturalistic sculptures of animals like this one are relatively uncommon in Olmec art. Most images drawn from the natural world are clearly intended as deities, combining the attributes of several animals, birds, and humans. This sculpture can be related to an Olmec category depicting the human body in various postures. Most commonly figures are shown reclining on one arm; the legs have various positions. The body, limbs, and head of this miniature simian are accurately represented, although in "human" posture. One small detail sets it apart from wild monkeys: the ears are pierced, as if for the attachment of earrings.

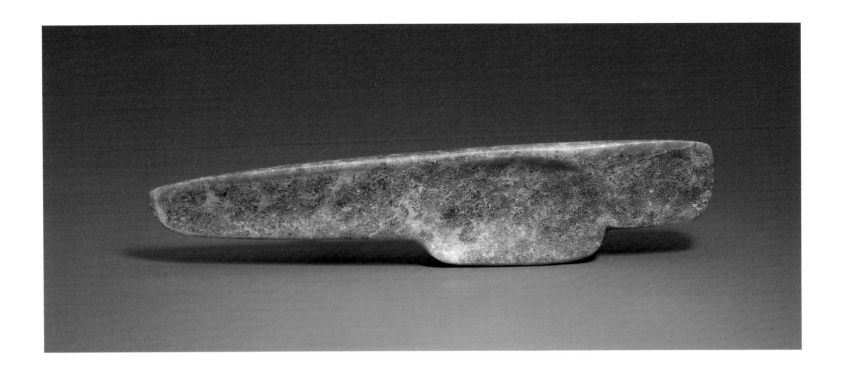

8 Jade spoon

Gray-green coarsely crystalline jade
Length: 17.4 cm; *height:* 1.2 cm
Mexico, possibly Guerrero
Olmec style
Preclassic, 1200–500 B.C.
30.3/2260

Small, pendantlike objects such as this one lack holes for cords that would have permitted them to be worn. Their shape with oval depression may indicate that they were used as spoons. If so, the precious material of which they are made suggests that they were intended for a substance with religious significance; further evidence for this are examples that feature were-jaguar and bird designs. Possibly they were instruments for inhaling a hallucinogenic snuff (Furst 1968:162). Some plant depictions on Olmec sculptures have been identified as members of the nightshade family.

The Olmec lavished much care on ritual celts (ax heads). Jade and other fine green stones were used and sometimes incised with complex religious designs. Such celts are found in graves and in buried offerings like those from La Venta (cf. Figure 5, comments). The shape of these spoons has been identified as that of an abstract bird (Furst 1968:162). However, their characteristic shape (back and top edge and tapering design) may have been produced by cutting them from celts ; the sectioning of these ritual axes would have produced this form (G. Ekholm, AMNH files).

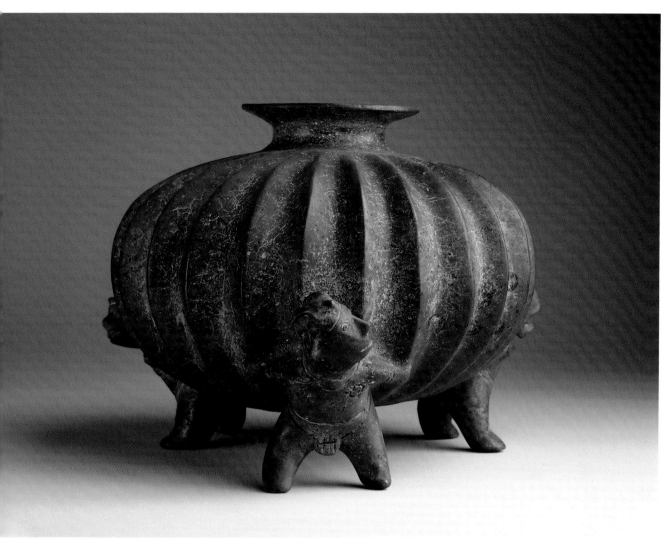

WEST MEXICO

The ceramic sculptures of West Mexico have long been admired for their distinctive and expressive depictions of the human form. The most widespread styles are named after the modern Mexican states of Colima, Jalisco, and Nayarit. Large hollow figures and smaller solid sculptures, some of extraordinary complexity, were made in all three styles.

The Colima hollow figures are generally monochrome, in red-brown colors with highly polished surfaces. Those of Jalisco tend to be monochrome or bichrome. The Nayarit figures are often brightly painted and wear the most elaborate personal adornment. A number of less

9 Jar supported by three men

Red ceramic.
Height: 25.0 cm; *diameter:* 31.0 cm
West Mexico, Colima
Colima style
Late Preclassic–Early Classic,
400 B.C.–A.D. 300
30.3/2407

frequently represented styles, such as the Chinesco, have been defined as well (Von Winning 1974).

Individual tombs, where most sculptures have been found, often contained many figures and vessels as mortuary offerings. They depict humans, animals, plants, and even musical instruments, such as shell trumpets. Men and women are often in pairs and sometimes embracing; represented too are warriors, dwarves, and hunchbacks. The wide range of animals includes birds, dogs, and even armadillos. Gourds and squashes are the predominant plant representations. Shaft-and-chamber crypts are the most complex of the tombs in which these objects were placed; they are reached by shafts cut into hard volcanic deposits and could include as many as five chambers. The multiple burials that took place may represent use by several generations of a family or kin group. The West Mexican ceramic and mortuary traditions began in the Early Preclassic period (ca. 1500 B.C.) and reached their culmination in the Late Preclassic (350 B.C. to A.D. 200).

The "simplicity hypothesis"—that these sculptures were produced by small-scale agricultural communities lacking complex social hierarchies—has been disproved by recent archaeological discoveries (Weigand 1985). West Mexican cultures created monumental earthen architecture, particularly complexes with multiple round buildings and associated ball courts. The buildings are composed of three concentric elements: a central terraced altar or pyramid surrounded by a patio that is encircled by a raised banquette. Atop the banquette are four to eight rectangular platforms that supported painted wattle-and-daub buildings (mud plaster and reeds or sticks). Tombs were excavated below the buildings. Such complexes were probably elite residential areas; they stand at the apex of a hierarchy of sites, including agricultural communities of varying sizes and locations for specialized activities, such as obsidian workshops. These complexes are represented by village models, two of which are in the Collection. Such models were known long before the buildings were discovered. The development of monumental architecture continued and intensified in the Early and Middle Classic periods (A.D. 200 to 700). Among the most impressive sites is the Guachimonton Complex in Jalisco, which includes five round buildings; the largest of them has a radius of 64 meters.

The Collection includes some of the finest and most important West Mexican sculptures in any museum. Although many of the pieces are important, the standing warrior with the treelike backpiece (Figure 12), the seated male figure in the Chinesco style (Figure 17) and the village model with the world tree at its center (Figure 18) are particularly notable.

Jars of this shape are common in West Mexican ceramic art. The supports are human figures, as in this example, or zoomorphic. The Collection also includes a jar that parrots are supporting on the ends of their tails. The figures in this piece have a relatively common posture, supporting the jar on their backs and outstretched arms. (For a similar jar, with the figures reversed, see Messmacher 1966, lám. 72.) Their heads are turned to the left, and their faces are directed upward. This double motion gives animation and a quality of observing. The leftward turn of the heads creates a sense of circular motion that reinforces the spherical shape of the vessel. This circular motion is counterclockwise, or anti-sunwise. This direction, associated with dance and ritual, is appropriate for jars which, like this one, served as mortuary offerings. The basic gadroon form of the jar is that of a cucurbit, or gourd; squash-shaped jars without supporting figures are also common. The vessel no doubt contained offerings of food for the dead.

concept, but extraordinarily expressive and free," perfectly captures the elegant arch of the acrobat's body (Covarrubias 1957:85). The stylization of hands and feet and the placement of the vessel mouth to one side of the trunk unify the sculpture in a single unbroken arc. The figure seems ready to spring into another position. Other examples of figures in this posture lack the unity, elegance, and fine naturalistic proportions of this piece (Nicholson and Cordy-Collins 1979, no. 50; Von Winning 1974, figs. 24 and 25). In most Colima standing figurines, the forward extension of the toes is matched by an unnatural backward projection of the heel for stability; the same treatment is extended to the hands in acrobat figures. Such distortion is not necessary—the four limbs provide ample support— but its absence here is unique.

The figure wears a loincloth with suspended ornaments, two shell pendants on his breast, and a helmet with a central serrated crest. Helmets with such crests are fairly common in Colima pieces (cf. Von Winning 1974, figs. 18, 19, 37, 40, 55).

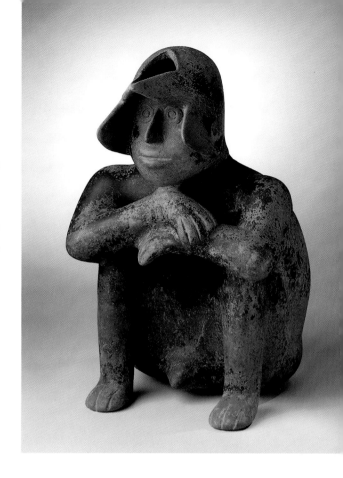

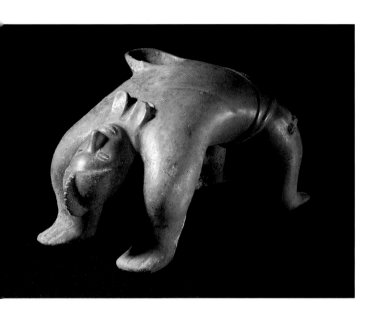

10 Male acrobat vessel

Buff ceramic with remains of color
that may indicate body paint or
textile patterns
Length: 24.0 cm; *width:* 13.0 cm;
height: 13.8 cm

West Mexico, Colima
Colima style
Late Preclassic,
400 B.C.–A.D. 200
30.3/2411

Perhaps of all the pieces in the Collection, this acrobat best exemplifies the forceful qualities that drew artists like Miguel Covarrubias and Diego Rivera to the sculpture of West Mexico. This delightful effigy vessel, "simple in form and

11 Seated man with helmet

Ceramic
Width: 26.0 cm; *height:* 39.0 cm
West Mexico, Colima
Colima style
Late Preclassic,
400 B.C.–A.D. 200
30.3/2415

Seated human figures are common in West Mexican ceramic sculptures. They sit directly on the ground, with the legs bent and extended or crossed, or they squat with arms resting on their knees, as in this

piece. The position of the hands, folded to provide support for the chin, is particularly lifelike. The helmet, with points projecting forward, appears to be made of a stiff, material like leather that has been worked. The round eyes—two concentric circles, the inner formed by pressing the end of a hollow reed into the clay—are the piece's most unusual features. Most Colima figures have more nearly oval eyes, slightly protruberant and marked off by incised lines; pupils are usually absent; when present, they are indicated by horizontal slits but are never round (Von Winning 1974:31). These "goggle-eyes" appear to be an organic part of the figure. Rings around the eyes are characteristic of water deities in Central Mexican iconography. (Published: Ekholm 1970:23.)

12 Standing warrior with treelike backpiece

Ceramic, with traces of white
pigment and incised lines
Width: 18.0 cm; *height:* 30.0 cm
West Mexico, Colima
Colima style
Late Preclassic,
400 B.C.–A.D. 200
30.3/2416

This dramatically posed, simply dressed male figure incorporates a complex iconography. He wears a headdress—a single hornlike projection above the middle of his forehead that is apparently held in place by wrapped bands—and he is looking to the left. Both the leftward orientation of the alert gaze and the headdress have led to identification of the figure as a shaman, the spiritual guardian of the community, facing supernatural danger (Furst 1966). The impression of vigilance is increased by the weapon (probably a throwing stick), held in the right hand, and by the left arm, held before the chest as if prepared to parry a blow. The object rising from the figure's back appears to be a branching plant; it has been identified as the cosmic tree or tree of life, a common feature of shamanic belief and a central feature of all Mesoamerican cosmography (Furst 1966). While they are not common, back devices are found on other West Mexican figures, including some that are clearly warriors (Furst 1966:36, fig. 10 and 39, fig. 20; Sotheby's 1987, no. 136; Nicholson and Cordy-Collins 1979:63, no. 43). The back device worn by warriors in Central Mexico during the Postclassic period was a light wicker-work piece that indicated the wearer's importance and served the practical function of allowing combatants to follow their commanders even in the heat of battle.

Possibly this sculpture represents a military figure of some importance. Incised lines at the neck, elbows, and waist appear to delineate a shirt, while further incised lines and the remains of white paint indicate the short pants commonly worn by Colima figures. The backpiece is mounted on the center rear of the pants, indicating that it is part of the costume—not an organic part of the figure.

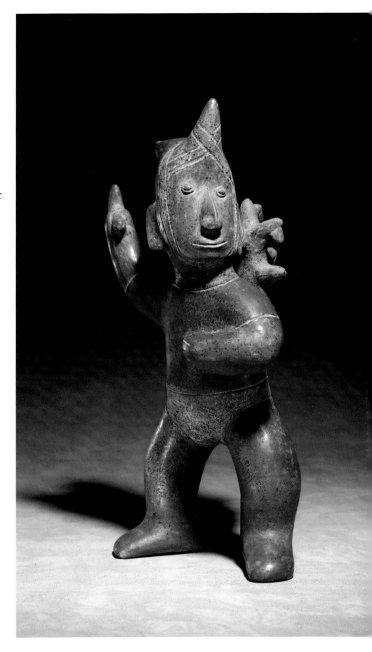

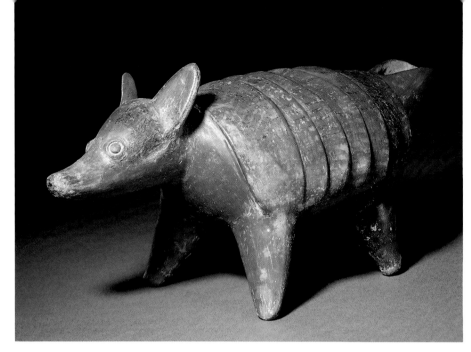

13 Armadillo figurine

Red ceramic with black paint
Length: 32.0 cm; *height:* 16.0 cm
West Mexico, Colima
Colima style
Late Preclassic,
400 B.C.–A.D. 200
30.3/2420

Armadillos are relatively uncommon in Colima animal sculpture. This example features an oversized head and carefully sculpted back plates further divided by black parallel lines.

14 Reclining puppy vessel

Red ceramic with black staining;
completely intact
Length: 24.0 cm; *height:* 12.0 in.
West Mexico, Colima
Colima style
Late Preclassic,
400 B.C.–A.D. 200
30.3/2429

A wide range of animals from the natural and social environment of West Mexico appear in Colima-style sculptures. Dogs are the most numerous, but ducks (often in pairs), parrots, rodents, snakes, tortoises, and even aquatic creatures like crabs and clams are also found. Dogs—the most useful domestic animals—may have been included in the tombs to serve as companions, as they did in life; the carefully observed posture of this reclining but alert puppy suggests this role. Ceramic dogs, fowl, and crustaceans may have been viewed as sustenance for the dead in the next world, just as were the actual foodstuffs offered in many of the vessels.

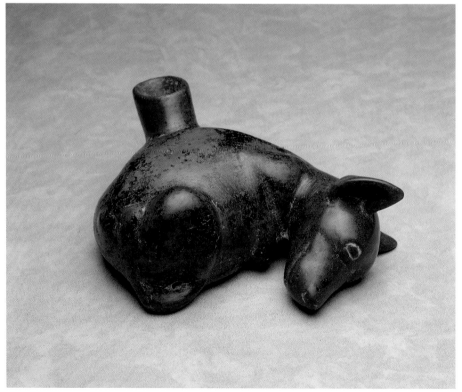

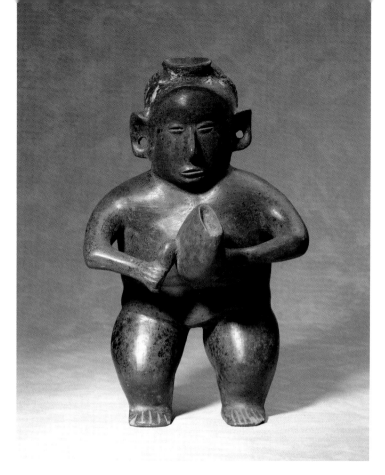

16 Seated woman

Ceramic
Length: 26.0 cm; *height:* 34.0 cm
West Mexico, Colima,
provenance unknown
Colima style
Late Preclassic,
400 B.C.–A.D. 200
30.3/2440

Like most female figures from West Mexico, this woman wears only a skirt; the pierced ear lobes—common in Colima figures—suggest that ear ornaments of a perishable material were originally attached. Most Colima figures look straight ahead and adopt a relatively limited number of postures. In this unique work, the head is turned to the right and slightly raised; the arms are wrapped across the chest with the left hand touching the cheek; and the legs are held together and extended directly outward.

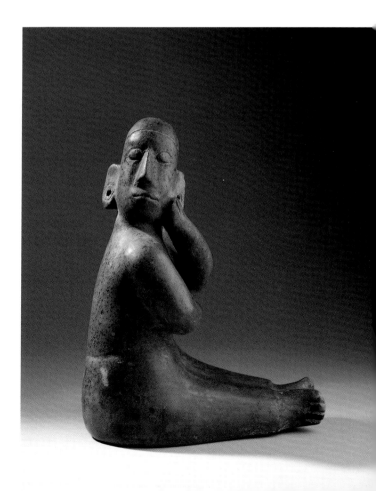

15 Drummer

Red ceramic
Width: 19.5 cm; *height:* 32.0 cm
West Mexico, Colima
Colima style
Late Preclassic,
400 B.C.–A.D. 200
30.3/2431

The rhythm of the percussive sounds produced by beating on turtle carapaces was joined by the notes of various other instruments depicted in West Mexican sculpture. Shells from the Atlantic coast were converted into trumpets (and copied in ceramic vessels) and blown, pan pipes were played, ceramic and gourd rattles were shaken, and drums made from hollowed logs were used as well.

The drummer wears a modeled loincloth and close-fitting cap; braided bands fall from the top of the head at each side of the vessel mouth and end in a large tassel at the back of the head. The large holes in the ear lobes (found also in Figure 16) suggest that the figure originally had earrings made of a perishable material.

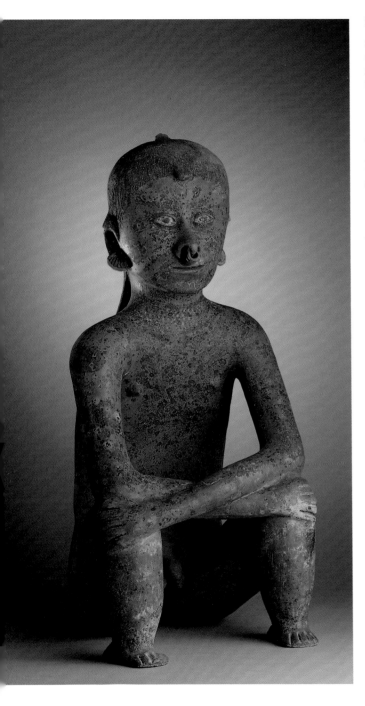

17 Chinesco male figure

Ceramic with highly burnished red slip and black spot patina, white paint, and negative painting on face and neck
Width: 34.0 cm; *height:* 73.0 cm

West Mexico, Nayarit-Jalisco border
Chinesco style
ca. 200 B.C.
30.3/2457

18 Village model with tree

Buff ceramic
Height: 28.0 cm; *diameter:* 30.0 cm
West Mexico, Nayarit
Late Preclassic,
400 B.C.–A.D. 200
30.3/2461

This figure in the so-called Chinesco style (a popular name, seemingly suggested by their exotic appearance) is one of a small group characterized by particularly fine workmanship; the slips are highly polished and the facial features carefully detailed. The eyes are almond-shaped, and the hair is delicately incised. A necklace and facial decoration are shown in black negative painting. The facial painting (or tattoos) consists of black lines radiating from the center; two triangular areas on the forehead and the cheeks feature white paint between the black lines. The pose is static and contemplative (Von Winning's Type A, monumental figures 1974:69–70). If the figure were standing, it would be almost five feet tall—thus it is nearly life size. The figure wears multiple earrings and a banded nose clip, but is otherwise nude.

The body is sculpted with extraordinary sensitivity. The collarbone and shoulder blades are finely modeled, and the navel and nipples are shown. Female figures in this style (far more numerous than male figures) most often sit in a birth-giving pose, while males adopt the posture seen here, with knees bent and folded arms resting on them (cf. Graulich and Crocker-Delataille 1985:175, no. 247). (Published: Ekholm 1970:16–19; Schiff 1970:37.)

Although not the most elaborate of the West Mexican village models, this example is unique and one of the most appealing. The huge tree rising from the village's center suggests that the whole sculpture should be seen as a cosmological model. A central feature of Mesoamerican cosmology from an early date is the world tree. It rises from the center of the world and joins the three levels of the universe: the world of the dead, the world of the living, and the heavens. This tree's careful geometry and relationship to the village also suggest a cosmological image. The two levels—each with four stylized branches—suggest orientation to the cardinal and intercardinal points. Two houses have saddle-shaped roofs, and two have pyramidal roofs.

Like other village models, this example includes many figures. The most important—larger than the others and the only one standing—is pointing into the tree's branches. A hole in the figure's hand may have held a perishable object, perhaps a feather. In no other village model is a figure set apart in this hieratic way; no conclusive interpretation can be made, but the figure may represent an individual who had an important religious or political role. The sculpture includes twenty-two human figures; eight of them are, like the large figure, pointing upward. A dog is lying

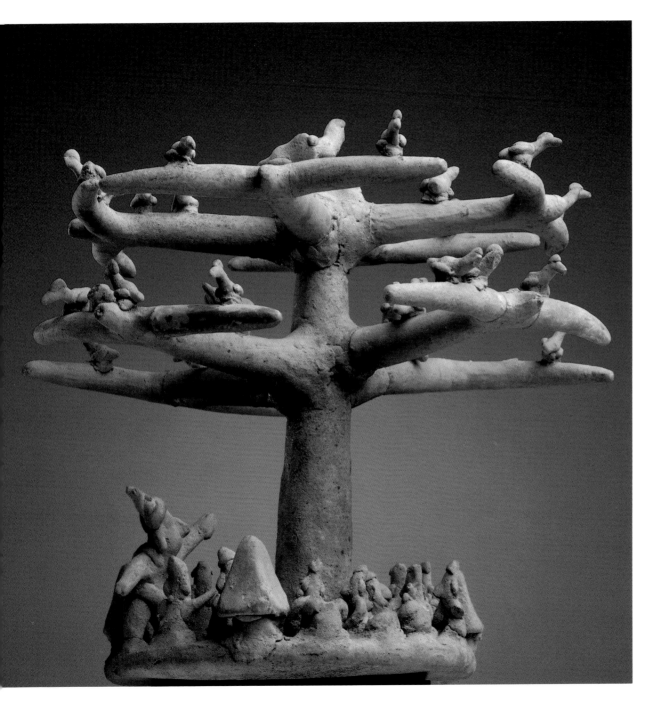

next to one of the houses; nearby is a cone-shaped object that may represent a vessel. Thirty-two birds are in the tree. (At least four more were attached at one time.) Although freely and simply depicted, the birds can clearly be divided into four types. A crested bird with a long neck is most common. Six birds with large heads and pellet eyes seem to represent parrots. Two types are depicted only once each—a flat-faced horned bird that is clearly an owl and a second (unidentifiable) horned and winged creature with an animal face.

The striking geometrical ordering of the tree and the village recall the complex ordering found in archaeologically known architectural complexes from West Mexico. In these complexes of monumental round earthen buildings, the outermost circle supported rectangular platforms for residential structures. At Preclassic sites, there are often eight such structures. (Here, the tree's branches intersect the diameter of the base at eight points.) Perhaps the model's round base represents one of these buildings; in that case, these houses may be identified as elite residences. This example was reportedly found in Colima. Made in Nayarit, village models were apparently widely traded. (Published: Ekholm 1970:24; Von Winning and Hammer 1972:61, no. 49.)

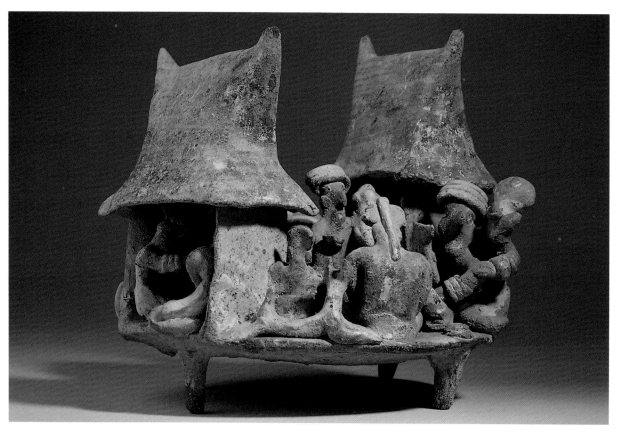

19 Village model with three houses

Ceramic with black paint
Width: 23.0 cm; *height:* 22.0 cm
West Mexico, Nayarit
Late Preclassic,
400 B.C.–A.D. 200
30.3/2459

The Nayarit house and village models make up one of the most fascinating and ethnographically revealing categories of West Mexican sculpture. The houses are of two types, distinguished by the construction of their roofs. Most common is a saddle-shaped, four-shed roof with a curved ridge and projecting ends; less frequent is the pyramidal roof, occurring primarily on attached secondary structures. This model has both types: two occupied houses with saddle-shaped roofs and open sides and a smaller empty building with a pyramidal roof and one side open to the village center.

Attached structures are sometimes occupied by sleeping figures (Von Winning and Hammer 1972:19); such a figure lies to one side here. The roofs are painted with narrow black bands, with a row of black triangles above the eaves. At the village's center are a jar—possibly a container for a fermented drink—and what may be a plate of food.

Each large house contains a seated male figure wrapped to the neck in a blanket and facing the center; female figures sit behind, touching them. Between the jar and the pyramidal roofed house are a seated male figure with pierced cheeks (cf. Figure 20) and a seated female offering a cup to one of the blanket-wrapped males. She wears a nose clip, as do the figures associated with the opposite house. In front of the jar, a standing male figure with filleted headbands is carrying an oversized conch-shell trumpet painted white; facing him is a seated male figure with filleted headband and a pendant "fall" at the back of his head. A seated male figure on the opposite side of the village wears identical ornaments; he is leaning forward as though ill. Two seated couples are making affectionate gestures. The model presumably represents a festive occasion involving two groups whose heads are the seated blanket-wrapped males inside the houses. Round altars are usually found at the center of the circular buildings of West Mexico. Some altars have depressions at their center that could have held a circular slab base like the one this model. The ritual or festival shown could have taken place around its depiction in miniature on an altar. (Published: Von Winning and Hammer: 1972:59, no. 42; Ekholm 1970:26.)

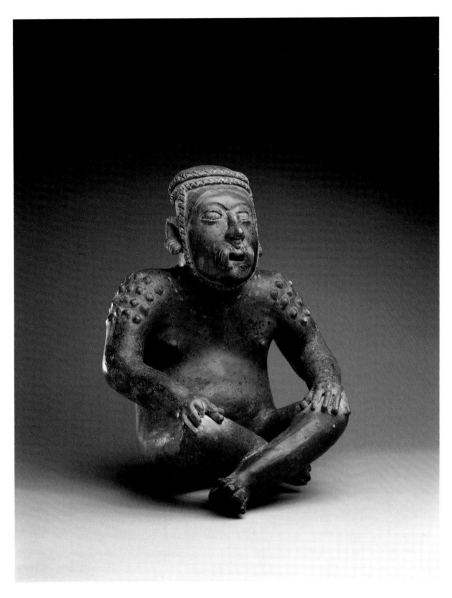

20 Seated male with pierced cheeks

Ceramic with traces of white paint
Width: 32.0 cm; *height:* 40.0 cm
West Mexico, Nayarit
Nayarit style
Late Preclassic,
400 B.C.–A.D. 200
30.3/2460

Although the proportions and facial features of this figure are close to the Colima style, the pierced cheeks strongly suggest that it is from the Nayarit area, while the triangular face is characteristic of Jalisco. The carefully observed features—combined with blank, staring eyes—suggest that this may be a portrait of a recently deceased individual created as a funerary offering. Nayarit figure groups and village models indicate that piercing the cheeks was a ceremony performed publicly as part of a group observance; one model shows the rite being carried out as part of a funeral observance (Von Winning and Hammer 1972:26–27, 84, no. 139a and b). Ritual bloodletting was a common Mesoamerican ritual practice, apparently from the Olmec period on. The autosacrifice was performed as part of the observance of festivals and life crises and in private religious practice. The Nayarit models suggest the importance of the flow of blood (shown being collected in bowls in one model) and indicate that both cheeks were pierced by a single long object (Von Winning and Hammer 1972:85, no. 141). The cheeks, swollen with multiple striations in this example, suggest that the rite might be repeated a number of times. This figure also shows rows of scarified decorations (knobs) on his shoulders and wears a filleted chin strap and headband; bead necklaces are indicated with white paint.

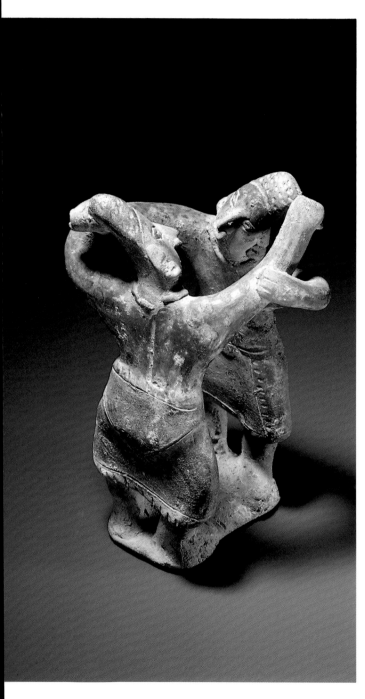

21 Two women fighting or dancing

Red ceramic, with incised
decoration and black and white
paint
Width: 6.5 cm; *height:* 13.0 cm
West Mexico, Nayarit
Nayarit style
30.3/2426

22 Standing woman

Buff ceramic with incising
Width: 2.2 cm; *height:* 8.0 cm
Colima style
Preclassic, 1200–500 B.C.
30.3/2425

Although reported to be from the modern Mexican state of Colima, these solid female figurines are clearly in the Nayarit style, with their broad faces, tall foreheads, and painted and incised decoration. Although the mirror-image postures of the two figures may at first appear like a dance movement— each woman raising her right hand to grasp a lock of her partner's hair while resting her left hand on her partner's arm—other examples make it clear that the women are fighting. In Mesoamerican art, victors in combat or battle are commonly shown grasping the defeated opponent's hair; the same iconography appears in other West Mexican sculptures (cf. Von Winning 1974, nos. 44 and 192). The two figures are dressed identically, each wearing a nose clip, a filleted necklace, a wraparound skirt with closure and fringes indicated by incising and has painted black circles with white centers on her arms. The skirt of one figure is painted black. Such pairs of combatants are usually male; in the Colima style, dogs are sometimes shown fighting. This example is unusual in showing women and in their pose, each grasping the hair of the other.

This small, delicately modeled and incised female figurine is unlike the solid types associated with the shaft-tomb cultures. The solemn expression and restrained pose create a monumentality unusual in a piece so small. The sense of reserve is increased by the careful parallel lines that have been incised to create the hair, arm bands, and triangular loincloth. The wide hips recall Preclassic figurines from other parts of Mexico.

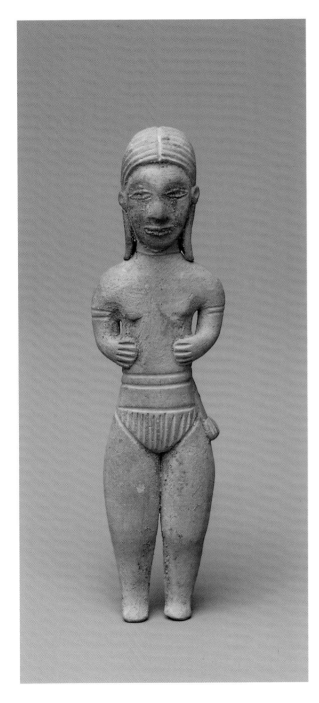

23 Hunchbacked pregnant female

Ceramic, red slipped with white
and black paint
Width: 11.0 cm; *height:* 16.5 cm
West Mexico, Guanajuato
Chupícuaro style
Preclassic, 500 B.C.–A.D. 1
30.3/2454

During the Late Preclassic period, a flourishing culture existed in the Chupícuaro area. Graves were lavishly furnished with striking ceramic vessels and figures decorated with geometric red or brown and black designs. Hollow painted figurines like this one are less common than the solid type. Preclassic figurines are overwhelmingly female, but this example is atypical in several ways, with its black face paint and projecting nose. Most unusual is the fact that it shows a humpback who may be pregnant. Humpbacked figures were depicted in the art of many Mesoamerican cultures, and there was undoubtedly a symbolic meaning attached to this deformity. The polychrome pottery tradition of Chupícuaro is related to the brightly painted ceramics of Nayarit. (Published: Ekholm 1970:15; Schiff 1970:38.)

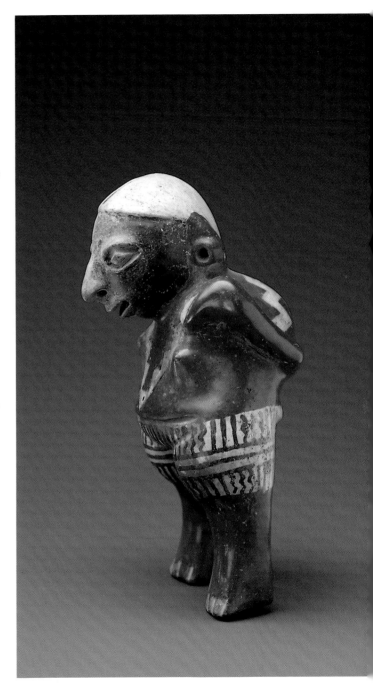

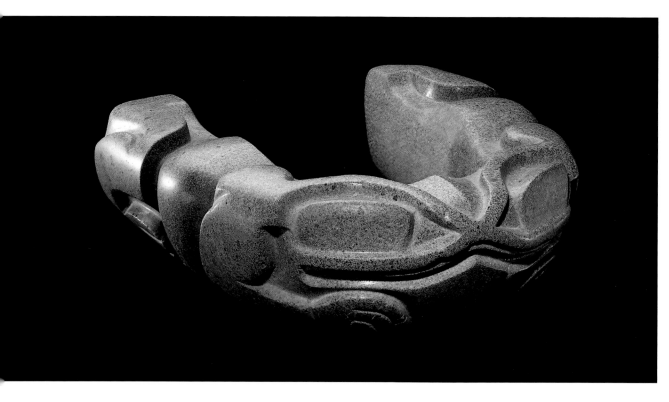

VERACRUZ

During the Preclassic period, the Gulf Coast region of Mexico was the heartland of the Olmec culture. During the succeeding Classic period, this area and especially its Veracruz section, continued to produce fascinating and diverse works of art. Especially notable are finely carved stone objects associated with the Mesoamerican ball game and a remarkable variety of ceramic sculptures.

The site of El Tajín in north-central Veracruz features monumental stone architecture such as the Pyramid of the Niches and the ball courts, whose stone reliefs are among the finest expressions of the Classic Veracruz style. Interlacing and interlocking scroll motifs,

24 Yoke with "frog"

Highly polished stone; in three fragments, repaired
Length: 42.0 cm; *width:* 39.0 cm
Gulf Coast (probably Veracruz)
Classic Veracruz style
Early Classic, A.D. 300–600
30.3/2357

Yokes are the most common and widely distributed of the Classic Veracruz-style carved stone objects. Their shape resembles that of the yoke (*yuguito*) used for oxen. Most have been found in central Veracruz, where the yoke was developed during the Early Classic period. By the Late Classic, the form had spread to neighboring Central Mexico and as far south as Guatemala and El Salvador (Proskouriakoff 1954:68). Yokes may be plain or carved; the complex carved examples are almost exclusively from Veracruz. That they were part of the equip-ment worn in the Mesoamerican ball game is virtually certain—the primary evidence being ceramic figurines wearing yokes around their waists, together with the associated hachas and palmas and ball-court relief sculptures such as those at El Tajín (Kampen 1972: figs. 5 and 6). Yokes are made of various types of stone; the finest are made of hard, fine-grained stone that can be highly polished. Whether the stone objects were the actual ball-game belts or are representations, or skeuomorphs, of equipment made in perishable materials is

regularized and geometricized, are characteristic of the style; the scroll motif is often delineated with double outlines and combined with abstract decorations that represent reptilian creatures.

The ball game is one of the unifying features of Mesoamerican civilization from the Preclassic to the Conquest and beyond. Ball courts have been found in places as far apart as the southwestern United States and Central America. Play must have varied in different times and places, but certain common features appear in accounts written after the Conquest. The use of hands and feet was not permitted; the ball was struck with the hips, knees, or buttocks. The balls were solid and heavy, weighing about five pounds and made of latex gathered from trees or bushes. The object was to strike the ball in such a way that the opponent was unable to return it or to hit stone markers or tenoned heads on the walls. Rings with openings just large enough to permit the ball's passage are generally associated with later courts.

In the Classic period, the game seems to have undergone a special development on the Gulf Coast and Pacific slope of Mexico and Guatemala. Ball-game scenes and players were depicted in important civic architectural contexts, in reliefs on the side walls of masonry ball courts, and on stelae. The Classic-period game may have been a ritual with cosmological significance; the reliefs show skeletalized figures and the sacrifice of players by decapitation. Veracruz was the center of development of the "yoke-hacha-palma complex"; these three pieces of the ballplayers' equipment were the subject of stone sculptures. These were often highly polished and had complex decorative carving.

The culture and art style known as Remojadas developed in south-central Veracruz during the Classic period. Typical of the period were stylized and engaging depictions of human beings that frequently featured decoration with locally found black bitumen. The best-known objects are the "smiling figures," of which a number of examples are found in the Collection. This ceramic tradition lasted throughout the Classic period (A.D. 200–900), producing striking portraitlike sculptures, carved and painted vessels, and complex solid figurines (Hammer 1971).

debatable. (Some ceramics show yokes with basketry patterns, and a wooden example has been found.) Accounts written by Europeans after the Conquest indicate that the ball was struck with hip, knee, or buttock (Stern 1949:59). Yokes weigh from 40 to 60 pounds; a solid, heavy yoke might have been advantageous in returning a fast-moving five- or six-pound solid rubber ball. (Ekholm 1973:45–48). However, their weight and elaborate carving, subject to damage, suggests that some yokes were used in game-related ceremonies as trophies or signs of rank or were made specifically as burial offerings.

This is a "standard yoke" in Proskouriakoff's terminology, with straight arms and a convex exterior. Such "frog" yokes are the most common type, showing a saurian creature carved in deep relief (Proskouriakoff 1971:562). The creature's face, with huge, nearly rectangular eyes, appears on the closed end of the yoke; its body is carved on the exterior faces of the two arms. The creature depicted in this example has been identified as a toad or the reptilian earth monster found in Aztec and Maya cosmology. In the best-known examples of saurian yokes, the creature's body is decorated with the complex interlacing scroll patterns characteristic of the Classic Veracruz style (cf. Figure 29). Their absence is sometimes associated with works of lesser quality (Proskouriakoff 1971:562; cf. Parsons 1980:172, no. 266); however, the finely polished surface and powerful, assured forms of this example belie such a judgment.

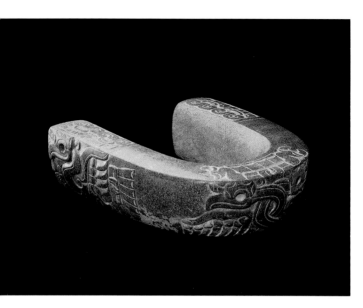

Yokes with avian figures are relatively uncommon. Birds are more often found on hachas (Figure 28 comments). Particularly notable are the repeating geometric high-relief patterns representing the wing and tail feathers found on this yoke (Proskouriakoff 1954, fig. 10b and 10c). Complex patterns of interlacing scrolls, carved in deep relief and delineated with double lines, are characteristic of the Classic Veracruz style. Rectangular areas of such scrollwork appear on the top, bottom, and ends of the arms of this yoke. The four birds also show such scroll designs, particularly on the long necks and primary feathers. In complex examples, the design may be created by rotating the scrolls 180 degrees; a similar process was used in creating the joined depictions of birds on the end of the yoke. All four are created from identical components. Those on the arms are in profile. On the end, two birds were combined by crossing their long necks. Wings are at the sides, and the tail feathers and clawed feet have been rotated so that they appear on the yoke's flat upper and lower surfaces. Large crests with a starlike design project from the front of the heads, and what appears to be a knotted band separates wing and tail feathers. The deep circular eye depressions may originally have held inlays. (Published: Ekholm 1973:46, fig. 5.)

25 Yoke with four birds

Highly polished stone with traces of red and yellow paint; broken in two parts and repaired
Length: 40.0 cm; *width:* 35.0 cm
Gulf Coast, provenance unknown, probably Veracruz
Classic Veracruz style
Late Classic, A.D. 600–900
30.3/2360

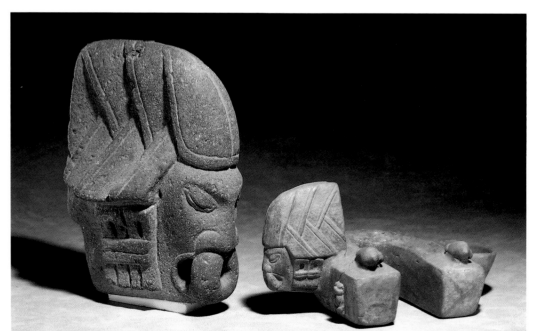

26 Hacha in the form of a human head

Stone
Length: 26.0; *width:* 17.2 cm; *height:* 2.5 cm
Veracruz, Cerro de las Mesas
Classic Veracruz style
Early Classic, A.D. 300–600
30.3/2363

27 Yoke-shaped vessel

Buff ceramic, unpainted
Width: 19.0 cm; *height:* 24.5 cm
Veracruz, Cerro de las Mesas (said to be from same tomb as Figure 26)
Classic Veracruz style
Early Classic, A.D. 300–600
30.3/2364

The name "hacha" is derived from the Spanish word for ax, as the object somewhat resembles a celt, or stone ax head. Hachas were originally believed to have functioned as sacrificial or votive axes, but clearly—like the yokes—they were ball-game equipment; these associated pieces provide convincing evidence. The shape of this hacha is typical of those found in Veracruz. (A nearly identical hacha was excavated at Costa da Sotavento, Veracruz, at the turn of the century [Batres 1905, lám. 13]). It is wedge-shaped in horizontal section, tapering toward the front, with a notch at the lower edge of the back (Proskouriakoff 1954:79; 1971:563-64). It depicts a human head (cf. Figure 28) with closed eyes, a nose ring, and an unusual "basket-weave" treatment of the hair, or helmet. The closed eyes indicate that the individual is dead; in later hachas, the death motif is continued through depictions of skulls. The Veracruz Aparicio Stela indicates association of human sacrifice with the ball game, showing a decapitated ballplayer (wearing glove, yoke, and palma) with blood represented as serpents emerging from his neck (García Payón 1971:525, fig. 19). Similar imagery appears on the ball-court reliefs at Chichén Itzá, Yucatán. The use of hachas in the ball game has long seemed mysterious.

The notch seems designed to fit into a slot or, as Proskouriakoff suggested, rest on a ledge on the low benches that flanked most courts. A number of figurines demonstrate that hachas were attached to yokes (Ekholm 1973:49, fig. 8; Hammer 1971:91, no. 150). These two pieces indicate the manner of attachment. The hacha notch is surrounded by an uncarved area below the hair and behind the ear ornament. The vessel shows that the notch slips into a slot in the yoke, with the uncarved area matching exactly the profile of the yoke. Stone yokes and hacha are probably replicas of objects made of perishable materials; this ceramic vessel, showing a yoke and hacha, is thus a replica of a replica. (Published: Ekholm 1970:79; Ekholm 1973:48, fig. 7.)

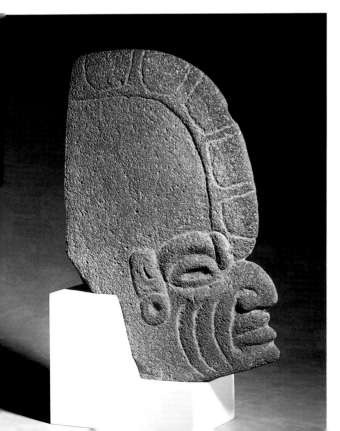

28 Hacha in the form of a human head

Stone with red pigment
Width: 20.0 cm; *height:* 35.0 cm
Tlaxcala-Puebla, border
Classic Veracruz style
Late Classic, A.D. 600–900
30.3/2355

The shape of this thin stone hacha is characteristic and demonstrates the strong sculptural qualities of the design of these objects. When the hacha is resting on its flat base, the back surface slopes and tapers toward the top. It is deeply notched at the lower rear, and its wedge shape is emphasized by the horizontal crest that rises above the forehead. The strong—indeed harsh—treatment of the facial features increases the power of the piece. It is clearly intended to represent an old person with a furrowed face and sharply hooked nose. The subject matter and central crest link this hacha to more fully three-dimensional objects depicting avian and human heads, a number of which show elderly persons (Proskouriakoff 1954:69). Such objects tend to be more common outside Veracruz, suggesting that the piece's reported provenance is correct (cf. Proskouriakoff 1954: fig. 10r, 10s). (Published: Proskouriakoff 1971:563, fig. 5.)

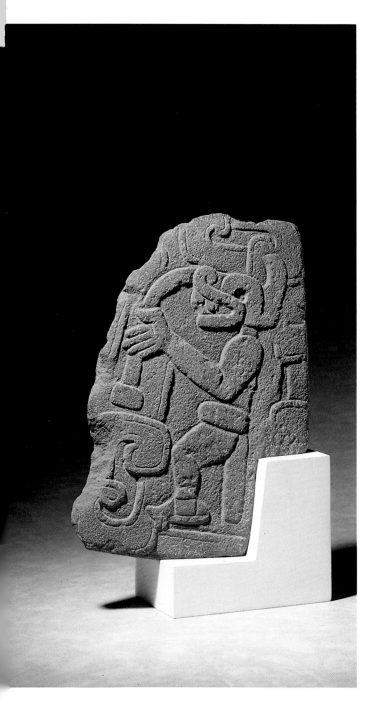

29 Hacha with two figures

Stone
Width: 22.0 cm; *height:* 31.0 cm
Tlaxcala-Puebla, border
Classic Veracruz style
Late Classic, A.D. 600–900.
30.3/2401

The human figure is characteristic of Veracruz sculptures. The figures are "stocky with broad faces, broad noses, and very full protruding lips"; they "wore sandals with a strap around the ankle and open heels" (Proskouriakoff 1954:72). An atypical feature is the coffee-bean eye. This athletic figure, with bent knee and arm thrown back, is reminiscent of the hachas that show acrobats, full human figures in inverted postures (Proskouriakoff 1971:564, fig. 7). He wears what appears to be a yoke around his waist and may thus be identified as a ballplayer. The animal-headed figure on the reverse also wears a yoke.

Human beings wearing animal masks that entirely cover the head are common in Pre-Columbian Mesoamerican art (cf. Figure 34). Although ballplayers are not usually shown wearing such masks, animal-headed figures do appear in the Tajín ball-court reliefs, and hachas showing human heads sometimes feature them as well (Graulich and Crocker-Deletaille 1985:59, no. 61). Both figures are surrounded by the double-outline scroll work of the Classic Veracruz style.

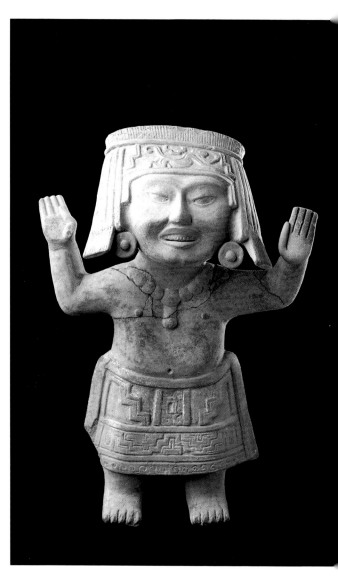

30 Smiling figure

Buff ceramic, mold-made with
traces of blue paint on lower right
of skirt; broken and mended across
chest and left arm
Width: 26.0 cm; *height:* 36.5 cm

Veracruz, provenance unknown
Remojadas style,
Nopiloa II tradition
Late Classic, A.D. 600–800
30.3/2386

The Veracruz "smiling figures" are well known in
the rich ceramic traditions of Mesoamerica. Most
come from ceremonial deposits. Many were found
broken and decapitated in what were apparently
ritual activities. A number of interpretations have
been suggested.

Naturalistic modeling and appealing
expressions led to the belief that they "were quite
evidently created for their [makers'] domestic
delectation, to be passed around and enjoyed in
daily life and not as representations of super-beings
or gods from another world" (Spratling 1960:11).
Their ritual use may indicate supernatural
meanings; their smile has been related to the
Postclassic-period Xochipilli-Macuilxochitl deity
complex—gods of merriment, feasting, dancing, and
gaming and of artists and musicians (Nicholson
1971:16; Paz and Medellín 1962:42–43). These
deities are associated with octli, or pulque, an
inebriating beverage made from the century plant.
Another interpretation, also based on contact-period
sources, is that they depict human beings who
represented the gods in the rites of the annual
festival calendar. Such "likenesses" (*ixiptlatli*) were
sacrificed during the ceremonies. Victims'
despondence over their fate was considered a bad
omen, so they were given inebriating potions. The
smiling faces and the characteristic raised hands
have been attributed to the effects of intoxicating or
hallucinogenic preparations given to the gods'
human impersonators (Heyden 1971). This example
features a male monkey on the customary headdress
(cf. Medellín Zenil 1960:81, lám. 42, 43), large ear
spools, a collar with a pendant, and a skirt
decorated with step frets and grecas.

31 Head from a smiling figure

Buff ceramic, mold-made
Width: 14.0 cm; *height:* 15.0 cm
Veracruz, provenance unknown
Remojadas style,

Nopiloa II tradition
Late Classic, A.D. 600–800
30.3/2376

Heads such as this one, relatively common in
collections, were originally part of complete
sculptures. Smiling figures were frequently
decapitated and buried in ritual deposits. The
bodies were smashed completely or buried
separately (McBride 1971:28). The decapitation of
the figures and their possible association with
pulque offer certain parallels to ball-game rituals
depicted on the ball-court reliefs at the central
Veracruz site of El Tajín (Kampen 1972). Offerings
found in a single tomb have included both
ballplayer figurines and smiling figures (Lifschitz
n.d.). This head, of the "wide triangular" type with
the "devilish" smile, has the typical protruding
tongue and shows intentional dental mutilation
(McBride 1971:28; Zenil 1960:80). The elegant and
lively decoration on the headdress is usually
associated with figurines having more naturally
shaped heads (cf. Hammer 1971:65, nos. 59 and 62;
Parsons 1980:166–67, no. 255). The sharp crest and
long neck strongly suggest that the bird is a great
blue heron.

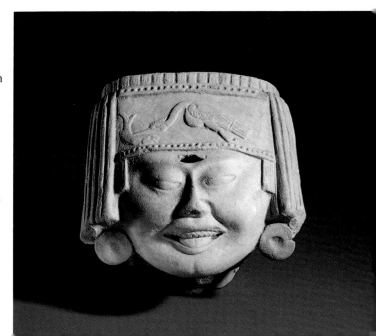

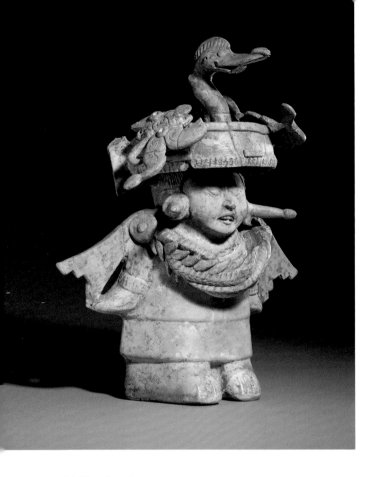

32 Smiling figurine with complex headdress

White ceramic, mold-made
and hand modeled
Width: 22.0 cm; *height:* 25.5 cm
Veracruz, provenance unknown
Remojadas style, Nopiloa tradition
Late Classic, A.D. 600–800
30.3/2388

The complex water-bird headdress clearly indicates the importance of avian imagery in the Remojadas tradition. The earliest figurines from southern Veracruz feature headdresses with stylized wings and tails of diving birds that rise as fanlike projections (McBride 1971:24). The tail in this headdress is missing but probably was the same. The wings incorporate stylized dragons. The headdresses of later "smiling face" figurines often feature herons, which have a similar crest (cf. Figure 31).

33 Ritual performer

Buff ceramic with black bitumen
pigment, mold-made, fingers, part
of arm, and streamers partially
missing
Width: 11.0 cm; *height:* 21.0 cm
Veracruz, Las Remojadas
Remojadas style
Late Classic, A.D. 600–800
30.3/2397

This figurine's elaborate headdress and costume seem to indicate a ritual performer. A widespread cult during the Classic and Postclassic periods was dedicated to a male deity whose rituals included wearing the flayed skin of a sacrificial victim. This

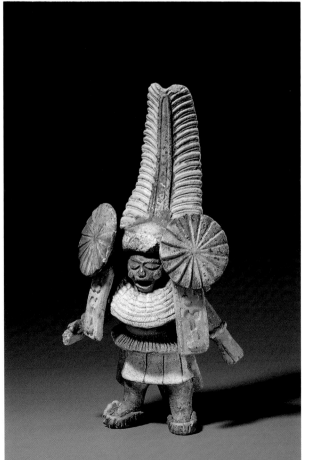

figure's closed eyes and open mouth are clear death imagery and may indicate the wearing of such skin. A somewhat earlier Remojadas monumental figure that depicts this deity, called Xipe Totec by the Aztecs, wears a similar headdress (Hammer 1971:54, no. 31). The tall central crest was probably made of feathers mounted on a shaft. The rosettes are identical in design to Postclassic costume elements made of paper, characteristically worn by deities associated with rain and agricultural fertility. The streamers hanging from the rosettes create a positive and negative mirror-image design; they seem to represent flaps cut from a light material such as cloth. The prototype of such a headdress would have exhibited extraordinary mobility when worn by a ritual performer. (Published: Ekholm 1970:76–77.)

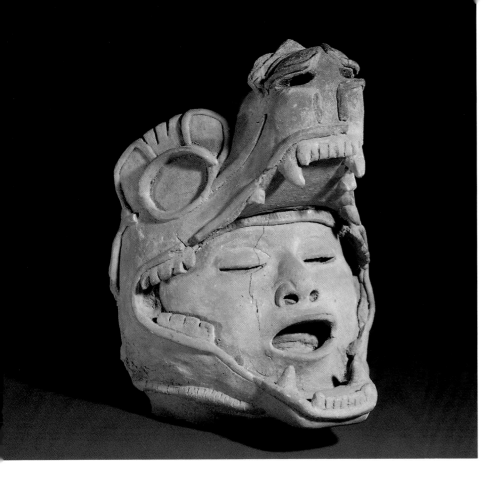

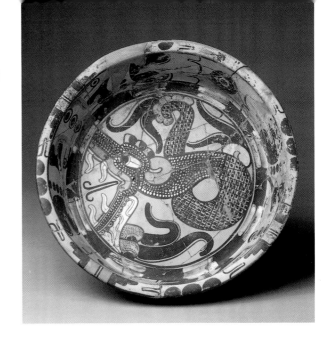

34 Helmet mask containing human face

Ceramic with black decoration
Width: 19.0 cm; *height:* 23.0 cm
Veracruz, Las Remojadas
Remojadas style
Late Classic, A.D. 600–800
30.3/2387

35 Flat-bottomed tripod bowl

Ceramic with black, orange, red,
and white paint on cream-colored
surface; broken and repaired
Height: 11.5 cm; *diameter:* 35.0 cm
Veracruz, Las Tuxtlas region
Postclassic, A.D. 900–1200
30.3/2369

Helmet masks were widespread in Pre-Columbian America—found from the Northwest Coast of North America to Peru. In Postclassic Mesoamerica, they were part of elaborate military costumes, identifying the wearer's rank and affiliation. A small but significant number of ceramic figures in the Remojadas style wear such masks (Hammer 1971:76–77, 80, 84, nos. 96–99, 107, and 118; Spratling 1960: pls. 5, 22–23, and 28). Most combine bird and serpent imagery, leading to their usual identification as Cipactli, the earth monster. This example, which is probably a fragment of a full human figure, is unusual in depicting the face with closed eyes and an open mouth as though dead. The head lacks bird attributes and may be intended to represent an animal. (Published: Soustelle 1967, plate 101; Ekholm 1970:67.)

This is one of a few known examples of this type of polychrome pottery, reported to be from south-central Veracruz, between the modern towns of San Andrés Tuxtla and Santiago Tuxtla. The bowl has small tripod feet and features a large dragonlike creature; other examples feature abstract images of monkeys (Groth-Kimball and Feuchtwanger 1954: no. 65) and human beings. In Maya iconography, dragons such as this one are associated with the heavens; the closest comparable examples are those found in the art of the Postclassic Maya site of Chichén Itzá. (Published: Ekholm 1970:72; Joralemon 1976:64, fig. 25c.)

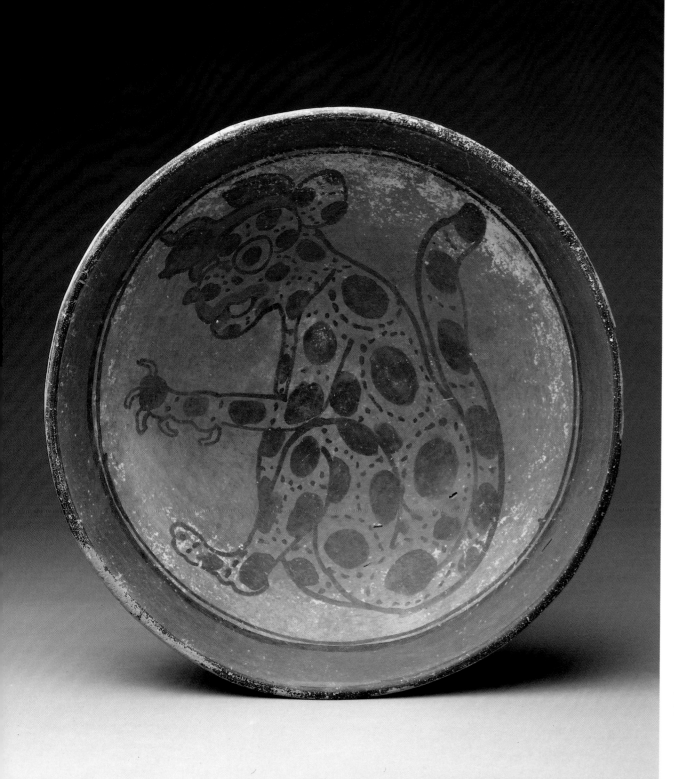

MAYA

Maya civilization reached its peak during the Classic period (A.D. 300–900) in the Yucatán tropical northern lowlands and Guatemala's rugged volcanic southern highlands. Although never unified, the individual city-states and local confederations of the Maya reached great artistic and intellectual heights. Their achievements included a calendar of great accuracy (with

36 Ring-based bowl with jaguar

Orange ceramic with red and black paint
Height: 7.8 cm; *diameter:* 30.5 cm
El Petén, Guatemala
Maya style
Late Classic, A.D. 600–900
30.3/2495

The jaguar, the largest feline in the New World, is frequently represented in the art of the Maya and other Mesoamerican peoples. Jaguars were associated with rulership; Maya lords frequently appear in jaguar-skin costumes and seated on jaguar thrones. The image shown here, a jaguar seated in a human posture, is relatively common on Maya painted vessels. The jaguar was seen by the Maya as the Lord of the Underworld. The water lily on its head is an ornament commonly associated with jaguars in what have been identified as funerary processions (Quirarte 1979).

concomitant mastery of astronomy); hieroglyphic writing; monumental and architectural stone and plaster sculpture, including stelae and altars set up in public spaces; and magnificent architecture characterized by great sensitivity to the landscape and the use of corbeled arches.

One of the most beautiful Maya site is Palenque, Chiapas, where the characteristic medium is stucco formed into reliefs to decorate piers and three-dimensional works to adorn building roofs. The Temple of the Inscriptions was built to house one of Mesoamerica's most magnificent tombs, that of the king known as Pacal (Sun Shield) (M.G. Robertson 1983–87).

In addition to public sculpture and monuments, the Maya developed a graceful and expressive painting style known primarily from ceramics. Although no Classic-period Maya manuscripts survive, painted ceramics have been seen as reflecting their contents (Coe 1978). The Collection includes a number of ceramic vessels from the Late Classic period. These elegant vessels are tumbler-shaped and have straight or in-curving sides. Maya painting is above all an art of line, the sure handling of the artist's brush creating the elegant contours and postures. The Collection includes depictions of single human figures with pose and costume adapted to the

vessel shape, depictions of deities whose bodies express the Maya ideal of beauty, and courtly scenes with elaborately costumed participants.

Ceramic sculpture was highly developed as well. In the Late Classic period, small-scale sculptures that combine hand-modeled and molded parts were created for burial with the dead, particularly on Jaina Island, Campeche. The Collection includes a variety of these; they exemplify the beauty with which the Maya depicted the human body (Figure 41) and provide a wealth of information about the costume and ideology of the Maya civilization.

37 Vessel with a seated deity

Buff ceramic with blue, red, and black paint; repaired, with several pieces missing
Height: 17.5 cm; *diameter:* 14.0 cm
Mexico or Guatemala,
provenance unknown
Maya style
Late Classic, A.D. 600–900
30.3/2492

Masked human figures and glyphs have been painted on the exterior of this piece, and there is a black geometric design on the inside of the rim. The vessel features an elegantly painted deity. His head and legs are in profile, but the torso is frontal to display his necklace and pendant. He is sitting on a low throne that features a quadripartite sign. The posture is one adopted by enthroned rulers; the most famous example is the Oval Palace Tablet from Palenque. The god's identity is revealed by the reptilian face and the object projecting from the forehead; it is probably a tube for smoking

tobacco—two curls of smoke project from its end. This deity is depicted in many contexts associated with royalty, most notably on the manikin scepters that rulers often held as a symbol of office. Rulers holding such scepters appear on public monuments at Maya sites, usually on the carved stone stelae that were erected to commemorate accession and other important events of their reigns. The deity is usually referred to as "God K" (Maya deities have been assigned letters of the alphabet) and as Bolon Dz'acab, "he of nine [many] generations" (Morley, Brainerd and Sharer 1983:473). Maya rulers may have been believed to become deities after death; their apotheosis transformed them into God K (D. Robertson). (Published: Ekholm 1970:114.)

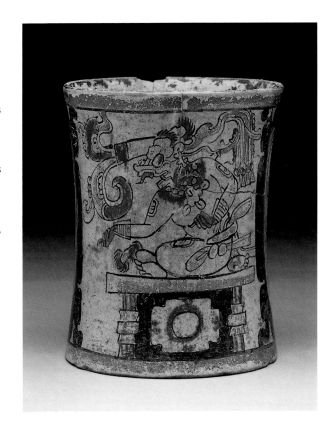

38 Fragment of an effigy incensario

Buff ceramic with remnants of red, white, and blue-green paint; broken and repaired
Width: 26.5 cm; *height:* 18.0 cm
Guatemala highlands, El Quiché
Maya style
Late Classic, A.D. 600–900
30.3/2489

This piece is probably from a style of incense burner that was common in the department of El Quiché. The Collection includes an example that is complete, but the sculpturing of the face here is far more accomplished. Such incense burners are commonly cylindrical, with flat flanges at each side and a low annular base. The upper rim is usually everted and decorated with "pie-crust" indentations. The complete example has a similar decorative band just above the lower rim. The spirals in the eyes and elements projecting from the mouth are attributes associated with several Maya deities.

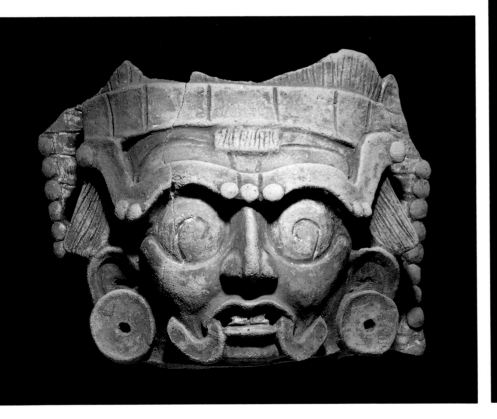

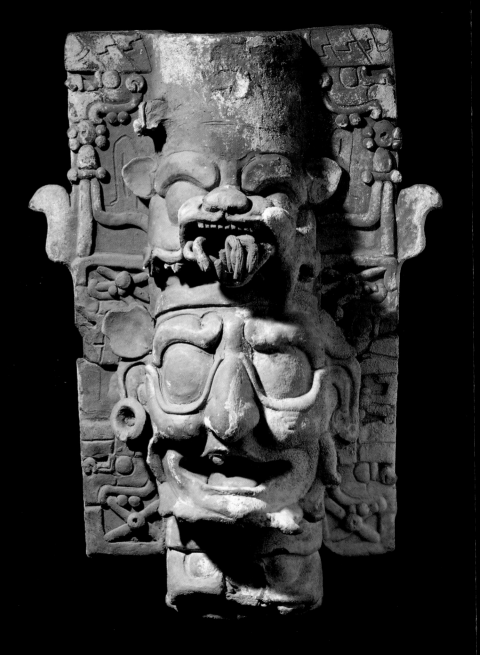

39 Incensario stand with masks

Buff ceramic with traces of stucco
and blue paint; damaged and
parts missing
Height: 60.96 cm
Chiapas, vicinity of Palenque,
provenance unknown
Maya style
Late Classic, A.D. 600–800
30.3/2503

This tall cylinder, with superimposed masks and
flanges at the sides, is of a type believed to have
been made in the vicinity of Palenque. Though
usually referred to as *incensarios*, these complex
objects probably functioned as stands for braziers
that were placed in the cylinders' open tops (Rands,
Bishop, and Harbottle 1979). This example
originally featured at least four, more probably five,
masks; the uppermost has been destroyed, and the
lowest is damaged.

The main head represents the Jaguar God of
the Underworld, as is usual on such stands.
Characteristic features include the "Roman" nose
and a fillet going under the eyes and twisted above
the nose; this twisted device (resembling a cruller)
is broken between the eyes. The eyes usually
contain spirals that may have been applied in paint
(cf. Figure 38). This mask probably represents the
night sun in the underworld; he is also identified as
God G III of the Palenque triad (Schele and Miller
1986:50). The other two preserved masks
characteristically lack lower jaws. A long-nosed
grotesque mask occupied the bottom of the stand
(nose missing); a deity mask of a bat appears above
the Jaguar God. The side flanges (seen as
continuations of the headdresses) contain motifs
usually found on this type of ceramic: crossed bands
in cartouches, flowerlike ornaments, and grotesque
heads in profile. The projecting "wings" associated
with the upper mask are also characteristic. These
impressive pieces clearly served an important
function in ritual contexts (Clancy et al. 1985:167).

40 Vessel with bat deities

Orange ceramic with white and
black paint
Height: 15.0 cm; *diameter:* 8.0 cm
Guatemala, reportedly from El
Quiché, provenance unknown
Maya style
Late Classic, A.D. 600–900
30.3/2487

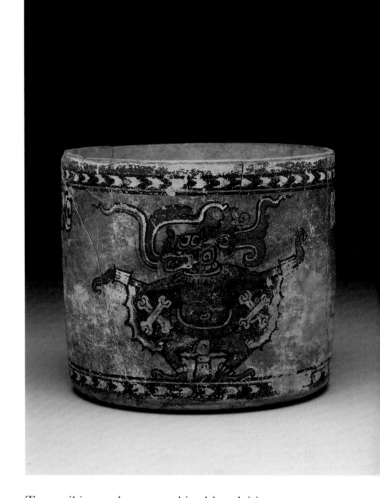

Two striking anthropomorphized bat deities are
featured on this jar. Their posture, with flexed legs
and raised and lowered hands, suggest a dance; the
outstretched arms reveal the crossed bones on the
interior of their wings. The bands of white-on-
black chevrons at the upper and lower rims link this
vase to the fine painted pottery from the Chamá
region along the Chixoy River. Bats were associated
with death and the Underworld; killer bats are one
of the perils encountered in the Underworld by the
twin heroes of the Maya epic poem "Popol Vuh"
(Tedlock 1985).

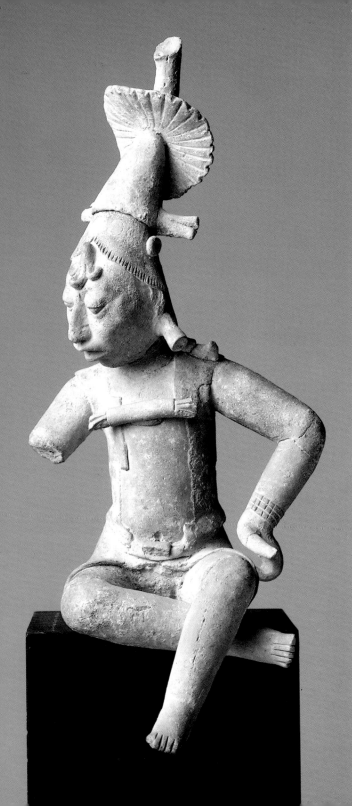

41 Seated dignitary with removable headdress

Orange ceramic with traces of blue
paint; right arm and right ear
ornament missing
Mexico, Campeche
Maya style
Late Classic (Jaina I),
A.D. 600–800
30.3/1225

During the Late Classic period, the Island of Jaina
off the Gulf Coast of Mexico apparently served as a
necropolis for the surrounding mainland, including
parts of the modern states of Campeche, Yucatán,
and Tabasco. Included in the burial offerings were
hand-modeled and mold-made figurines, large
numbers of which have been excavated. The hand-
modeled figurines are among the finest ceramic
sculptures made in Pre-Columbian America.

 This imposing figure, larger than is usual,
depicts a seated noble or dignitary. He wears a
vestlike garment, large ear spools, and a segmented
bracelet and a tubular chest ornament, both
probably of jade. His removable peaked hat with a
circular pleated fan covers an elaborate coiffure.
This elegant aristocratic pose is adopted by royal
figures in Maya art, as on Piedras Negras Stela 12
(Morley, Brainerd, and Shearer 1983:314, fig.
11.37). In addition, the figure's forehead and eyes
reflect ideals of beauty that are specifically Mayan
and attained in childhood. The depressed forehead
shows cranial deformation; the crossed eyes result
from focusing on nearby suspended objects. The
figure also wears a prosthetic device that extends
the bridge of the nose to the forehead. (Published:
Ekholm 1970:116–17 and front cover; Corson 1976:
front cover.)

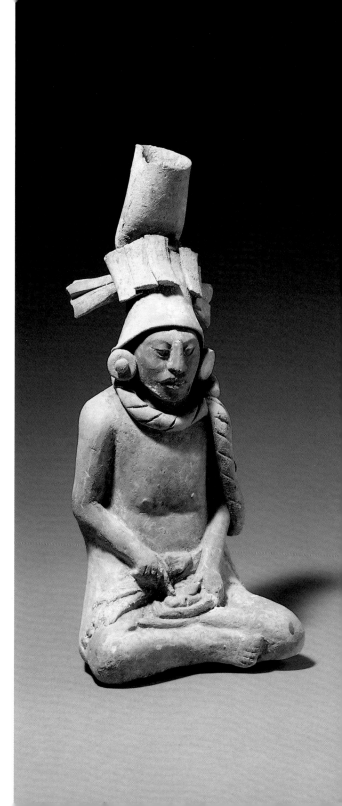

42 Noble performing autosacrifice

Orange ceramic with traces of blue
and red paint
Width: 9.0 cm; *height:* 20.0 cm
Jaina, Campeche,
provenance unknown
Maya style
Late Classic, A.D. 600–800
30.3/2524

This small, well-preserved figurine of a noble or
dignitary shows even more clearly than the
preceding example the artificial extension of the
bridge of the nose well onto the forehead. The
figure wears a tubular headdress and is seated cross-
legged, with a rope around his neck. He is
apparently not a prisoner, but is engaged in a
penitential rite. He is letting blood; the rope is
associated with drawing and collecting blood. In his
lap is a pile of blue paper; in his right hand, he
holds a piercer and draws blood from his phallus
(Schele and Miller 1987:192). (Published: Schele
and Miller 1987: pl. 69.)

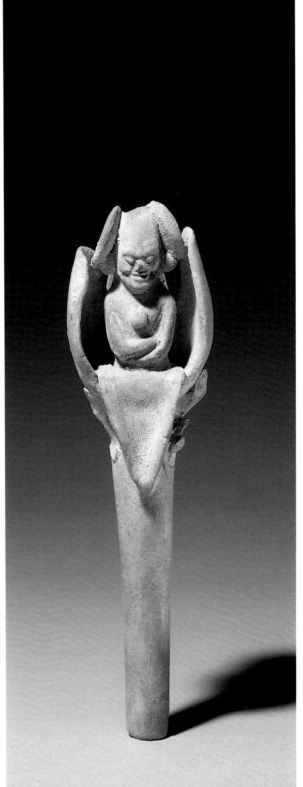

43 Old man seated in a flower

Orange-buff ceramic with blue and
red paint; back leaf missing
Width: 4.5 cm; *height:* 14.5 cm
Mexico, Campeche (?),
provenance unknown
Maya/Jaina style
Late Classic, A.D. 600–800
30.3/2532

This type of figurine, showing a person emerging
from a flower, perhaps a water lily, is relatively
common among Jaina figurines. The figure shown
here has crossed arms, as is usual, and wears a
pectoral ornament. Elderly men in flowers are
usually shown with fangs; they are absent here.
(Published Kurbjuhn 1985:233, fig. 10.)

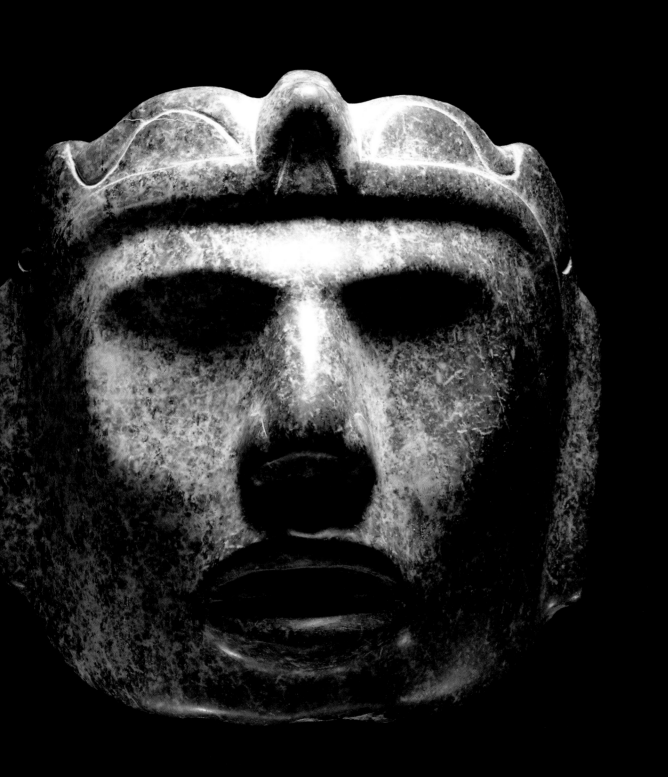

44 Mask
Grayish-green stone
Height: 17.14 cm
Mexico, Guerrero,
provenance unknown
Mezcala style
30.3/2287

GUERRERO

The archaeology of the mountainous state of Guerrero, in the southwest part of Mexico along the Pacific Coast, is not well known. That this area was a center for the production of works of art from the Preclassic period until the Conquest has long been clear (Gay 1967; Jones 1987).

The best-known style is seen in stone sculptures having a remarkably powerful abstract quality, usually referred to as Mezcala; the name is taken from a modern town on the Balsas River in the area where they were produced. Although few have been excavated archaeologically in Guerrero, they were apparently produced as offerings for the dead. Among these are stone masks with empty, unpierced eye sockets (Figure 44). Masks with pierced eyes have been found also—some in the related Chontal style. Stone masks in the style of the great Classic-period site of Teotihuacán are also found in Guerrero.

The most numerous objects are figurines of stone, which are among the most powerful abstract sculptures created in Pre-Columbian America. Their shape resembles that of stone axes, and the anatomical features are created by knife-sharp planes. While Guerrero stone art objects were long considered Preclassic- or Classic-period products, several caches containing hundreds of examples were found during the excavations of the Postclassic-period Aztec Templo Mayor in Mexico City.

Stone masks of this type, with the eye sockets hollowed but not pierced through, cannot have been worn by living persons, but must have been made for another purpose. Four holes were drilled for attachment at the upper and lower corners. These may have served to attach the masks to the face of a corpse or to the head of a statue, perhaps made of wood and fully dressed in a costume and other ornaments. Guerrero masks are of various types. Some are strikingly stylized and have sharp, pointed noses, or fractured planes that resemble those of the Mezcala figurines. Others are more naturalistic, as is this example, whose parted lips give it a quality of animation. The crown or headdress recalls the single-horn forehead ornaments worn by figures in West Mexican ceramic sculptures. A published example is similar except for the design of the crown (Graulich and Crocker-Delataille 1985:192–93, no. 294). (Exhibited: Allentown Art Museum, Allentown, Pennsylvania 1972; Huntington Galleries, Huntington, West Virginia 1974.)

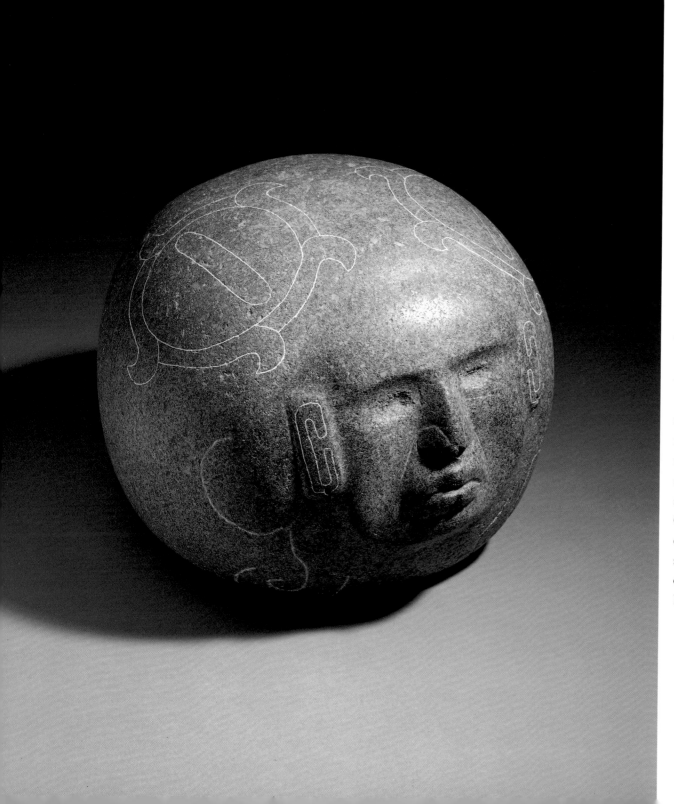

45 Spherical sculpture

Stone with incised designs
Height: 24.0 cm: *diameter:* 36.0 cm
Mexico, Guerrero,
provenance unknown
Preclassic, 500 B.C.–A.D. 200 (?)
30.3/2292

This sculpture has been attributed to Guerrero because of the style of the masklike relief face, which recalls stone masks in the Mezcala style (cf. Figure 44). Archaeological work in the state of Guerrero has not been extensive, but it is clear that fine works in stone were produced there from the time of the Olmec until the Conquest. This sculpture suggests comparison with the colossal stone heads found at the Olmec sites of the Gulf Coast. Three circular glyphlike symbols are carved on the sides and reverse of the sculpture. The scrollwork that forms the borders of these glyphs is characteristic of the Izapan style. (Published: Ekholm 1970:94–95.)

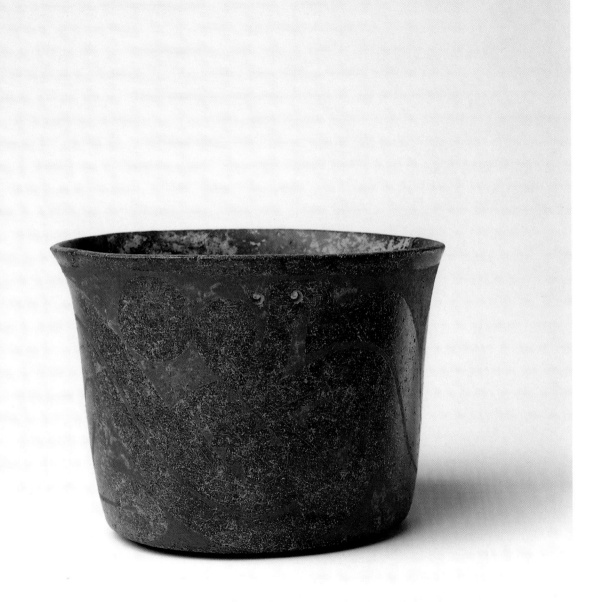

46 Bowl with serpents

Stone with incised designs and
cinnabar coloring
Height: 13.5; *diameter:* 18.5 cm
Mexico, Guerrero,
reportedly Xochipala
Olmec style
Preclassic, 1000–500 B.C.
30.3/2286

This stone bowl, decorated with two undulating
reptilian creatures, is reportedly from Xochipala, a
site known for its early Olmec ceramics. Stone
vessels of similar shape have been found there and
at other sites in Guerrero. Reliefs carved on stone
slabs at the site of Placeres de Oro are similar in
style and subject matter (Spinden 1911), and the
vessel may well have come from that area. An early
date is suggested by iconographic similarities
between this piece and Olmec-style petroglyphs at
the site of Chalcatzingo, Morelos. Petroglyph 15
also features a reptilian creature whose body is
formed by an undulating double line, with
featherlike shapes atop the head, and accompanied
by a large, round object (Goldstein, Marilyn,
AMNH files).

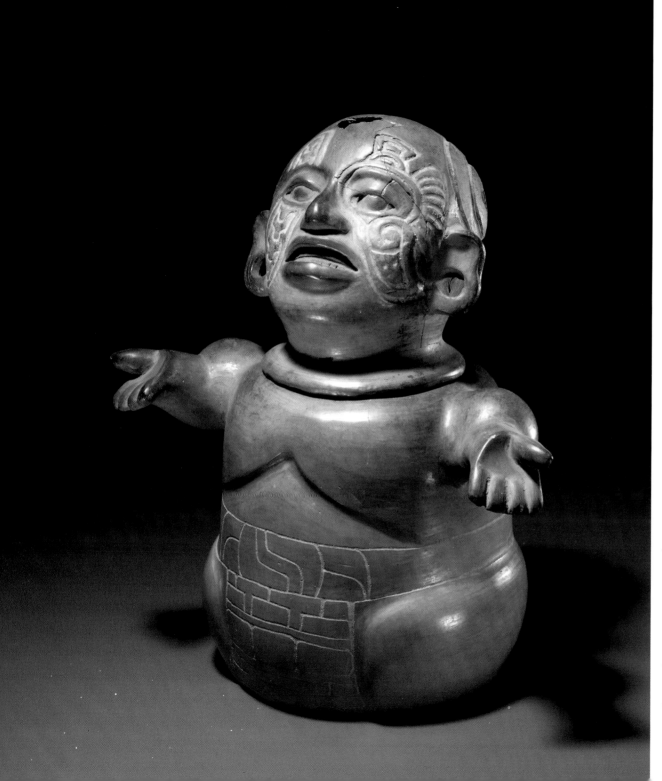

CENTRAL MEXICO

A succession of state-level societies that produced imposing urban centers developed in the high plateau area of Central Mexico: Teotihuacán, Tula, Tenochtitlán. The sprawling site of Teotihuacán (A.D. 250–750), north of modern Mexico City, is Mexico's most rigidly planned Pre-Columbian city. It is organized along a major axial roadway, now called Avenue of the Dead. The avenue is lined with imposing buildings, including the monumental Pyramids of the Sun and Moon. The buildings' powerful tectonic shapes were created by using the slope-and-panel profile for their exteriors. Although their strong geometry makes them appear stark and somewhat foreboding, they were originally entirely covered with plaster, which served as a base for painted decorations. These ranged from simple monochrome geometric shapes to complex, richly polychromed murals featuring deities and their impersonators, mythological animals, and scenes combining various activities (Miller 1973). Teotihuacán was immensely influential in Mesoamerica, clearly functioning as a major center of trade if not as a conquest state. Its ceramics were traded and imitated everywhere; ties from other parts of Mesoamerica formed part of the city itself; and Teotihuacán figures appear in the arts of other areas, notably on Maya public monuments.

Around A.D. 750, Teotihuacán's political and trade systems collapsed, perhaps as a result of competition from rival city-states; much of the city appears to have been burned, and tombs were systematically looted (Millon 1973).

Important cultural centers—Cholula, Xochicalco, and later Tula—developed to the north and south of Teotihuacán. From about A.D. 900 to 1200, the Toltecs, whose culture and art style are thought to have developed at Tula, dominated much of Mesoamerica (Diehl 1983). The Aztecs revered them as originators of the arts, visiting Tula and copying its sculptural forms. Iconography and architecture similar to that of the Toltecs appear in the Maya area, concentrated at the site of Chichén Itzá in the Yucatán clearly indicating contact with Central Mexico at this time. The Toltec period is represented in the Collection by two plumbate effigy vessels; plumbate ware is lead-colored glazed pottery that was made on the Pacific Coast of Guatemala and widely traded.

The final state to arise in Central Mexico was the Aztec empire. Its capital was at Tenochtitlán, built on land reclaimed from Lake Tlatelolco. A group of Nahuatl speakers who called themselves "Mexica" united most of Mesoamerica into a tribute empire through military conquest. From the founding of Tenochtitlán until the Spanish Conquest was a period of about two hundred years—a remarkably short time for the creation of so ensive an empire. The Aztecs synthesized preceding cultural developments, creating impressive public architecture accompanied by one of the few fully developed traditions of free-standing stone sculpture in pre-Conquest Mesoamerica. Post-Conquest accounts and a few surviving examples demonstrate their achievements in feather work, textiles, wood carving (Figure 53), and painted pictorial manuscripts. Their iconography and painting style depended greatly on that of the Mixtecs to the south in Oaxaca and Puebla, particularly in the small-scale arts; drawing clear distinctions between them is difficult (Figure 54).

The Aztec empire was conquered by Hernando Cortés between 1519 and 1521. His rapid success was largely due to his ability to enlist as allies peoples who had been conquered and subjected to tribute payments. However, the spread of introduced diseases weakened the Aztecs' will to resist. A smallpox epidemic raged during the final siege of Tenochtitlán; such diseases were the primary factor in reducing Native American populations from 80 million in 1519 to 10 million by 1600.

47 Two-part effigy jar

Light brown ceramic with incised
designs; feet and tripod supports
missing, head damaged
Width: 25.0 cm; *height:* 29.0 cm
Mexico, reportedly
from Teotihuacán
Teotihuacán style
Classic, A.D. 250–750
30.3/2326

This two-part effigy vessel is unique but appears to be in the style of the great Central Mexican urban site of Teotihuacán. The figure's head forms the lid of the vessel. The closest parallels to it are two-part ceramic effigies made in the Maya area in the Early Classic period, but these figures are usually divided at the waist, not at the neck. Archaeologically recovered Maya vessels were filled with copal incense; they may have functioned as censers, with the smoke flowing from the mouth (Clancy et al. 1985: 120, nos. 35–36). Possibly this vessel was intended for a similar use. Two openings surrounded by incised concentric circles are found at the rear of the head.

The incising around the eyes, perhaps representing tattooing or facial paint, has two distinct designs. Crossing the right eye is a pattern representing the rattles of a rattlesnake; crossing the left eye is a compound pattern that includes a spiral and feathers. Fine incisions around the waist indicate a belt that is knotted at the front and has decorated panels falling at front and rear.

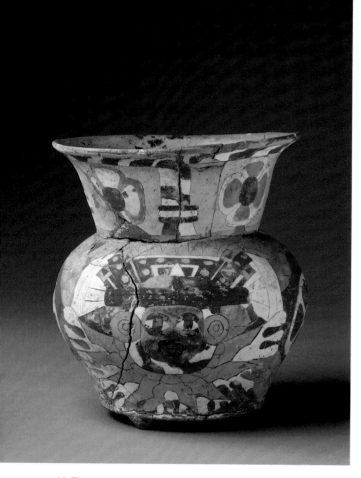

The vessels were coated with a thin layer of white plaster (the same surface on which the murals were executed), then painted; in this example, all the color areas are carefully outlined with fine black lines. Fresco vessels of this shape are less common than the flaring cylinders with slab tripod feet (cf. Figure 49; Pasztory 1947:7, fig. 6). The jar depicts two conventionalized faces with large jade ear spools, a necklace of maguey leaves, and an elaborate headdress surmounted by feathers. The central element of the headdresses is the trapeze-and-ray motif, an element with calendrical associations. The figures may be identified as a female deity with attributes similar to those found in the murals of Tepantitla (Pasztory 1976). Around the neck of vessel is a series of quatrefoil floral elements.

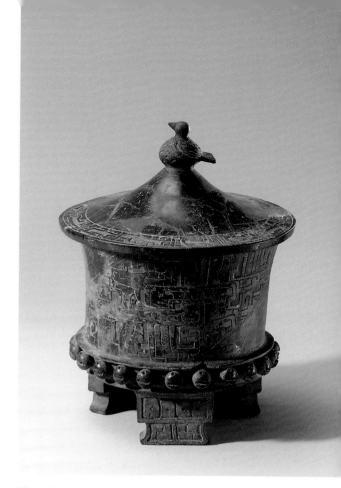

48 Frescoed vessel

Orange ceramic (thin orange),
plaster, and red, pink, turquoise,
green, white, and black paint
Height: 21.5 cm; *diameter:* 20.5 cm
Mexico, Teotihuacán,
provenance unknown
Teotihuacán style
Classic, A.D. 250–750
30.3/2328

Ceramic vessels such as this one—covered with plaster and then polychromed—were traded (and imitated) all over Mesoamerica. The style and technique used are closely akin to those of the murals that covered the buildings at Teotihuacán.

49 Covered tripod vessel with bird handle

Black ceramic with relief carving
and red pigment; broken and
repaired; bird's head restored
Height: 28.0 cm; *diameter:* 21.0 cm
Mexico, Teotihuacán,
provenance unknown
Teotihuacán style
Classic, A.D. 250–750
30.3/2334

Vessels of this shape typically had conical lids, usually with handles in the form of human heads, birds, or simple knobs. The body of the vessel and the border of the lid are decorated with plano-relief carving in complex geometric shapes. The body is decorated with a series of small ceramic rattles—a most unusual feature. Also unusual are the mold-made slab legs. Such tripod supports are generally decorated more simply or not at all. The decorations consist of two panels; the upper panels contain four rectangles with punctate centers, and the lower panels contain two knot symbols.

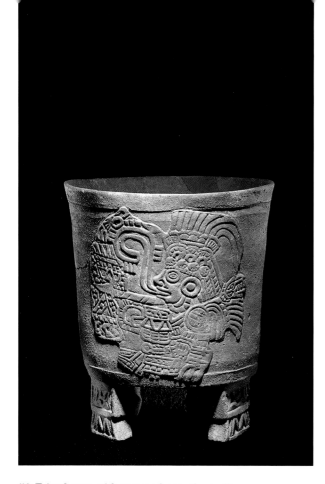

figurines. The slab feet were made in the usual way, but the relief of the profile figure appears to have been made with thin layers of clay pressed into a mold, then applied to the vessel. The figure wears an elaborate headdress topped with feathers and carries a shield in his left hand, with a spear pointing forward; the trapeze-and-ray device appears at the end of the spear. A decorated scroll, indicating speech or song, is emerging from his mouth. "Goggles" surround his eyes. Such goggles are usually associated with Tlaloc, the god of rain, but Pasztory has demonstrated that not all figures with goggles can be so identified in Teotihuacán art. This depiction may be compared with Teotihuacán murals from the Tepantitla and Atetelco compounds, which also show armed figures wearing goggles—though these figures carry darts and spearthrowers (Pasztory 1974:11–13).

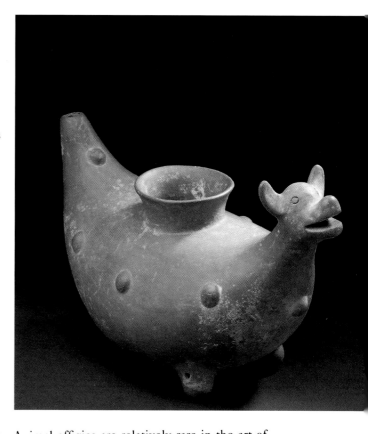

50 Tripod vase with man and speech scroll

Ceramic (thin orange); with
applied mold-made design; broken
and repaired; parts missing
Width: 29.8 cm; *height:* 31.0 cm
Mexico, Teotihuacán
Teotihuacán style
Classic, A.D. 250–750
30.3/2331

This large cylindrical vessel features an unusual use of a mold in creating two-dimensional decorative elements. Molds were widely used at Teotihuacán to create elements for vessels like this one, for large and elaborate braziers or incensarios, and for

51 Effigy vessel of a deer (?)

Orange ceramic with rattle
supports
Length: 37.0 cm; *width:* 20.0 cm;
height: 21.0 cm
Mexico, Teotihuacán, border of
Puebla, Oaxaca, and Veracruz
Teotihuacán style
Classic, A.D. 250–750
30.3/2333

Animal effigies are relatively rare in the art of Teotihuacán. Most frequently appearing in mural painting are jaguars—powerful images frequently anthropomorphized or provided with complex attributes, including feather headdresses and speech scrolls. This charming effigy vessel, which may represent a deer, is more reminiscent of the sculpture of West Mexico.

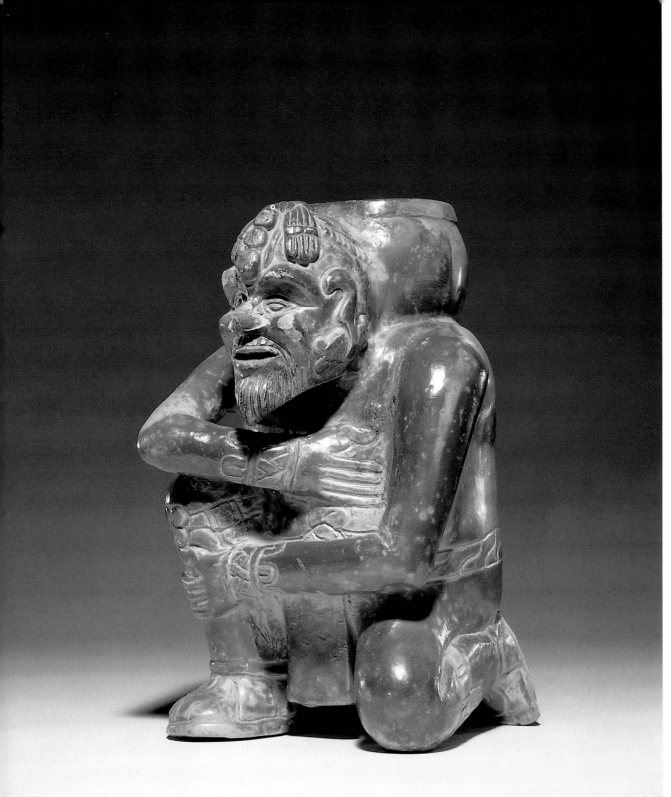

52 Kneeling hunchback, effigy jar

Plumbate ware
Width: 16.0 cm; *height:* 27.5 cm
Guatemala, Pacific slope,
provenance unknown
Toltec style
Early Postclassic, A.D. 900–1200
30.3/2543

Plumbate ware was the most widely traded ceramic in Mesoamerica in Early Postclassic times; it is found at all major Toltec sites from Tula to Chichén Itzá. It is the only true glazed pottery of Pre-Columbian America, apparently manufactured in only one region along Guatemala's Pacific slope. The kilns in which the vessels were fired must have been enclosed so that the high temperatures necessary for vitrification of the silica glaze could be reached. This vessel is one of the largest and finest examples known. It shows a kneeling, bearded man carrying a vessel on his back by means of a tumpline, a sling knotted on the forehead and stretched around the burden. No beasts of burden were domesticated in Mesoamerica, and bearers carried goods by this method. This figure, however, appears too richly dressed to be an ordinary bearer. He wears sandals, a decorated loincloth, and knotted bracelets and ornaments below his knees. His beard, rare in Native American populations, also indicates age or high status (cf. Figure 54). Plumbate vessels were made in molds or, as in this case, sculpted by a combination of modeling and incising.

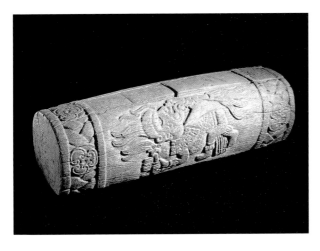

the drum are decorated with bands featuring woven patterns and trilobed elements representing flowers (intimately associated with song in metaphorical Nahuatl speech).

Drums such as this one continued to be made during the Early Colonial period. The Florentine Codex shows the *teponaztli* with a European-style base being played. This encyclopedia of Aztec culture was compiled by the Franciscan missionary Fray Bernardino de Sahagún (Sahagún 1950–86, book 4 and 5, illus. 91). Such drums continued to be used in some areas into this century.

53 Wooden drum with dancer

Wood, with carving
Length: 59.0 cm; *height:* 20.0 cm;
diameter: 17.5 cm
Reportedly used in Colima
Aztec style
Postclassic or Early Colonial,
A.D. 1400–1600
30.3/2471

Mesoamerican people played a wide variety of musical instruments, including shell trumpets, ceramic whistles, flutes and ocarinas, gourd and ceramic rattles. In the Postclassic, they used two kinds of wooden and ceramic drums. One was called *huehuetl* in Nahuatl; it is an upright cylindrical drum with open ends, the top covered with animal hide. The *teponaztli* is a wooden cylinder made from a hollowed-out log and played in a horizontal position. Slits cut in the top create two tongues; each produces a slightly different sound.

The dancer featured on the side of this drum is a frequent feature of these instruments. The contorted posture, bent forward and looking back over one shoulder, animates the figure and serves to fit it into the restricted space. The dancer holds two wands or batons decorated with feathers. Scrolls, indicating speech or song, usually found in front of the mouth, appear above the forehead. The ends of

54 Knife handle with crouching figure

Wood with carving; blade restored
Length: 19.0 cm; *width:* 5.0 cm
Central Mexico, Valley of Mexico
Aztec style
Postclassic, A.D. 1200–1520
30.3/2464

Sacrificial knives with elaborate wood handles were made by Aztec and Mixtec artists in the Postclassic period. Most famous are the turquoise mosaic knife handles associated with the Mixtec. This knife handle depicts a crouching figure with beard and fangs. The clear, refined treatment of the iconography and especially the naturalistic depiction of the hands and face suggest the work of an Aztec craftsman. However, the treatment of the beard is closer to images in Mixtec manuscripts. The figure depicted cannot be securely identified.

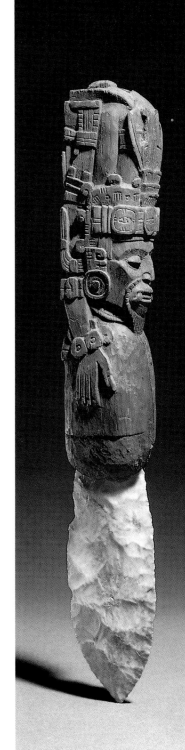

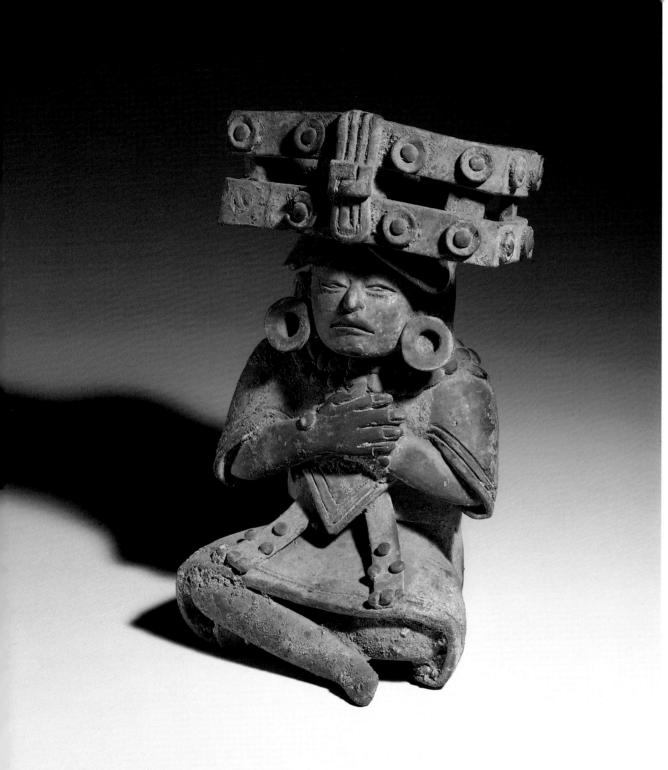

OAXACA

The modern Mexican state of Oaxaca, a region of high and arid mountains and beautiful fertile valleys, has been a center of cultural developments from the Preclassic period on. Two major foci may be recognized: the Valley of Oaxaca, today inhabited by the Zapotec; and the

55 Goddess 13 Serpent urn

Fine light gray ceramic with traces of red pigment
Width: 13.0 cm; *height:* 22.0
Mexico, Oaxaca, provenance unknown

Monte Albán style
Classic (Monte Albán II–IIIa Transition), A.D. 100–300
30.3/2297

The ceramic urns of Oaxaca were the major medium for depicting the human form in this area from the Monte Albán period I (ca. 600 B.C.) through the sixteenth century. They are most often discovered on the floors of tombs and thus have been called funerary urns. They are also found as part of the furnishings of ceremonial centers or buried as offerings. A complete effigy is attached to the front of a cylindrical vessel and hides it completely. Most are a mixture of mold-made and hand-modeled parts made from a fine gray clay and often washed with red pigment. Attention paid to the body was often cursory, and legs were

Mixtecs to the north, extending into the state of Puebla. The Valley of Oaxaca and surrounding regions developed complex societies and monumental architecture at an early date. The magnificent site of Monte Albán, located on a hilltop near modern Oaxaca, was built over many centuries, beginning in the Late Preclassic period. Splendidly isolated, the city apparently functioned as a center of integration for autonomous polities in the region and declined when the fall of Teotihuacán made such integration unnecessary.

The Zapotec developed a system of hieroglyphic writing at an early date, as seen in the stone reliefs (Danzantes), which probably commemorate military conquests. They also excelled at ceramic sculpture, creating countless urns representing deities or rulers, which they placed in architectural contexts and tombs.

About A.D. 1200, part of the Zapotec region was conquered by the Mixtecs, who began to use Monte Albán as their own ceremonial center and necropolis. The Mixtecs were masters of manuscript painting, lapidary work (including mosaics) and goldsmithing. Their style was widespread in the Postclassic period, perhaps because their work was both desirable and portable (Paddock 1966; Blanton 1978:4; Flannery and Marcus 1983).

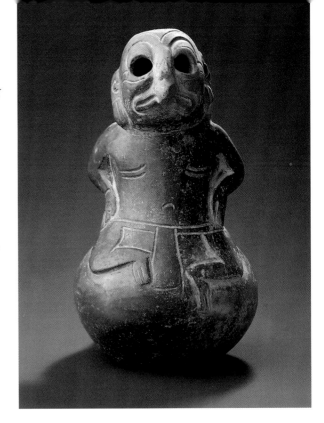

sometimes omitted entirely. The woman shown here is complete, with legs crossed and hands folded expressively. The headdress and pendants or ornaments of urn figures are usually their most elaborate and complex features. This female figure wears a rectangular headdress, apparently made of light wooden strips and decorated with circular medallions. At the front, a four-part element is shown tied to the framework with the symbol identified as a knot (Caso's glyph A). She wears what appears to be a *quechquemitl*, a rectangular upper garment with points descending at front and back, a skirt, and large ear spools. Most Oaxacan urn figures have been identified as deities or their human impersonators—probably priests (Caso and Bernal 1952). From the headdress, this figure has been identified as the Goddess "13 Serpent," a name taken from a day of the calendar, The circular decorations would usually appear on a basket-weave, rather than latticework, headdress (Boos

1960:362). A suggestion has been made that the figures are depictions of ancestors rather than deities and made to be buried with their descendants. Humans were named after the day in the divinatory calendar on which they were born; thus "13 Serpent" would be the name of an ancestor rather than a deity (Marcus 1983:144/48). (Published: Boos 1960:362, fig. 338; Ekholm 1970:102/103.)

56 Effigy vessel with anthropomorphic bird

Black ceramic whistle jar; spout
missing and right arm restored
Width: 12.0 cm; *height:* 19.0 cm
Valley of Oaxaca,
provenance unknown
Monte Albán style
Classic (Monte Albán I),
500–200 B.C.
30.3/2299

Spout-handled effigy vessels as well as urns were used to depict ancestors or deities in the cultures associated with Monte Albán, particularly in periods I and II (Covarrubias 1957: pl. 32, above left). The figures' posture—legs flexed and arms bent at the sides—is reminiscent of relief carvings on monolithic blocks of stone found at Monte Albán and the nearby site of Dainzu (Bernal 1967:207-10, nos. 141–43). Although these sculptures are called *danzantes* (dancers), the general consensus is that they represent conquests; the eyes are usually closed, and the figures are often accompanied by glyphs that may represent localities. There is no evidence that the spout-handled effigy vessels have a similar meaning, but the similarity of posture is reinforced here by the skeletalizaton of the ribs and by the empty eye sockets.

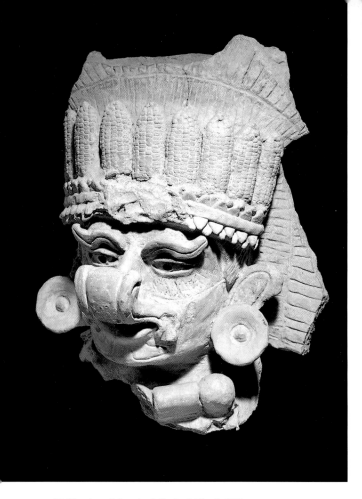

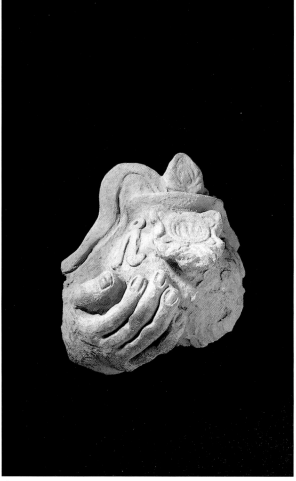

161). The badly damaged headdress features nine carefully and accurately molded ears of corn. The central medallion is gone, but many examples include the glyph "C" (Boos 1960:178).

The hand is modeled with great sensitivity. It is grasping a small spherical vessel with a flaring mouth; on the side is an eroded glyph in a cartouche and tassels, considered symbols of liquid. A central leaf and flowing elements emerge from the vessel mouth at each side. Glyph "L" (meaning unknown) is usually drawn as a vessel of this shape with an undulating band often associated with leaves (Leigh 1966). Thus this vessel may be a three-dimensional representation of the glyph. (Published: Boos 1960:195, fig. 175.)

57 Head and hand of God of Glyph "L"

Reddish ceramic
Head width: 29.0 cm;
height: 38.0 cm
Hand length: 17.0 cm;
width: 12.5 cm
Mexico, reportedly eastern Oaxaca
Monte Albán style
Classic (Monte Albán
III-B), A.D. 300–900
30.3/2301A and 30.3/2301B

These two fragments are from an extraordinarily large urn—approximately five feet in height. Even if the lower body had been summarily treated, as was usually the case, the vessel may still have been close to life size (Boos 1960:14). This splendidly sculpted figure is one of a well-known type that is identified by the nasal and buccal masks. The nasal mask (usually three plumelike elements) has a single curved shape with side bands that extend to form the buccal mask bordering the mouth. The teeth are clearly indicated, and the bifurcated tongue is incised (cf. Easby and Scott 1970, no.

58 Bowl with eagle design and jaguar supports

Reddish-brown ceramic Cholula polychrome, gold ocher, burnt sienna, gray, orange, white, and black paint
Height: 9.0 cm; *diameter:* 21.0 cm
Mexico, probably Puebla
or Oaxaca
Mixtec style
Postclassic, A.D. 1250–1520
30.3/2312

This tripod vessel, one of three examples of Mixteca-Puebla or Cholula polychrome pottery in the Collection (cf. Figures 59 and 60), has complex painting in a style closely similar to that found in

Postclassic-period Mixtec manuscripts. These manuscripts present calendrical and ritual information and histories of Mixtec dynasties in pictorial fashion.

The central image of this vessel is the head of an eagle, one of the named days in the Central Mexican calendar; five flint knives surround the head and a floral ornament sits above the forehead. The tripod supports mimic feline limbs and are painted with jaguar pelage markings; in a visual pun, the feet end in small jaguar faces with open jaws.

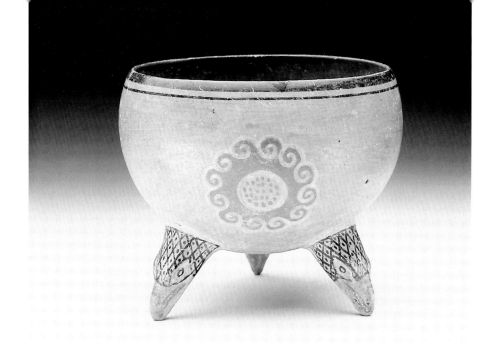

59 Tripod bowl with bird's head supports

Reddish-brown ceramic, gold ocher, burnt sienna, orange, white, and black paint
Height: 14.0 cm; *diameter:* 17.0 cm
Mexican, probably Puebla or Oaxaca
Mixtec style
Postclassic, A.D. 1250–1520
30.3/2313

This Cholula polychrome vessel has supports made in the form of eagle heads, which recall the jaguar heads in Figure 58. Unlike the more common low, shallow Cholula polychrome tripods (cf. Figure 60), this hemispherical vessel has a monochromatic interior and a relatively simple exterior decoration composed of repeating spirals .

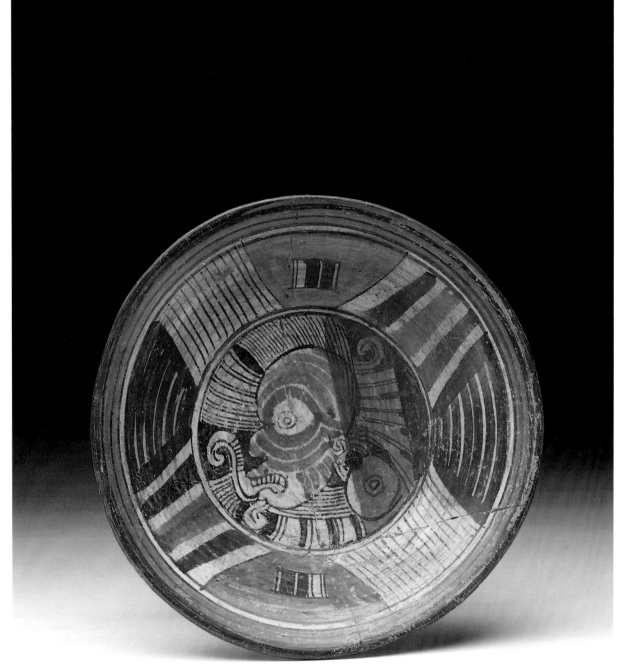

60 Tripod plate with warrior's head

Reddish-brown ceramic Cholula
polychrome, gold ocher, burnt
sienna, orange, white, and black
paint
Height: 8.5 cm; *diameter:* 8.5 cm
Mexico, probably Puebla
or Oaxaca
Mixtec style
Postclassic, A.D. 1250–1520
30.3/2317

The striking image in the center of this Cholula
polychrome tripod plate is the profile of a human
head; the two curling elements emerging from the
mouth are speech scrolls indicating that the figure
is speaking, singing, or perhaps in this case crying
out. The figure wears a large ear spool, and there
are concentric bands of orange paint on his face.

In Mixtec manuscript painting, color was
applied between black frame lines (D. Robertson
1959). In the ceramics, color was used more freely,
without bounding lines. This man may be a warrior.
The hair appears to be shorn to leave a single
central ridge across the top of the head. Among the
Aztecs, this style was associated with an order of war-
riors called *quachic*, who had sworn never to give way
before an enemy advance (Codex Mendoza fol. 64r).

61 Incense burner in the form of a feline

Gray ceramic with punched
surface; broken, with some
restoration
Width: 38.0 cm; *height:* 56.0 cm
Mexico, probably eastern Oaxaca
Monte Albán style
Classic (Monte Albán II–III?), 200
B.C.–A.D. 600.
30.3/2300

This sculpture may originally have been polychrome
like one in the Mexican National Museum of
Anthropology that retains its original paint and was
excavated in the same area (Bernal 1967, no. 37).
This sculpture resembles ceramic incensarios, called
xantiles, anthropomorphic or zoomorphic effigies—
often representing deities—that are hollow and
open at the bottom. Copal incense was apparently
placed beneath them; the orifices of the head
permitted the smoke to escape. Although the
bottom of the piece is closed, it probably
functioned similarly.

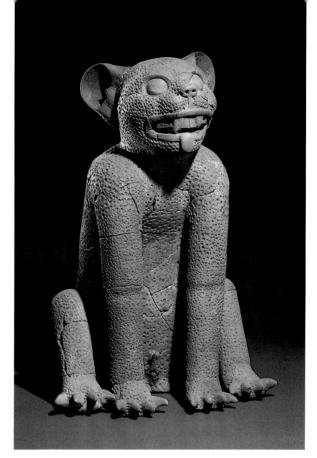

62 Turquoise mosaic pendant

Stone inlays on bone; piece of
original string
Length: 4.0 cm; *width:* 3.0 cm
Mexico, Oaxaca or Puebla region
Mixtec style
Postclassic, A.D. 1200–1500
30.3/2314

The Mixtecs were renowned as masters of small-
scale works of art, precious and highly portable
objects that were widely traded. Their
craftsmanship is exemplified by their metalwork,
especially in gold; their painted manuscripts and
luminous polychrome pottery; their work with jade

and onyx; and their mosaics made from stone,
shells, and other materials. A number of their
mosaic objects have survived, possibly because they
had been placed in dry caves in the highlands.
Mosaic shields, masks, and ornaments—some with
designs as complex as those of ceramics or pictorial
manuscripts—are found in museum collections
(Saville 1922). This example, probably part of a
larger ornament, depicts what may be an elaborate
speech scroll (cf. Figure 60 comments).

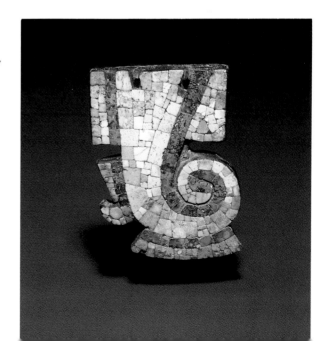

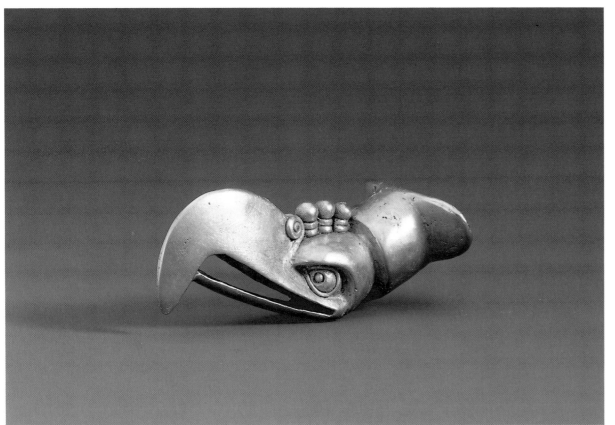

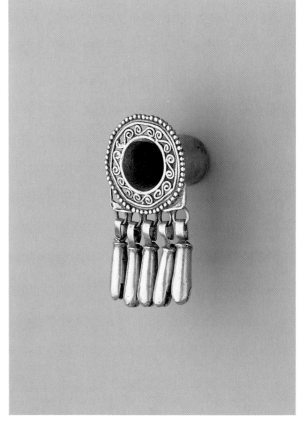

63 Lip-ornament with long-beaked bird

Cast gold
Length: 4.76 cm
Mexico, Oaxaca or Puebla,
possibly Tatutepec
Postclassic, A.D. 1200–1500
30.3/2303

Lip ornaments, or labrets, such as this one fitted into a slit cut below the lower lip and were an important part of upper-class regalia. The famous portrait of King Nezahualcoyotl of Texcoco that depicts the savant and poet in full battle array, wearing such a labret (Codex Ixtlilxochitl 1976, fol. 106r). Labrets were made in gold, fine-grained stones, and volcanic glass and were held in place by the flange at the rear, inserted between lip and teeth. This example, cast by the lost-wax process, is a particularly simple and forceful piece. Other examples feature complex feather filigree (cf. Emmerich 1965:140, fig. 175). Some gold pieces even include movable parts. (Published: Emmerich 1965:139, fig. 173.)

64 Ear spool with pendant bells

Cast gold with five bells
Height: 4.76 cm
Mexico, Oaxaca or Puebla region
Mixtec style
Postclassic, A.D. 1200–1500
30.3/2307

Mixtec gold pieces are always small in scale, and although most examples have been found in burial sites, they were certainly designed to be worn by the living. The tiny gold bells are characteristically

Mixtec in design; similar ones are found on necklaces and pendants. The loops from which they are suspended allow them to move freely, and they produce a pleasing sound when they strike each other as they would when the wearer walked or turned his head (Easby 1961:36). The wearer passed the cylinder at the back of the spool through a hole in his ear lobe so that only the flat filigree face and bells would be seen. The open-work scrolls in these ear spools show the extremely fine cast, or false, filigree work favored by Mixtec craftsmen. Rather than working with gold wire, they created the filigree by casting the pieces from a wax model. (Published:Emmerich 1965:128, fig. 158.)

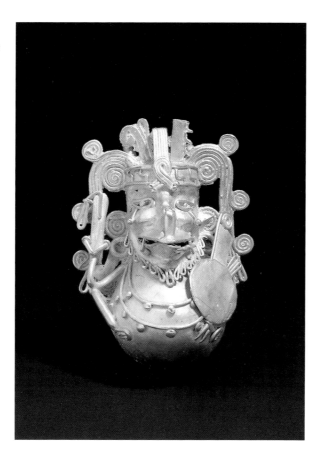

65 Effigy bell

Cast gold
Height: 5.08 cm
Veracruz, vicinity of Venustiano Carranza
Mixtec style
Postclassic, A.D., 1200–1500
30.3/2304

This gold effigy bell is an extraordinarily fine and elaborate Mixtec gold piece. It approaches the Mixtec manuscripts in iconographic complexity and is best compared with the finds from the famous Tomb 7 at Monte Albán. Apart from Xipe Totec (Our Lord, the Flayed One—among the most ubiquitous deities in Mesoamerica), few of the gods depicted in Mixtec goldwork can be clearly identified. This object, however, is very close to images of the deity Xolotl found in a number of Mixtec and Aztec pictorial manuscripts. Xolotl has canine features and often shares attributes with Quetzalcoatl; one source describes them as brothers. In the Codex Borbonicus, Xolotl and Quetzalcoatl are depicted presiding over a priestly dance, suggesting that both acted as patron deities of priests. In this gold bell, Xolotl is shown holding a shield and an atlatl, or spearthrower. His beard is clearly depicted, a symbol of a tear descends from each eye, and fangs protrude from his upper lip. A creature resembling Xolotl is depicted in a mural at Mitla, Oaxaca, with projecting upper teeth (Spence 1923:346). This art of gold working developed first in Central America and spread north; the shape of this bell is reminiscent of Central American works. (Published: Ekholm 1970:104.)

CATALOGUE

The entries on ceramics and sculptures are based on the original work of Gordon F. Ekholm and have been edited by N.C. Christopher Couch and Stacy A. Marcus. Those on textiles are based on the original work of Junius B. Bird and have been edited by Vuka Roussakis. Additional editorial work in preparing these entries has been done by Lisa Whittall and Peter Kvietok.

PRECLASSIC MEXICO

30.3/2255

Standing hunchback figurine, finely crackled deep bluish-green jade; perforated hump broken.
Height: 5.0; *width:* 2.5 cm. *Locale:* Veracruz, El Meson. *Style:* Olmec. *Period:* Preclassic, 1200–500 B.C.
Hunchback figurine or pendant with bent knees and perforations in ears and nose. A tongue or beard, which extends from lower lip to chest, is decorated with incised chevrons (cf. 30.3/2261; 30.3/2259, Figure 4).

30.3/2256

Ring or ear spool, deep translucent sea-green jade.
Length: 1.8 cm; *diameter:* 2.4 cm. *Locale:* Guerrero (?). *Style:* Olmec. *Period:* Preclassic, 1200–500 B.C.
The raised band around one edge, defined by a wide irregular incised line, suggests use as an ear spool.

30.3/2257

Jaguar-claw pendant, translucent sea-green jade, perforated at round end.
Length: 5.9 cm. *Locale:* Guerrero or Veracruz. *Style:* Olmec. *Period:* Preclassic, 1200–500 B.C.
The pendant is probably from a necklace, a skeuomorph of a jaguar claw in the material most precious to the Olmec.

30.3/2258

Standing male figurine, bluish-green serpentine; left arm broken off.
Length: 6.8 cm; *height:* 6.8 cm. *Locale:* Veracruz, San Cristobal Tepatlasco. *Style:* Olmec. *Period:* Preclassic, 1200–500 B.C.
Finely drilled perforations pierce the ears; conical drilling forms the nostrils. Figure 5.

30.3/2259

Head of a "chinless dwarf" statue, brown stone with black inclusions.
Height: 16.51 cm. *Locale:* Provenance unknown, possibly Veracruz. *Style:* Olmec. *Period:* Preclassic, 1200–500 B.C. Figure 4.

30.3/2260

Jade spoon, coarsely crystalline gray-green jade.
Length: 17.4 cm; *height:* 1.2 cm. *Locale:* Guerrero (?). *Style:* Olmec. *Period:* Preclassic, 1200–500 B.C.

This spoon or pendant has been sectioned three times; planes of front, back, and top edges are convex, as though cut from a celt. Figure 8.

30.3/2261

Crouching hunchback, dark brown stone; both arms and left leg broken.
Height: 10.0 cm. *Locale:* Mexico. *Style:* Olmec. *Period:* Preclassic, 1200–500 B.C.
The bent posture and upturned face suggest the appearance of the statue from which 30.3/2259 may have come.

30.3/2262

Monkey pendant, deep sea-green jade with buff; fine perforations through nose, ears, and foot.
Height: 6.2 cm. *Locale:* Mexico. *Style:* Olmec. *Period:* Preclassic, 1200–500 B.C. Figure 7.

30.3/2263

Figurine with jaguar mouth, brown jade, with incised glyphs and "padded" eyes.
Height: 7.94 cm. *Locale:* Mexico. *Style:* Olmec. *Period:* Preclassic, 1200–500 B.C.
The bottom structure indicates probable original use as a piercer that was subsequently broken off and hollowed out. Figure 6.

30.3/2264

Mask, pale-green serpentine jade.
Height: 5.9 cm. *Locale:* Mexico. *Style:* Olmec. *Period:* Preclassic, 1200–500 B.C.
The mask is thick at the chin with a flat bottom, its reverse hollowed out smoothly. Ear lobes and septum are pierced, two perforations for suspension flank cleft at top of head; deeply cut eyes (with pits indicating pupils) are encircled by a shield-shaped form created by an incised line. Grooves on the back of the ears define the rim of the perforation.

30.3/2265

Half mask, jade; sawing apparently removed at least 5 mm from center of original mask.
Height: 6.5 cm. *Locale:* Guerrero, La Sabana. *Style:* Olmec.
Mask somewhat hollowed out, nose completely gone, nostril perforation may have gone through to inside; possibly a slice removed from center.

30.3/2266

Standing male, translucent sea-green jade with light spots, yellowish areas, and traces of interior green.
Height: 14 cm. *Locale:* Mexico. *Style:* Olmec.
Drillings and a straight sawcut separated arms from body; the right arm was also cut off with a straight saw.

30.3/2267

Simian mask, crystalline jade speckled with grayish green.
Height: 6.2 cm. *Locale:* Mexico. *Style:* Olmec. *Period:* Preclassic, 1200–500 B.C.
Mask whose skeletal appearance is enhanced by the eyes, large drilled pits with smaller central pits edged by an incised line, and a raised crescent on the nose. The back was hollowed out with large tubular drills; a wide slit in the mouth was produced by drilling corners, then sawing between them with a cord.

30.3/2268

Mask pendant, mottled green jade.
Height: 8.0 cm. *Locale:* Mexico. *Style:* Olmec (?). *Period:* Preclassic, 1200–500 B.C.
Mask (or head) that has a downturned Olmec mouth and other features, though it is not typically Olmec. Use as a pendant indicated by angular perforations,

large ones in the temples and smaller ones in the chin that were done later with a tubular drill.

30.3/2269

Head, whitish stone with traces of red paint.
Height: 6.0 cm. *Locale:* Mexico, Puebla. *Style:* Olmec. *Period:* Preclassic, 1200–500 B.C.
The head derives from a Preclassic figurine.

30.3/2270

Figurine, ceramic with burnished white slip, red on hair.
Width: 6.4 cm; *height:* 11.0 cm. *Locale:* Puebla, Las Bocas. *Style:* Olmec. *Period:* Preclassic, 1200–500 B.C.
Cross-legged seated figure, said to be from an Olmec site in southeastern Puebla. Figure 3.

30.3/2271

Head, gray stone.
Height: 9.5 cm. *Locale:* Central Mexico. *Style:* Olmec. *Period:* Preclassic, 1200–500 B.C.
From a Preclassic figurine.

30.3/2272

Double-headed bird stamp, ceramic.
Height: 2.5 cm; *diameter:* 5.0 cm. *Locale:* Central Mexico, Chalco. *Period:* Preclassic, 1200–500 B.C. (?).
Flat stamp used on paper or for body decoration.

30.3/2273

Frog holding vessel.
Width: 3.5 cm; *height:* 5.5 cm. *Locale:* Central Mexico, Chalco. *Period:* Classic–Postclassic (?).
The object functioned as an incense burner.

30.3/2274

Head from flute, ceramic with painted lip.
Height: 7.62 cm. *Locale:* Central Mexico, Culhuacán, *Period:* Unknown.

30.3/2275

Fragment of face, ceramic with burnished white slip.
Height: 7.0 cm. *Locale:* Central Mexico, Puebla, Las Bocas (?). *Style:* Olmec. *Period:* Preclassic, 1200–500 B.C.
Finely modeled fragment from the face of a figural sculpture, showing nose and mouth with an "egg tooth." This arrestingly naturalistic fragment suggests the power of the original.

30.3/2276

Effigy jar with human figure, black ceramic.
Height: 22.0 cm; *Locale:* Central Mexico, Tlapacoya (?). *Period:* Preclassic, 1200–500 B.C.

30.3/2277

Mask, ceramic with red paint; broken and repaired.
Width: 9.5 cm; *height:* 8.0 cm. *Locale:* Valley of Mexico, Tlatilco.
A small grotesque mask with some restoration. Figure 1.

30.3/2278

Seed bowl, polished white ceramic.
Diameter: 11.43 cm. *Locale:* Valley of Mexico, Tlatilco. *Style:* Olmec. *Period:* Preclassic, 1200–500 B.C.
Central Mexican ceramics in the Olmec style are characterized by their polished white surfaces.

30.3/2279

Head, red paint remains in cracks and on beard.

Height: 8.4 cm. *Locale:* Valley of Mexico, Tlatilco (?). *Style:* Olmec. *Period:* Preclassic, 1200–500 B.C.

Head with helmet and heavy mouth mask derives from an Olmec-style figurine.

30.3/2280

Figurine of a young woman, ceramic with red and yellow paint.

Width: 3.0 cm; *height:* 7.5 cm. *Locale:* Valley of Mexico, Tlatilco (?). *Period:* Preclassic, 1200–500 B.C.

A D-1 type Tlatilco figurine. Figure 2.

30.3/2281

Figurine, remains of paint.

Width: 5.0 cm; *height:* 12.0 cm. *Locale:* Valley of Mexico, Tlatilco (?). *Period:* Preclassic, 1200–500 B.C.

30.3/2282

Figurine, remains of paint.

Width: 4.5 cm; *height:* 12.4 cm. *Locale:* Valley of Mexico, Tlatilco (?). *Period:* Preclassic, 1200–500 B.C.

30.3/2283

Figurine.

Height: 9.53 cm. *Locale:* Valley of Mexico, Tlatilco (?). *Period:* Preclassic, 1200–500 B.C.

WEST MEXICO

Colima

30.3/2403

Back-rest vessel, burnished red ceramic.

Length: 30.0 cm; *height:* 25.0 cm. *Locale:* West Mexico. *Style:* Colima. *Period:* Late Preclassic, 400 B.C.–A.D. 200.

Small ceramic sculptures show this object in use; the back rest is made in abstract animal form.

30.3/2404

Parrot whistle, ceramic.

Length: 12.5 cm. *Locale:* West Mexico. *Style:* Colima. *Period:* Late Preclassic, 400 B.C.–A.D. 200.

30.3/2405

Figurine of seated male with fan, solid ceramic; slight breakage in turban.

Height: 12.0 cm. *Locale:* West Mexico. *Style:* Colima. *Period:* Late Preclassic, 400 B.C.–A.D. 200.

Seated figure with a fan in his right hand, wearing a loincloth, necklace, and headdress.

30.3/2406

Conch-shell trumpet, ceramic.

Length: 17.14 cm. *Locale:* West Mexico. *Style:* Colima. *Period:* Late Preclassic, 400 B.C.–A.D. 200.

West Mexican shaft-and-chamber tombs have been found to contain actual conch-shell trumpets, sometimes in large numbers.

30.3/2407

Jar supported by three men, burnished red ceramic.

Height: 25.0 cm; *diameter:* 31.0 cm. *Locale:* West Mexico. *Style:* Colima. *Period:* Late Preclassic, 400 B.C.–A.D. 200.

Red gadrooned jar with three men as supports. Figure 9.

30.3/2408

Jar, burnished red ceramic.

Height: 24.0 cm; *diameter:* 35.0 cm. *Locale:* West Mexico. *Style:* Colima. *Period:* Late Preclassic, 400 B.C.–A.D. 200.

Red gadrooned jar with three parrots as supports.

30.3/2409

Two ducks, burnished red ceramic; neck of right duck mended.

Height: 12.7 cm. *Locale:* West Mexico. *Style:* Colima. *Period:* Late Preclassic, 400 B.C.–A.D. 200.

The vessel is formed by effigies of two ducks, joined at the side (cf. 30.3/2439). In Colima-style works, multiple animals appear both as effigy vessels and as decorations on globular or gadrooned vessels.

30.3/2410

Head from effigy vessel, burnished red ceramic.

Width: 15.0 cm; *height:* 15.0 cm. *Locale:* West Mexico. *Style:* Colima. *Period:* Late Preclassic, 400 B.C.–A.D. 200.

Human head from an effigy vessel that may have been 25 inches high; the person wears a tightly fitting cap or helmet.

30.3/2411

Acrobat vessel.

Length: 24.0 cm; *width:* 13.0 cm; *height:* 13.8 cm. *Locale:* West Mexico. *Style:* Colima. *Period:* Late Preclassic, 400 B.C.–A.D. 200. Figure 10.

30.3/2412

Sleeping dog, burnished red ceramic.

Length: 34.0 cm; *height:* 13.0 cm. *Locale:* West Mexico. *Style:* Colima. *Period:* Late Preclassic, 400 B.C.–A.D. 200.

The vessel, depicting a dog prone with legs extended, has its mouth with an everted rim in the center of the dog's back.

30.3/2413

Ballplayer, burnished red ceramic.

Width: 13.0 cm; *height:* 18.7 cm. *Locale:* West Mexico. *Style:* Colima. *Period:* Late Preclassic, 400 B.C.–A.D. 200.

The ballplayer is wearing "bell-bottom" trousers and an elaborate belt. The vessel opening emerges from the top of his head.

30.3/2414

Musician, gray ceramic, solid.

Height: 20.0 cm. *Locale:* West Mexico. *Style:* Colima. *Period:* Late Preclassic, 400 B.C.–A.D. 200.

The figurine stands on a thin pedestal, with knees bent and arms extended. He wears a large headdress and holds a gourd rattle in his right hand; the pierced left hand seems originally to have held an object also. A whistle is found on the back of the head.

30.3/2415

Seated man with helmet, red burnished ceramic.

Width: 26.0 cm; *height:* 39.0 cm. *Locale:* West Mexico. *Style:* Colima.

The man is resting his arms on his knees and has hands folded. He wears a helmetlike hat with points projecting forward; the phallus is indicated. The circular eyes suggest a costume element—"goggles," associated with rain deities in Central Mexico. Figure 11.

30.3/2416

Male with hooked object protruding from his back, burnished red-brown ceramic with traces of white paint, incised lines.

Width: 18.0 cm; *height:* 38.0 cm. *Locale:* West Mexico. *Style:* Colima.

A single horn is rising from the center of the figurine's forehead, and he holds a weapon in his right hand. The object at the rear, attached below the waist, may be a backpiece, an identification worn by warriors; it represents a tree. Figure 12.

30.3/2417

Figurine, solid buff ceramic; left hand missing.

Height: 8.8 cm. *Locale:* West Mexico. *Style:* Colima.

The individual, probably a dignitary, is seated beneath a semicircular canopy. Other seats and elaborate backrests are shown in West Mexican sculpture (cf. 30.3/2403).

30.3/2418

Figurine of a seated drummer, solid buff ceramic.

Height: 8.0 cm. *Locale:* West Mexico. *Style:* Colima.

The musician, who is playing an upright drum with skin stretched across its top, wears a single, hornlike ornament projecting from the center of his forehead.

30.3/2419

Geometrically shaped jar, burnished red ceramic; outer edge and portions of rim restored.

Diameter: 37.0 cm. *Locale:* West Mexico. *Style:* Colima.

Vessels like these were placed in the shaft tombs, presumably holding offerings of food and drink.

30.3/2420

Armadillo, burnished red ceramic with black paint.

Length: 32.0 cm; *height:* 16.0 cm. *Locale:* West Mexico. *Style:* Colima. Figure 13.

30.3/2421

Parrot, red burnished ceramic; right foot damaged.

Height: 20.5 cm. *Locale:* West Mexico. *Style:* Colima.

The spout of the vessel appears at the top of the head. Parrots also appear in the tree at the center of a village model (cf. 30.3/2461, Figure 18).·

30.3/2422

Figurine of a serpent or seal, burnished red ceramic; spout chipped.

Length: 19.0 cm; *height:* 11.5 cm. *Locale:* West Mexico. *Style:* Colima. The triangular head and apparent rattles indicate a serpent; however, aquatic animals such as sharks and killer whales are found in Colima ceramics, and the posture recalls a seal or sea lion.

30.3/2423

Jar ringed with ten trophy heads, chip in rim.

Height: 19.5 cm; *diameter:* 29.0 cm. *Locale:* West Mexico. *Style:* Colima. The many warrior figures in West Mexican art suggest interpretation of these as trophy heads; figures are sometimes shown wearing human heads on their belts.

30.3/2424

Petal-shaped jar supported by three men, burnished red ceramic.

Height: 25.0 cm; *diameter:* 30.0 cm. *Locale:* West Mexico. *Style:* Colima. The jar is not gadrooned like a squash but has large leaves on the sides. The men face straight ahead, wearing loincloths and single-horn forehead ornaments.

30.3/2425

Standing woman, solid buff ceramic with incising.

Width: 2.2 cm; *height:* 8.0 cm. *Locale:* West Mexico. *Style:* Colima. *Period:* Preclassic, 1200–500 B.C. Figure 22.

30.3/2426

Two women fighting or dancing, solid red ceramic with incised decoration and black paint.

Width: 6.5 cm; *height:* 13.0 cm. *Locale:* West Mexico. *Style:* Colima. Groups of ceramic figurines engaged in activities are the strongest examples of the anecdotal qualities of West Mexican sculpture. Figure 21.

30.3/2427

Conch shell, brown burnished ceramic.

Length: 38.10 cm. *Locale:* West Mexico. *Style:* Colima. *Period:* Late Preclassic, 400 B.C.–A.D. 200. This conch shell has incised bands along its end and shoulders and a solid interior.

30.3/2428

Seated male, burnished red ceramic.

Height: 26.5 cm. *Locale:* West Mexico. *Style:* Colima. *Period:* Late Preclassic, 400 B.C.–A.D. 200. A man shown seated with one knee raised, one lowered to the ground; his hands rest on the left knee, and he leans forward to rest his chin on his hands. (Published: Ekholm 1970:25.)

30.3/2429

Reclining puppy, burnished red ceramic with considerable black staining.

Length: 24.0 cm; *height:* 12.0 cm. *Locale:* West Mexico. *Style:* Colima. *Period:* Late Preclassic, 400 B.C.–A.D. 200. The dog has his paws folded under him; although not seen when the vessel rests flat, the limbs are modeled and the claws are indicated by incising. Figure 14.

30.3/2430

Jug, red ceramic with painted black circular bands.

Height: 19.5 cm. *Locale:* West Mexico, *Style:* Colima. A fully modeled three-dimensional human head projects from the upper vessel body.

30.3/2431

Drummer, burnished red-brown ceramic; perforated ear lobes.

Width: 19.5 cm; *height:* 32.0 cm. *Locale:* West Mexico. *Style:* Colima. *Period:* Late Preclassic, 400 B.C.–A.D. 200. Figure of musician shown drumming on a turtle carapace. Figure 15.

30.3/2432

Reclining dog, burnished red ceramic.

Length: 28.0 cm; *width:* 21.0 cm; *height:* 12.5 cm. *Locale:* West Mexico. *Style:* Colima. *Period:* Late Preclassic, 400 B.C.–A.D. 200.

30.3/2433

Funerary mask, red ceramic.

Height: 24.0 cm. *Locale:* West Mexico. *Style:* Colima. Ceramic masks have been found in West Mexican graves from Chupícuaro to Colima; this example, with eyes not pierced through, appears made only for burial. The ear lobes are pierced, probably for earrings of perishable material. (Published: Ekholm 1970:29.)

30.3/2434

Curled-up dog, brown ceramic.

Length: 11.4 cm. *Locale:* West Mexico. *Style:* Colima. This small brown dog, lying in a curled-up position, shows skeletalization of the spine. This feature, more extensive in other examples, has been interpreted as showing the role of dog as psychopomp, companion of spirits after death. (Published: Ekholm 1970:21)

30.3/2435

Figurine with high pointed head, buff ceramic.

Height: 7.9 cm. *Locale:* West Mexico. *Style:* Colima.

30.3/2436

Figurine with high pointed head, buff ceramic.

Height: 7.8 cm. *Locale:* West Mexico. *Style:* Colima.

30.3/2437

Female figurine, solid red ceramic with paint on body; left hand and right foot chipped.

Height: 28.5 cm. *Locale:* West Mexico, Jalisco (or Colima?). *Style:* Jalisco, Tuxcacuesco type. A large, flat solid standing figurine with a concentric diamond pattern painted on lower torso and thighs; pellet applied to the shoulders indicate scarifications. The figure wears fillet bracelets and necklace and a headband.

30.3/2456

Effigy vessel of a woman with pierced cheeks, red-brown ceramic; left arm restored.

Height: 22.5 cm. *Locale:* West Mexico, Colima–Jalisco, Volcan de Colima area (?). *Style:* Colima-Jalisco. *Period:* Late Preclassic, 400 B.C.–A.D. 200. This vessel is shaped like a squash pot, the spout of which has been transformed into a female figure; the navel and buttocks are indicated on the globular body, perhaps showing pregnancy.

30.3/2438

Standing male, solid burnished brown ceramic; right hand chipped and right ear missing.

Height: 20.3 cm. *Locale:* West Mexico. *Style:* Colima. Figurine with finely modeled face, body, and headdress, with belt tabs featuring careful and exact incised decoration. (Published: Ekholm 1970:21.)

30.3/2439

Two ducks, burnished red ceramic.

Width: 22.5 cm; *height:* 16.0 cm. *Locale:* West Mexico. *Style:* Colima. The vessel is formed by effigies of two ducks joined at the side, with the spout emerging at rear. Effigy animals in West Mexican tombs may have been seen as offerings of sustenance, comparable to actual food in vessels (cf. 30.3/2409).

30.3/2440

Seated woman, burnished red-brown ceramic.

Length: 26.0 cm; *height:* 34.0 cm. *Locale:* West Mexico. *Style:* Colima. Seated woman with head turned sideways, left hand raised to cheek. Figure 16.

30.3/2441

Jar with carinated base and flaring rim, brown ceramic.

Diameter: 20.32 cm. *Style:* Colima. *Period:* Late Preclassic, 400 B.C.–A.D. 200.

Jalisco

30.3/2442

Seated male, buff ceramic.

Height: 16.5 cm. *Locale:* West Mexico. *Style:* Jalisco. The figure is very short-bodied, hunched over, with the right arm across the knees. His chin is resting on his arm, and his right hand is raised to the back of his head, touching the fontanel. He wears a filleted headdress with three applied decorations that may be animal heads. (Published: Ekholm 1970:20.)

30.3/2443

Mace head, buff-colored stone.

Height: 11.4 cm. *Locale:* West Mexico, probably Jalisco. *Style:* Jalisco. Human figure with what appears to be a pack on his back. A doughnut-shaped opening at bottom allowed insertion of wooden handle.

30.3/2444

Head from effigy vessel, buff-orange ceramic with white, black, and red paint.
Length: 24.0 cm. *height:* 19.5 cm. *Locale:* West Mexico, Jalisco, probably Etzatlán area. *Style:* Jalisco.
This head from an effigy vessel probably 25 inches tall (half life-size), may be a portrait of a bearded warrior wearing stiff, protective armor and carrying a weapon. The bucket helmet with triangular crest is painted with polychrome geometric designs (cf. Von Winning 1974, figs. 130 and 132; Medioni and Pinto 1941).

30.3/2445

Censer, buff ceramic.
Height: 24.5 cm.
Locale: West Mexico, Nayarit-Jalisco border area, possibly Ahuacatlán. *Style:* Jalisco.
A censer or brazier in the form of a woman. Her chin is resting on her right knee, and a bowl with a serrated edge is sitting on the crook of her neck.

Nayarit

30.3/2455

Female figurine, solid buff ceramic.
Height: 10.6 cm. *Locale:* West Mexico, reportedly Nayarit. *Style:* Nayarit. *Period:* Late Preclassic, 400 B.C.–A.D. 200.
A nude female with enormous nose and coffee-bean eyes is wearing a flat rectangular headdress.

30.3/2457

Chinesco male, ceramic with highly burnished red slip and black spot patina and white and black negative paint.
Width: 34.0 cm; *height:* 73.0 cm. *Locale:* West Mexico, Nayarit–Jalisco border region. *Style:* Nayarit, Chinesco. *Period:* Late Preclassic, ca. 200 B.C.
Negative painting appears on the face and neck to depict the collar of this monumental seated male figure. Figure 17.

30.3/2458

House model, buff clay with polychrome paint.
Height: 40.0 cm. *Locale:* West Mexico. *Style:* Nayarit. *Period:* Late Preclassic, 400 B.C.–A.D. 200.
A saddle-roofed house with open sides is on a rectangular platform, with birds at the four corners. The house has two stories with double stairways in front. The lower room containing two seated figures may represent the chamber of a shaft tomb.

30.3/2459

Village model with three houses on a circular slab, ceramic with black paint.
Width: 23.0 cm; *height:* 22.0 cm. *Locale:* West Mexico. *Style:* Nayarit. *Period:* Late Preclassic, 400 B.C.–A.D. 200.
The model includes fifteen human figures engaged in various activities. Black bands and triangles are painted on the roofs, reflecting the geometric designs painted on the mud walls of such houses. Figure 19.

30.3/2460

Seated male with pierced cheeks, ceramic with traces of white paint; left leg restored.
Width: 32.0 cm; *height:* 40.0 cm. *Locale:* West Mexico, Jalisco–Nayarit border region. *Style:* Nayarit. *Period:* Late Preclassic, 400 B.C.–A.D. 200.
A number of styles appear to be combined in this large seated figure with headband and chin strap. The triangular face derives from Jalisco style, but the eye construction is like that of Chinesco figures. Figure 20.

30.3/2461

Village model with central tree, buff ceramic.
Height: 28.0 cm; *diameter:* 30.0 cm. *Locale:* West Mexico, reportedly from Colima. *Style:* Nayarit. *Period:* Late Preclassic, 400 B.C.–A.D. 200.
The tree filled with birds is surrounded by figures and four small houses. A large male figure points to what appears to be a dog in the tree. Figure 18.

30.3/2462

Sprawled dog, buff ceramic with red paint; left ear and end of body restored.
Length: 13.0 cm; *width:* 7.5 cm. *Locale:* West Mexico. *Style:* Nayarit (?). *Period:* Late Preclassic, 400 B.C.–A.D. 200.
Red chevrons are painted on the dog's back.

Michoacán

30.3/2446

Ear plugs, silver.
Height: 0.6 cm, 0.8 cm; *diameter:* 3.6 cm. *Locale:* West Mexico, Michoacán. *Style:* Tarascan (?).

30.3/2447

Miniature jar, ceramic.
Height: 3.0 cm. *Locale:* West Mexico, Michoacán. *Style:* Central Michoacán. *Period:* Postclassic, A.D. 1200–1500.

30.3/2448

Miniature vessel with strap handle and long spout, ceramic.
Height: 9.0 cm. *Locale:* West Mexico, Michoacán. *Period:* Postclassic, A.D. 1200–500.

30.3/2449

Miniature tripod dish, ceramic with resist decoration.
Diameter: 5.8 cm. *Locale:* West Mexico, Michoacán. *Style:* Central Michoacán. *Period:* Postclassic, A.D. 1200–1500.

30.3/2450

Miniature tripod dish, ceramic, one foot shaped as a handle.
Height: 4.0 cm; *diameter:* 6.9 cm. *Locale:* West Mexico, Michoacán. *Style:* Central Michoacán. *Period:* Postclassic, A.D. 1200–1500.

30.3/2451

Ear plugs, silver.
Height: 2.4 cm, 2.2 cm; *diameter:* 5.0 cm. *Locale:* West Mexico, Michoacán. *Style:* Tarascan. *Period:* Postclassic, A.D. 1200–1500.

30.3/2452

Miniature shoe-shaped vessel, ceramic.
Length: 9.5 cm. *Locale:* West Mexico, Tzintzuntzan, Michoacán. *Style:* Tarascan. *Period:* Postclassic, A.D. 1200–1500.

30.3/2453

Miniature tripod vessel, red on buff ceramic.
Diameter: 5.4 cm. *Locale:* West Mexico, Michoacán, Tzintzuntzan. *Style:* Tarascan. *Period:* Postclassic, A.D. 1200–1500.

30.3/2402

Finger ring, carved shell.
Length: 4.4 cm; *width:* 3.2 cm. *Locale:* West Mexico, provenance unknown. *Period:* Postclassic, A.D. 1200–1500 (?).

Chupícuaro

30.3/2454

Hunchbacked pregnant female, black polychrome ceramic.
Width: 11.0 cm; *height:* 16.5 cm. *Locale:* West Mexico, Guanajuato. *Style:* Chupícuaro. *Period:* Preclassic, 500 B.C.–A.D. 200. Figure 23.

VERACRUZ

30.3/2338

Bowl, polychrome ceramic with abstract bird designs.
Height: 11.0 cm; *diameter:* 20.5 cm. *Locale:* Veracruz, El Cocuite, near Cerro de las Mesas. *Period:* Late Classic, A.D. 600–900.

30.3/2339

Rabbit vessel, alabaster (*tecali*), eyes with obsidian inlay.
Length: 16.0 cm; *width:* 14.5 cm. *Locale:* Mexico, Sierra de Puebla, near the border of Veracruz. *Period:* Postclassic, A.D. 900–1200.
Rabbits were the symbol of a ritually (and socially) important fermented drink (pulque) in Postclassic Mexico.

30.3/2340

Dignitary, buff ceramic with traces of paint; left fan extension restored, arms missing.
Width: 17.0 cm; *height:* 19.0 cm. *Locale:* Central Veracruz. *Style:* Los Cerros. *Period:* Late Classic, A.D. 750–900.
Winglike extensions, possibly of paper, are mounted behind the arms of this standing figurine; an animal head pendant hangs from its large, bulky collar. The face shows scarification on the forehead and bridge of nose and around the mouth.

30.3/2341

Jar, black ceramic with red paint.
Height: 9.0 cm; *diameter:* 7.5 cm. *Locale:* Mexico, Veracruz.
Molded design is combined with carved relief decoration.

30.3/2342

Fragment of bowl, buff ware, mold-impressed with ceremonial figures in relief.
Height: 8.0 cm; *diameter:* 13.5 cm. *Locale:* Mexico, Veracruz, upper Rio Blanco region. *Period:* Late Classic, A.D. 600–900.
The bowl, semiglobular in shape, was made from a two-piece mold. The fragment shows three ballplayers. Two are kneeling and facing each other; the one at the right is making a commanding gesture.

30.3/2343

Vessel, black ceramic with incising.

Height: 13.0 cm; *diameter:* 12.5 cm. *Locale:* Mexico, probably Veracruz. A band of long-beaked birds is incised around the body of this spouted vessel.

30.3/2344

Hemispheric bowl, buff ware, mold-impressed with figures in deep relief and traces of cinnabar; repaired.

Height: 10.5 cm; *diameter:* 17.4 cm *Locale:* Mexico, Veracruz, upper Rio Blanco region. *Period:* Late Classic, A.D. 600–900.

The bowl features depictions of a naturalistic turtle and a figure in a buccal mask, possibly Quetzalcoatl.

30.3/2345

Monkey jar, onyx (*tecali*). *Height:* 13.0 cm; *diameter:* 6.0 cm. *Locale:* Mexico, probably Veracruz. *Style:* Veracruz. *Period:* Postclassic, A.D. 900–1200.

A rectangular opening in the side was repaired in ancient times with a shell patch.

30.3/2346

Hemispherical tripod bowl, ceramic.

Height: 11.5 cm; *diameter:* 16.5 cm. *Locale:* Mexico, southern Veracruz. *Period:* Late Classic, A.D. 600–900.

Three seated jaguars with erect tails are engraved and painted around the body of the vessel; an impressed design is found on the bottom.

30.3/2347

Bowl with abstract birds, ceramic; yellow and white paint and incising.

Height: 10.5 cm; *diameter:* 16.5 cm. *Locale:* Mexico, Veracruz. *Period:* Late Classic, A.D. 600–900. Long-beaked birds with human arms and feather headdresses are depicted on the bowl.

30.3/2348

Man with trumpet and club, bone; lower portion missing.

Height: 4.5 cm. *Locale:* Mexico, central Veracruz (?).

Bone figurine of a man with a large trumpet in his left hand and a club in his right.

30.3/2349

Figurine, ceramic.

Width: 4.5 cm; *height:* 7.8 cm. *Locale:* Mexico, probably Veracruz. Mold-made figure of an old man.

30.3/2350

Bowl with bird decorations, buff ceramic with black, orange, and red paint.

Height: 9.0 cm; *diameter:* 22.5 cm. *Locale:* Mexico, probably central Veracruz.

30.3/2351

Stamp representing a long-nosed bird, orange ceramic.

Length: 12.0 cm. *Locale:* Mexico, probably Veracruz. *Period:* Classic, A.D. 300–900. (Published: Ekholm 1970:76.)

30.3/2352

Tripod vessel, black ceramic; portion of one leg missing.

Height: 10.5 cm; *diameter:* 10.0 cm. *Locale:* Mexico, probably Veracruz. *Period:* Classic, A.D. 300–900.

An incised band encircles the exterior of this vessel with slab legs; there is a sculptured figure of a monkey on inside bottom.

30.3/2353

Fish tripod, buff ceramic with red; broken rim restored.

Length: 22.0 cm; *height:* 13.0 cm. *Locale:* Mexico, probably Veracruz. The head is red with black eyes; an incised design on the body surface indicates the fish scales.

30.3/2354

Bowl with crustaceans and wading birds, fine white ceramic, painted brown on cream with asymmetrical orange band and white interior with incising; broken, repaired.

Height: 10.8 cm; *diameter:* 18.8 cm. *Locale:* Mexico, Veracruz. *Style:* Cerro Montoso. *Period:* Postclassic, A.D. 1200–1500.

30.3/2355

Hacha in the form of a human head, red stone.

Width: 25.0 cm; *height:* 35.0 cm. *Locale:* Mexico. *Style:* Classic Veracruz. *Period:* Late Classic, A.D. 600–900. Figure 28.

30.3/2401

Hacha with two figures, stone. *Width:* 22.0 cm; *height:* 31 cm. *Locale:* Tlaxcala-Puebla border region. *Style:* Veracruz. *Period:* Late Classic, A.D. 600–900. Figure 29.

30.3/2356

Palma, stone, not decorated. *Height:* 44.0 cm. *Locale:* Mexico, probably Veracruz. *Style:* Classic Veracruz.

30.3/2386

Smiling figure, buff ceramic, mold-made with traces of blue paint; broken and mended. *Width:* 26.0 cm; *height:* 36.5 cm. *Style:* Remojadas, Nopiloa tradition. *Period:* Late Classic, A.D. 600–800. Figure 30.

30.3/2357

Yoke with saurian creature, highly polished stone; in three fragments, repaired.

Length: 42.0 cm; *width:* 39.0 cm. *Style:* Classic Veracruz. Figure 24.

30.3/2358

Hacha in the shape of a head, gray stone.

Height: 26.0 cm. *Locale:* Mexico, probably Veracruz. *Style:* Classic Veracruz. *Period:* Late Classic, A.D. 600–900.

The hacha shows a human face with a bar under the nose and tigerlike ears; the stone is cut through in three places.

30.3/2359

Hacha in form of a head, gray stone with red paint.

Length: 17.5 cm. *Locale:* Mexico, probably Veracruz. *Style:* Classic Veracruz.

Human or deity head with scrolls on temples, around eyes, and on top of the head.

30.3/2360

Yoke with four birds, highly polished stone with traces of red and yellow paint; broken in two parts and repaired.

Length: 40.0 cm; *width:* 35.0 cm. *Locale:* Mexico, probably Veracruz. *Style:* Classic Veracruz. *Period:* Late Classic, A.D. 600–900. Figure 25.

30.3/2361

Hacha of man with bird headdress, green mottled stone.

Length: 19.0 cm. *Locale:* Mexico, probably Veracruz. *Style:* Classic Veracruz. *Period:* Early Classic, A.D. 300–600.

The hacha is more three-dimensional than flat.

30.3/2362

Palma, gray stone.

Length: 22.0 cm; *width:* 15.5 cm; *height:* 17.0 cm. *Locale:* Mexico, probably Veracruz. *Style:* Classic Veracruz. *Period:* Early Classic, A.D. 300–600.

An "ironing-board type" palma with a human head and Tajín-style scrolls.

30.3/2363

Hacha in the form of a head, dark gray stone with carving. *Length:* 26.0 cm; *width:* 17.2 cm; *height:* 12.5 cm. *Locale:* Mexico, Veracruz, Cerro de las Mesas area. *Style:* Classic Veracruz. *Period:* Early Classic, A.D. 300–600. Figure 26.

30.3/2364

Yoke-shaped vessel, buff ceramic, unpainted.

Width: 19.0 cm; *height:* 24.5 cm. *Locale:* Mexico, Veracruz, Cerro de las Mesas area. *Style:* Classic Veracruz. *Period:* Early Classic, A.D. 300–600. Figure 27.

30.3/2365

Peccary jug, black and red on cream paint, bridge spout on back. *Height:* 22.23 cm. *Locale:* Mexico, central or northern Veracruz. *Style:* Huastec. (Published: Ekholm 1970:89)

30.3/2366

Ballplayer with yoke, buff ceramic.

Width: 13.0 cm; *height:* 20.2 cm. *Locale:* Mexico, central or northern Veracruz. *Style:* Huastec.

30.3/2388

Smiling figurine, white clay, mold-made.

Width: 22.0 cm; *height:* 25.5 cm. *Locale:* Veracruz. *Style:* Remojadas, Nopiloa tradition. *Period:* Late Classic, A.D. 600–800. Figure 32.

30.3/2397

Figurine of ritual performer, buff ceramic, mold-made; fingers, part of arm, and streamers missing. *Width:* 11.0 cm; *height:* 21.0 cm. *Locale:* Veracruz, Las Remojadas. *Style:* Remojadas. *Period:* Late Classic, A.D. 600–800. Figure 33.

30.3/2367

Figurine with deformed head, ceramic, firing clouds; right arm restored.

Height: 3.81 cm. *Locale:* Mexico, central or northern Veracruz. *Style:* Huastec.

30.3/2368

Spouted and handled jar, ceramic, polychrome with painted cloisonné decoration. *Height:* 19.05 cm. *Locale:* Mexico, central or northern Veracruz. *Style:* Huastec.

30.3/2369

Flat-bottomed tripod bowl, ceramic with black, orange, red, and white paint on cream-colored surface; broken, repaired. *Height:* 11.5 cm; *diameter:* 35.0 cm. *Locale:* Mexico, Veracruz, Las Tuxtlas region. *Period:* Postclassic, A.D. 900–1200. Figure 35.

30.3/2387

Helmet mask containing human head, ceramic with black decoration. *Width:* 19 cm; *height:* 23.0 cm. *Locale:* Veracruz, Las Remojadas. *Style:* Remojadas. Figure 34.

30.3/2370

Bowl, polychrome ceramic; broken and repaired. *Height:* 10.5 cm; *diameter:* 27.5 cm. *Locale:* Mexico, central Veracruz. The polychrome bowl has various bird designs in the interior and on the exterior along the rim on a white paint background; a figure appears in the center.

30.3/2372 A.B.

Ear spools, ceramic. *Diameter:* 3.0 cm. *Locale:* Mexico, Veracruz. *Period:* Late Preclassic, 400 B.C.–A.D. 300. Pair of ear spools with cut-out and painted design of white spots, one spool partially restored.

30.3/2373

Head, brown ceramic. *Height:* 8.50 cm. *Locale:* Mexico, Veracruz. *Style:* Remojadas. *Period:* Late Classic, A.D. 600–800. Figurine head with Tajín design on forehead.

30.3/2374

Double whistle with attached mask, gray ceramic; right side of headdress missing. *Height:* 11.4 cm. *Locale:* Mexico, Veracruz. *Style:* Remojadas. *Period:* Late Classic, A.D. 600–800.

30.3/2375

Head from smiling figure, ceramic, painted red. *Height:* 18.5 cm. *Locale:* Mexico, Veracruz. *Style:* Remojadas. *Period:* Late Classic, A.D. 600–800. The figure has a wide triangular forehead with a spiral and possibly a floral decoration.

30.3/2376

Head from a smiling figure, ceramic, mold-made. *Width:* 14.0 cm; *height:* 15.0 cm. *Locale:* Mexico, Veracruz. *Style:* Remojadas. *Period:* Late Classic, A.D. 600–800. Figure 31.

30.3/2377

Head with closed eyes, ceramic. *Height:* 22.0 cm. *Locale:* Mexico, Veracruz. *Style:* Remojadas Monumental Sculpture. *Period:* Classic, A.D. 200–500.

30.3/2378

Head from a smiling figure, ceramic, mold-made. *Height:* 10.5 cm. *Locale:* Mexico, Veracruz. *Style:* Remojadas. *Period:* Late Classic, A.D. 600–800. Head with earrings and a spiral decoration.

30.3/2379

Seated figurine, ceramic, painted red. *Height:* 15.0 cm. *Locale:* Mexico, Veracruz. *Style:* Remojadas. *Period:* Late Classic, A.D. 600–800. The figure is seated cross-legged, wearing a headdress with a central crest.

30.3/2380

Figurine, brown ceramic. *Height:* 15.0 cm. *Locale:* Mexico, Veracruz. *Style:* Las Animas. *Period:* Middle Classic, A.D. 500–700. The seated figure wears a face mask and large headdress.

30.3/2381

Smiling figure, ceramic, yellow paint remains on most of body; hands are missing. *Height:* 24.5 cm. *Locale:* Mexico, Veracruz. *Style:* Remojadas. *Period:* Late Classic, A.D. 600–800. The figure stands with arms and legs outstretched, wearing a helmet and bell around the neck; it has a hand-modeled body and mold-made face.

30.3/2382

Head from a figure, ceramic. *Height:* 8.0 cm. *Locale:* Mexico, Veracruz. *Period:* Late Classic, A.D. 600–900. The small head has black knobs for hair, slit eyes, and a gaping mouth suggestive of death.

30.3/2383

Head fragment, ceramic. *Length:* 18.5 cm. *Locale:* Mexico, Veracruz. *Style:* Veracruz Monumental Sculpture. *Period:* Late Classic, A.D. 600–800. Fragment of the head of large clay figure with "spectacles" (goggle eyes) and twisted ear.

30.3/2384

Head and upper torso, ceramic, black bitumen on headdress, red paint on body and chin. *Height:* 18.0 cm. *Locale:* Mexico, Veracruz. *Style:* Remojadas. *Period:* Late Classic, A.D. 600–800. The figure wears an elaborate (beaded?) headdress with asphalt paint and large ear spools.

30.3/2385

Seated female figure, ceramic; hands and feet missing, headdress chipped. *Height:* 29.0 cm. *Locale:* Mexico, Veracruz. *Style:* Remojadas. An unusually expressive sculpture, with large eyes, recurved nose, and partially open mouth showing filed teeth—only portions of the central incisors are left intact. She wears a *quechquémitl,* a capelike garment with points depending at front and rear. (Published, Ekholm 1970:74).

30.3/2389

Figurine, ceramic; broken and repaired, right arm and left foot missing. *Height:* 15.0 cm. *Locale:* Mexico, Veracruz. *Style:* Remojadas. *Period:* Late Classic, A.D. 600–800. Figurine of a sitting woman; the head is similar to Teotihuacán portrait-type figurines.

30.3/2390

Head of a man, buff ceramic. *Height:* 20.0 cm. *Locale:* Mexico, Veracruz. *Style:* Veracruz Monumental Sculpture. *Period:* Late Classic, A.D. 600–800. The head, broken from a monumental sculpture, depicts a man with a mustache and small beard.

30.3/2391

Monkey jug, black ceramic; head broken off and neckline restored, spout reconstructed. *Height:* 22.0 cm. *Locale:* Mexico, Veracruz. *Style:* Remojadas. *Period:* Late Classic, A.D. 600–800. Jug in the shape of a monkey with a bridge spout and an opening at back of the head.

30.3/2392

Pair of ear spools, white ceramic. *Length:* 10.4 cm. and 10.5 cm; *width:* 6.5 cm. *Locale:* Mexico, Veracruz. *Style:* Remojadas. *Period:* Late Classic, A.D. 600–800. A pair of elaborate ceramic ear plugs with three levels and a partial flange; they may be compared with those worn by the Remojadas figure in an elaborate costume: figure 32.

30.3/2393

Blanket-wrapped figure, ceramic; cracks in front, head projections missing, Lirios Portrait Figure. *Locale:* Mexico, Veracruz. *Period:* Late Classic, A.D. 750–900. Such portrait figures are rare; they show some stylistic affinities with eastern Puebla and Oaxaca (Hammer 1971:85, no. 120). (Published: Ekholm 1970:85.)

30.3/2394

Acrobat whistle, white ceramic. *Length:* 15.5 cm. *Locale:* Mexico, Veracruz. *Style:* Remojadas. *Period:* Late Classic, A.D. 600–800. Rather than being contorted or caught in a back flip, as are most Mesamerican acrobat figures, this one does a handstand, with feet raised in the air.

30.3/2395

Head of a figure, ceramic; two projections broken away, top left of ear missing. *Height:* 10.5 cm. *Locale:* Mexico; Veracruz. *Style:* Remojadas. *Period:* Late Classic, A.D. 600–800.

30.3/2396

Standing female figurine, pink ceramic with white slip, mold-made; top left portion repaired. *Height:* 27.5 cm. *Locale:* Mexico, Veracruz. *Style:* Nopiloa II, Mayoid figure. *Period:* Late Classic, A.D. 600–750.

Woman with an elaborate hairdo wearing a skirt and *huipil* (blouse); such figures are extremely similar to Maya figures found in Campeche, on the Island of Jaina. The raised hands may be compared to the gesture of the smiling figure shown in Figure 30.

30.3/2398

Seated figure with elaborate headdress, ceramic. *Height:* 35.0 cm; *width:* 21.5 cm. *Locale:* Mexico, Veracruz. *Style:* Remojadas. *Period:* Late Classic, A.D. 600–800.

30.3/2399

Head of a man, ceramic with asphalt paint.
Height: 19.0 cm. *Locale:* Mexico, Veracruz. *Style:* Remojadas Monumental Sculpture. *Period:* Early Classic, A.D. 200–500.
The head, broken from a monumental sculpture, depicts a man with closed eyes and an open mouth.

30.3/2400

Face of a man, ceramic fragment.
Width: 24.0 cm; *height:* 20.0 cm.
Locale: Mexico, Veracruz, Tierra Blanca, near La Llave. *Style:* Veracruz Monumental Sculpture.
Period: Late Classic,
A.D. 500–700.
The head, broken from a monumental sculpture, depicts a man wearing a chin strap and the remains of a helmet. The helmet features a knot at the front center.

MAYA

30.3/2474

Carved relief bowl, gray ceramic.
Height: 12.5 cm; *diameter:* 12.8 cm.
Locale: Mexico, Yucatán, Calcetok.
Style: Maya, Chocholá. *Period:* Late Classic, A.D. 600–900.
Head and left arm of a man wearing a water-lily jaguar headdress appear in an elaborate scroll medallion; he holds a flexible object that ends in a water lily; four glyphs appear on the reverse. (Published: Spinden 1913:136.)

30.3/2475

Bowl with incised gadrooning and large negative painted scrolls, ceramic.
Height: 12.0 cm; *diameter:* 12.8 cm.
Locale: Mexico or Guatemala, Maya lowlands. *Style:* Maya.
Period: Late Classic,
A.D. 600–900.

30.3/2476

Fragment of figure-painted vessel, ceramic.
Length: 18.0 cm; *height:* 12.0 cm.
Period: Late Classic,
A.D. 600–900.
A seated dignitary is facing an animal-headed figure.

30.3/2246

Fragments of a figure-painted vessel, ceramic.
Width: 17.0, 18.5 cm; *height:* 17.0.
Period: Late Classic,
A.D. 600–900.
Standing figures are holding shields and spears.

30.3/2477

Figure painted vessel; one side of the painting badly eaten into with root marks.
Height: 20.0 cm; *diameter:* 17.0 cm.
Style: Maya. *Period:* Classic,
A.D. 600–900.

30.3/2478

Bowl, carved panel on one side, black ceramic with red pigment, remains of fresco painting on rim.
Height: 7.0 cm; *diameter:* 21.0 cm.
Period: Late Classic,
A.D. 600–900.

30.3/2479

Bowl, polychrome ceramic.
Height: 7.0 cm; *diameter:* 29.0 cm.
Locale: Mexico, Yucatán. *Style:* Maya. *Period:* Middle Classic, A.D. 300–600.
Basal flange bowl with three small legs, painting of head of human figure in interior. (Published: Emmerich 1963:145.)

30.3/2480

Jar, red ceramic with deeply carved design.
Height: 12.5 cm; *diameter:* 15.0 cm.
Style: Maya. *Period:* Late Classic, A.D. 600–900.

30.3/2481

Jar, gray ceramic with bulbous face on side.
Height: 13.5 cm; *diameter:* 14.2 cm.
Locale: Mexico, Yucatán, Uxmal region. *Style:* Maya. *Period:* Late Classic, A.D. 600–900.

30.3/2482

Flask with thick rim and handles, gray ceramic, carved decoration.
Width: 10.0 cm; *height:* 10.5 cm.
Locale: Mexico, Yucatán, Uxmal region. *Style:* Maya. *Period:* Late Classic, A.D. 600–900.
The decoration includes a long-nosed figure, with a diagonal glyph band on the reverse (cf. Coe 1973:138, no. 77).

30.3/2483

Cylindrical jar, polychrome ceramic with seated figures.
Height: 17.5 cm; *diameter:* 17.5 cm.
Locale: Mexico, Yucatán or Campeche. *Style:* Maya. *Period:* Late Classic, A.D. 600–900.

30.3/2484

Carved relief bowl, gray ceramic, carved decoration.
Height: 11.0 cm; *diameter:* 15.2 cm.
Locale: Mexico, Yucatán, possibly Uxmal region. *Style:* Chocholá.
Period: Late Classic,
A.D. 600–900.
Carved bowl depicting two seated figures—a man painting the face of a woman; she is leaning forward and holding a dish. The woman has spiral motifs on her arm and leg; the man shows circular forms on his arms, possibly tattooing or painting. A diagonal glyph band appears on the reverse side. (Published: Emmerich 1963: 143; Ekholm 1970:111.)

30.3/2485

Effigy vessel, orange ceramic, inlays in eyes.
Length: 14.0 cm; *height:* 13.5 cm.
Period: Late Classic,
A.D. 600–900.
God N, one of the major deities of the Underworld, here as an old man with hooked nose emerging from a snail shell.

30.3/2486

Vessel, fine orange ceramic, fresco paint, and incising.
Height: 13.5. *Style:* Maya. *Period:* Late Classic, A.D. 600–900.
The vessel features three round medallions with Quetzal bird designs.

30.3/2487

Bat gods vessel, polychrome ceramic.
Height: 15.0 cm; *diameter:* 18.0 cm.
Locale: Guatemala, El Quiché.
Style: Maya, Chamá. *Period:* Late Classic, A.D. 600–900. Figure 40.

30.3/2488

Urn, buff ceramic with traces of white, red and blue-green paint; broken and repaired, two rim pieces missing.
Height: 34.5 cm; *diameter:* 38.0 cm.
Locale: Guatemala, El Quiché.
Style: Maya. *Period:* Late Classic, A.D. 600–900.
Large urn with stylized face; cylindrical, with flat flanges at each side and a low annular base. The upper rim has a series of indentations; a similar "pie-crust" decorative band appears above the base.

30.3/2489

Fragment of an effigy incensario, buff ceramic with remnants of red, white, and blue-green paint; broken and repaired.
Width: 26.5 cm; *height:* 18.0 cm.
Locale: Guatemala, El Quiché.
Period: Late Classic,
A.D. 600–900. Figure 38.

30.3/2490

Cylindrical vessel, ceramic; fluted sides and a painted glyph band.
Height: 17.2 cm; *diameter:* 17.5.
Style: Maya. *Period:* Late Classic, A.D. 600–900.

30.3/2491

Cylindrical vessel, buff ceramic, polychrome painting.
Height: 17.0 cm; *diameter:* 13.8 cm.
Period: Late Classic, A.D. 600–900.
Two seated figures with long-stemmed lotus flowers; a row of glyphs around the rim.

30.3/2492

Cylindrical vessel, ceramic, with polychrome painting; repaired with several pieces missing along the rim.
Height: 17.5 cm; *diameter:* 14.0 cm.
Period: Late Classic,
A.D. 600–900.
The painting, in blue, red and black, shows masked human figures and glyphs. A black geometric design appears on the inside of the surface of the rim of the vase. Figure 37.

30.3/2493

Cylindrical vessel, ceramic with polychrome painting; broken and repaired.
Height: 21.0 cm; *diameter:* 11.4 cm.
Period: Late Classics,
A.D. 600–900.
Cylindrical vessel with four painted figures. A captive wearing a water-lily jaguar headdress is being presented to a dignitary whose headdress features the Jaguar God of the Underworld. (Published: Ekholm 1970:113; Schele and Miller 1986:226, 236, no. 88 and 88a.) Figure 37.

30.3/2494

Cylindrical vessel, brown ceramic with cream slip; broken and repaired.
Height: 17.0 cm; *diameter:* 16.0 cm. *Locale:* Guatemala, Alta Verapaz or El Quiché. *Style:* Maya. *Period:* Late Classic, A.D. 600–900.
Fine incised decoration showing four seated human figures flanking a vase and offering basket.

30.3/2495

Ring-based bowl, black on orange ceramic.
Height: 7.8 cm; *diameter:* 30.5 cm. *Locale:* Guatemala. *Style:* Maya. *Period:* Late Classic, A.D. 600–900.
Painting of a jaguar. A lotus flower is coming out of the animal's head on the interior. Figure 36.

30.3/2496

Footed bowl, very thin polished blackware.
Height: 13.0 cm; *diameter:* 18.0 cm. *Locale:* Guatemala. *Style:* Maya. *Period:* Early Classic, A.D. 300–600.
Triangular cutouts around the foot.

30.3/1225

Seated dignitary with removable headdress, orange ceramic with traces of blue paint; right arm and right ear ornament missing.
Width: 15.5 cm; *height:* 34.0 cm. *Locale:* Mexico, Campeche. *Style:* Maya. *Period:* Late Classic (Jaina I), A.D. 600–800. Figure 41.

30.3/2524

Noble performing autosacrifice, orange ceramic with traces of blue and red paint. *Width:* 9.0 cm; *height:* 20.0 cm. *Locale:* Campeche, Jaina. *Style:* Maya. *Period:* Late Classic, A.D. 600–800. Figure 42.

30.3/2497

Pendant, bright green jade.
Length: 6.35 cm. *Style:* Maya. *Period:* Late Classic, A.D. 600–900.
A human hand carved in jade. (Published: Rands 1965: 570, fig.30)

30.3/2498

Pendant, green "Maya" jade.
Height: 4.45 cm. *Period:* Late Classic, A.D. 600–900.
Human figure with the face in profile.

30.3/2499

Plaque, light green jade; top right corner missing.
Length: 8.89 cm. *Style:* Maya. *Period:* Late Classic, A.D. 600–900.
Frontal human face with closed eyes, wearing ear spools and surrounded by scrolls.

30.3/2500

Pendant, jade, shaded green through whitish, irregular shape.
Height: 7.62 cm. *Style:* Maya. *Period:* Late Classic, A.D. 600–900.
Relief carving of a face and headdress.

30.3/2502

Incensario stand, buff ceramic with traces of white, blue, and red paint; right hand missing and left hand damaged.
Width: 32.38 cm; *height:* 58.42 cm. *Locale:* Mexico, Tabasco or Campeche. *Style:* Maya. *Period:* Late Classic, A.D. 600–900.
This stand for a censer depicts a man clothed with sandals, fringed belt and breech cloth, and a small poncho with cut-out geometric designs. He is holding a tabletlike object in his left hand. He wears a bivalve shell pendant and the twisted nose ornament of the Jaguar God of the Underworld. He stands on the back of a turtle and is flanked by animal-headed figures holding staffs or spears; they are shown in profile on the lateral panels. (Published: Ekholm 1970:115.)

30.3/2503

Incensario stand, buff ceramic with traces of stucco, blue paint.
Height: 60.96 cm. *Locale:* Mexico, Palenque region. *Period:* Late Classic, A.D. 600–900.
Vertical tube with side flanges and superimposed sculptured heads. Figure 39.

30.3/2504

Carved bone.
Length: 13.0 cm; *diameter:* 3.0 cm. *Locale:* Mexico, Campeche, Lion Island. *Style:* Maya. *Period:* Late Classic, A.D. 600–900.
Section of a human femur with elaborately carved glyphic images, including jaguar heads.

30.3/2515

Tripod bowl, *Cui-*orange polychrome (black and red paint on buff slip), perforated in center.
Height: 7.5 cm; *diameter:* 31.0 cm. *Locale:* Mexico, Campeche. *Style:* Maya.
A stylized bird, anthropomorphized by wearing a headdress and necklace, is painted in the center of the bowl. The bird on this funerary ceramic may be an owl, because it is iconographically associated with death, although the large hooked beak suggests a raptorial bird (Clancy et al. 1985).

30.3/2505

Head, stucco (limestone plaster), remnants of red paint on face.
Height: 24.13 cm. *Locale:* Mexico, Palenque region. *Style:* Maya. *Period:* Late Classic, A.D. 600–900.
Head, wearing a large nose bar and preserved portions of a conical cap, may be from a sculpture decorating the top of a temple or palace, supported by a roof comb.

30.3/2506

Bat-head hacha, black specked stone, top portion missing.
Height: 21.5 cm. *Locale:* Guatemala. *Style:* Maya. *Period:* Late Classic, A.D. 600–900.

30.3/2507

Human figure, light brown stone.
Height: 16.0 cm; *Length:* 19.5 cm. *Locale:* Belize, Punta Gorda region. *Style:* Maya. *Period:* Late Classic, A.D. 600–900.
Crouching, hunchbacked figure with a nose plate; perforated behind the head for suspension.

30.3/2508

Bird pendant, carved shell. *Length:* 6.8 cm; *width:* 3.0 cm. *Locale:* Campeche. *Style:* Maya. *Period:* Late Classic, A.D. 600–900.

30.3/2509

Head, stucco (limestone plaster); eroded. *Height:* 13.5 cm. *Locale:* Mexico, Palenque region. *Style:* Maya. *Period:* Late Classic, A.D. 600–900.
Fragment of a relief sculpture, with a reptilian appearance, large eyes containing spirals, an open mouth, and a heavy snout. It may represent Chac (God B), the Maya rain deity.

30.3/2510

Pendant, mottled green jade.
Height: 4.76 cm. *Style:* Maya. *Period:* Late Classic, A.D. 600–900.
Small, finely carved face with large, almost rectangular eyes; a short, blunt snout; and a "beard." A projection above the forehead is pierced for suspension. It may represent Chac (God B), the Maya rain deity.

30.3/2512

Figurine head, ceramic.
Height: 5.5 cm; *width:* 8.0 cm. *Style:* Maya.

30.3/2513

Figurine head.
Height: 7.2 cm; *width:* 6.5 cm. *Style:* Maya.

30.3/2514

Figurine head.
Height: 8.5 cm; *width:* 6.0 cm. *Style:* Maya.

30.3/2501

Figurine, ceramic.
Height: 11.0 cm. *Locale:* Guatemala, San Augustin Acasaguascatlán. *Style:* Maya. *Period:* Late Classic, A.D. 600–900.

30.3/2511

Figurine head.
Height: 6.5 cm. *Locale:* Mexico, Campeche (?). *Style:* Maya.
Figurine representing a man with mustache and beard.

30.3/2516

Hooded female figurine whistle, ceramic, feet restored.
Height: 13.5 cm. *Locale:* Mexico, Jonuta, Lower Usumacinta. *Style:* Maya. *Period:* Late Classic, A.D. 600–800.
A female figure is shown with her hands folded and fingers pointing upward; her hair is cut in stepped bangs. Fragments of white slip are preserved on the cowl. The entire front of the figure is painted red—apart from Maya blue on the ear spools, necklace, and wristlets and yellowish paint on the face and hands. The whistle is in the rear support.

30.3/2517

Double-bird figurine, buff ceramic, traces of blue paint.
Height: 11.0 cm. *Locale:* Mexico, Campeche. *Style:* Maya/Jaina. *Period:* Late Classic, A.D. 600–800.
Double figurines show only birds and humans or deities, not other kinds of animals (cf. Rands and Rands 1965:543, fig. 18).

30.3/2518

Bearded rabbit figurine, ceramic.
Height: 12.06 cm. *Locale:* Mexico, Campeche. *Style:* Maya.

30.3/2519

Seated female figurine, orange ceramic, modeled, head possibly mold-made, traces of blue paint on skirt, white on *quechquemitl*.
Height: 21.0 cm. *Locale:* Mexico, Campeche–Lower Usumacinta region. *Style:* Maya, Jaina Group C.
This common type of figurine characteristically features a notch in the head, perhaps for the addition of an ornament; the *quechquemitl* was modeled separately and applied to the figurine.
(cf. 30.3/2526 and 30.3/2527).

30.3/2520

Pendant, carved shell.
Length: 6.8 cm; *width:* 9.0 cm.
Locale: Mexico, Campeche, Jaina. *Style:* Maya.
Disc-shaped shell pendant with seated openwork figure.

30.3/2521

Standing dwarf figurine, gray ceramic.
Height: 11.5 cm. *Locale:* Mexico, Campeche. *Style:* Maya, Jaina Group L(a).
Dwarf figurines, smaller than other types of Jaina figurines, show standing or seated corpulent figures. This example wears a pellet necklace and large headdress; the whistle is in the shoulder.

30.3/2522

Standing female figurine, orange ceramic, mold-made.
Height: 20.2 cm. *Locale:* Mexico, Campeche, Jaina. *Style:* Maya, Jaina Group M(b).
The woman, her face showing scarifications, wears a *quechquemitl*, skirt, and two strands of pellet beads; the larger features two depending strands ending in tassels. The elaborate headdress includes a tasseled rosette at the center.

30.3/2523

Mother and child figurine, ceramic, modeled, blue paint on body.
Height: 15.5 cm. *Locale:* Mexico, Campeche, Jaina. *Style:* Maya.
A seated woman with baby on back; a detachable headdress appears to be missing.

30.3/2525

Jaguar whistle, buff clay, white paint.
Length: 16.5 cm; *width:* 5.0 cm.
Locale: Mexico, Campeche, Jaina. *Style:* Maya.
A whistle with a single tube with an applied jaguar face and resonating chamber.

30.3/2526

Seated female figurine, orange ceramic, modeled, head possibly mold-made, blue paint remains on skirt.
Height: 19.0 cm. *Locale:* Mexico, Campeche–Lower Usumacinta region. *Style:* Maya, Jaina Group C. (cf. 30.3/2519 and 2527).

30.3/2527

Female figurine, orange ceramic, modeled, head possibly mold-made, *Quechquemitl* painted blue with white semicircular designs preserved on proper left side; lower half missing.
Height: 16.2 cm. *Locale:* Mexico, Campeche–Lower Usumacinta region. *Style:* Maya, Jaina Group C.
The figure was undoubtedly seated originally; facial sacrification is common on this type of figure but is absent on the other two examples in the collection (cf. 30.3/2519 and 2526).

30.3/2528

Female figurine, light orange ware, mold-made, white paint traces.
Height: 17.8 cm. *Locale:* Mexico, Jonuta–Lower Usumacinta. *Style:* Maya, Jonuta Group A. *Period:* Late Classic, A.D. 600–900.
This broad, flat rattle figurine depicts a woman with her hands upraised. The double hairline, the lower one cut in stepped bangs, appears to indicate that the figure is wearing a wig (Corson 1976:64).

30.3/2529

Female figurine, ceramic, mold-made figurine.
Height: 18.5 cm. *Locale:* Mexico, Campeche (?). *Style:* Maya. *Period:* Late Classic, A.D. 600–900.
This rattle figurine shows only a pointed face, collar, breasts, and arms, with hands holding circular object in front of body—all surrounded by the flat front surface.

30.3/2530

Woman and dwarf figurine, buff ware, mold-made, remains of white or orange and blue paint, legs of dwarf reconstructed.
Height: 21.0 cm. *Locale:* Mexico, Campeche, Jaina. *Style:* Maya. *Period:* Late Classic, A.D. 600–900.
Double figurine showing standing female wearing a long cape, a dwarf crouching before her under the cape. (Published Coe 1966, pl. 58; 1980:114, ill. 89; cf. Kimball 1961:29, no. 36.)

30.3/2531

Dwarf figurine, orange ceramic, mold-made with appliques.
Height: 12.0 cm. *Locale:* Mexico, Campeche, Jaina. *Style:* Maya, Jaina Group L(a). *Period:* Late Classic, A.D. 600–900.
Dwarf with rounded features standing in a partial crouch, with a headdress in the form of a hooked beaked bird's head, worn upright.

30.3/2532

Man in blossom figurine, buff ceramic with blue and red paint, back leaf missing.
Width: 4.5 cm; *height:* 14.5 cm.
Locale: Mexico, Campeche, Jaina. *Style:* Maya. *Period:* Late Classic, A.D. 600–900.
Small sculpture of man with folded arms and a pellet necklace seated in a lotus blossom on a high stem. Figure 43.

30.3/2533

Dancing figurine, with large ear of corn, ceramic, mold-made.
Height: 19.0 cm. *Locale:* Guatemala (?). *Style:* Maya. *Period:* Late Classic, A.D. 600–900.
Such dancing male figures may hold corn or cacao, and may represent performers in agricultural rituals (cf. Rands and Rands 1965:550, fig. 38).

30.3/2534

Warrior figurine, ceramic, mold-made.
Height: 18.5 cm. *Locale:* Mexico, Campeche, Jaina. *Style:* Maya. *Period:* Late Classic, A.D. 600–900.
The standing warrior holds a rectangular shield and wears a headdress of a deer's head.

30.3/2535

Ballplayer figurine, ceramic, blue paint on headdress, mold-made.
Height: 18.2 cm. *Locale:* Mexico, Campeche. *Style:* Maya. *Period:* Late Classic, A.D. 600–900.
The ball player wears a thick yoke around his waist, which he supports with his right hand, and a blue animal headdress.

30.3/2536

Standing male figurine, ceramic, mold-made.
Height: 16.0 cm. *Locale:* Mexico, Campeche. *Style:* Maya. *Period:* Late Classic, A.D. 600–900.
The figurine depicts an old warrior with sunken features holding a fan in his right hand.

30.3/2537

Warrior figurine, ceramic, mold-made.
Height: 16.0 cm. *Locale:* Mexico, Campeche. *Period:* Late Classic, A.D. 600–900.
This canine-headed warrior raises a knife is his right hand and holds a round shield in his left.

30.3/2538

Female figurine fragment, finely modeled ceramic, head and upper torso only.
Height: 10.0 cm. *Locale:* Mexico, Campeche, Jaina. *Style:* Maya. *Period:* Late Classic, A.D. 600–900.
Only the head and bust are preserved; the woman wears a choker and necklace (of which only one pellet bead remains); the fine modeling and turn of the head suggest portraiture.

30.3/2539

Figurine head, ceramic, red and green paint.
Width: 8.5 cm; *height:* 7.0 cm.
Locale: Mexico, Campeche, Jaina.
Style: Maya. *Period:* Late Classic, A.D. 600–900.

30.3/2241

Seated man, brown stone.
Height: 17.5 cm. *Locale:* Guatemala.
Style: Maya. *Period:* Classic, A.D. 300–900.

30.3/2243

Zoomorphic figurine, stone.
Width: 8.5 cm; *height:* 12.5 cm.
Style: Maya (?). *Period:* Classic, A.D. 300–900.

GUERRERO

30.3/2284

Mask, gray stone.
Width: 13.5 cm; *height:* 15.0 cm.
Locale: Mexico, Guerrero. *Style:* Mezcala (Chontal).
Stone mask with perforated eyes and mouth.

30.3/2285

Animal effigy jar, buff ceramic, black decoration.
Height: 19.5 cm. *Locale:* Mexico, Guerrero.
A globular jar with a flat bottom and two small lug handles; the spout was transformed into a rounded animal head with a triangular mouth and projecting eyes and ears.

30.3/2286

Bowl with reptilian creatures, stone, cinnabar in ground.
Height: 13.5; *diameter:* 18.5 cm.
Locale: Mexico, Guerrero, Xochipala. *Period:* Preclassic, 1000–500 B.C.
Stone vase with painting of dragon. Figure 46.

30.3/2287

Mask, grayish-green stone.
Height: 17.14 cm. *Locale:* Mexico, Guerrero. *Style:* Mezcala.
Figure 44.

30.3/2288

Mask pendant, iron pyrite mixed with other minerals and possibly galena; nose damaged.
Width: 8.0 cm; *height:* 9.5 cm.
Locale: Mexico, Guerrero. *Style:* Mezcala.
Use as a pendant is suggested by angular perforations at jaw and center of top (Brooklyn Museum 1966:19, no. 39).

30.3/2289

Mask pendant, opaque, finely veined green and buff jade.
Height: 5.2 cm. *Locale:* Mexico, Guerrero. *Style:* Mayoid.
The back of the mask is flat with a slight circular hollow—possibly related to "bib" faces.

30.3/2290

Head, gray stone, thin.
Height: 6.2 cm. *Locale:* Mexico, Guerrero. *Style:* Mezcala.

30.3/2291

Seated figure, green stone.
Height: 11.0 cm; *width:* 7.5 cm.
Locale: Mexico, Guerrero.
Style: Olmec. *Period:* Preclassic, 1000–500 B.C.
This small but blocky and monumental figure, related to the Guerrero Olmec style, is shown seated cross-legged with hands resting on its knees; there are two perforations in each ear and one in each hand.

30.3/2292

Spherical sculpture, with masklike relief face on side, stone.
Height: 24.0 cm; *diameter:* 36.0 cm.
Figure 45.

30.3/2293

Figurine head, ceramic.
Height: 11.4 cm. *Locale:* Mexico, Guerrero, Pie de la Cuerta. *Period:* Preclassic, 1200–500 B.C.

30.3/2294

Figurine, orange ceramic, heavy lime deposit
Height: 5.5 cm. *Locale:* Mexico, Guerrero. *Style:* Xoxipala. *Period:* Preclassic, 1500–500 B.C.
This grotesque figurine has a large round hollow head with an open circular mouth and protruding tongue, with attached fillet arms and legs.

CENTRAL MEXICO

Teotihuacán

30.3/2323

Mask fragment, with green-flecked black obsidian.
Width: 14.5 cm; *height:* 13.5 cm.
Locale: Mexico, Teotihuacán.
Period: Classic, A.D. 250–750.
Although fragmentary, the carving of the abstract human face is excellent. Such masks were apparently funerary; few have been excavated archaeologically, but more are reported from Guerrero than from Teotihuacán itself.

30.3/2324

Vessel, black ware.
Height: 13.0 cm; *diameter:* 7.0 cm.
Locale: Mexico, Cholula. *Style:* Teotihuacán. *Period:* Classic, A.D. 250–750.
The vase has three loop handles and a polished surface with curving areas of matte decoration.

30.3/2325

Frescoed tripod vessel, ceramic, polychrome; broken and repaired, two shards missing at rim.
Height: 16.0 cm; *diameter:* 17.8 cm.
Locale: Mexico, Teotihuacán. *Style:* Teotihuacán. *Period:* Classic, A.D. 250–750.
This cylindrical tripod vessel is decorated with fresco painting of goggle-eyed figures; it has slab feet in slope and panel shape.

30.3/2326

Two-part effigy vessel with carved facial designs, light brown ceramic; feet missing.
Width: 25.0 cm; *height:* 29.0 cm.
Locale: Mexico, Teotihuacán. *Style:* Teotihuacán. *Period:* Classic, A.D. 250–750. Figure 47.

30.3/2327

Openwork jar, red ceramic.
Height: 14.5 cm; *diameter:* 10.5 cm.
Locale: Guatemalan highlands.
Style: Teotihuacán. *Period:* Classic, A.D. 250–750.
The jar has a squat body and tall flaring rim; the body is composed of an open lattice-work outer layer.

30.3/2328

Frescoed jar, orange ceramic (thin orange); polychrome fresco depicts figures and floral motifs.
Height: 21.5 cm; *diameter:* 20.5 cm.
Locale: Mexico, Teotihuacán. *Style:* Teotihuacán. *Period:* Classic, A.D. 250–750. Figure 48.

30.3/2329

Tripod vessel, brown polished ware, incised decoration.
Height: 13.4 cm; *diameter:* 13.5 cm.
Locale: Mexico, Teotihuacán. *Style:* Teotihuacán. *Period:* Classic, A.D. 250–750.

30.3/2330

Fragment of mirror back, carved slate, traces of red paint.
Length: 12.5 cm. *Locale:* Mexico, Puebla, Cerro de la Malinche area.
Style: Teotihuacán. *Period:* Classic, A.D. 250–750.
This mirror was probably originally circular in shape, the reflective surface created by pyrite crystals glued to the slate. A standing figure in an elaborate costume is shown on the fragment.

30.3/2331

Tripod vessel, orange ceramic (thin orange), with mold-made decorations of profile figure, slab feet; broken and repaired.
Width: 29.8 cm; *height:* 31.0 cm.
Locale: Mexico, Teotihuacán. *Style:* Teotihuacán. *Period:* Classic, A.D. 250–750.
The mold-made design shows a man with a headdress and speech scroll, repeated on front and back. Figure 50.

30.3/2332

Standing figurine, dense black stone.
Width: 2.4 cm; *height:* 4.2 cm.
Locale: Mexico, Teotihuacán. *Style:* Teotihuacán. *Period:* Classic, A.D. 250–750.
The female figurine wears a skirt and blouse; the figurine has a flat back.

30.3/2333

Vessel.
Length: 37.0 cm; *width:* 20.0 cm; *height:* 21.0 cm. *Locale:* Mexico, border of Puebla, Oaxaca, and Veracruz. *Style:* Teotihuacán.
Period: Classic, A.D. 250–750. Figure 51.

30.3/2334

Tripod vessel with cover, black ceramic, red paint.

Height: 28.0 cm; *diameter:* 21.0 cm. *Locale:* Mexico, Teotihuacán. *Style:* Teotihuacán. *Period:* Classic, A.D. 250–750. Figure 49.

30.3/2335

Figurine, buff ceramic, yellow and blue paint.

Width: 2.5 cm; *height:* 4.6 cm. *Locale:* Mexico, Veracruz. *Style:* Teotihuacán. *Period:* Classic, A.D. 250–750.

Figurine with aviator-type headdress and thick belt.

30.3/2371

Pendant, green black diorite with false spots.

Height: 6.5 cm. *Locale:* Mexico. *Style:* Teotihuacán.

The pendant is in the form of a human head with angular perforation in the top, fine bionical perforations in ears and nostrils, and a flat back beveled forward to the chin; Olmec features.

30.3/2319

Mask, ceramic.

Width: 7.0 cm; *height:* 8.0 cm. *Locale:* Mexico, Santiago Ahuizotla. Grotesque mask; a complete work, not broken from a larger figure.

30.3/2320

Mask, buff ceramic.

Width: 8.0 cm; *height:* 9.0 cm. *Locale:* Mexico, Santiago Ahuizotla. *Style:* Teotihuacán. *Period:* A.D. 250–75.

A mask of the type whose best known examples are carved in stone (cf. 30.3/2323); a complete work, not broken from a larger figure.

30.3/2545

Dog head, carved shell.

Length: 3.5 cm; *height:* 3.0 cm. *Locale:* Veracruz. *Period:* Classic, A.D. 300–900.

Toltec

30.3/2540

Plumbate ware effigy tripod jar.

Height: 18.5 cm; *diameter:* 16.0 cm. *Locale:* Mexico, Yucatán. *Style:* Toltec. *Period:* Early Postclassic, A.D. 900–1200.

A human head wearing a mask projects from one side of the globular body of the jar, which has rounded supports set at an angle. Plumbate tripods are relatively uncommon.

30.3/2541

Collar-shaped pendant, shell.

Length: 15.0 cm. *Locale:* Mexico, Chalco. *Style:* Toltec. *Period:* Early Postclassic, A.D. 900–1200.

The engraved scene with five figures appears to center on altar, on top of which is a plant in a vessel (perhaps the day sign for one reed, associated with Quetzalcoatl); a plant with leaves and flowers serves as a decorative background. (Published: Ekholm 1970:55.)

30.3/2542

Tripod bowl, ceramic with black and red paint.

Height: 19.0 cm; *diameter:* 15.8 cm. *Locale:* Mexico, Cholula. *Style:* Toltec. *Period:* Early Postclassic, A.D. 900–1200.

The tripod feet appear to be stylized reptilian heads; an animal head is attached to one side of the wide, shallow bowl.

30.3/2543

Plumbate ware, effigy of a kneeling man.

Width: 16.0 cm; *height:* 27.5 cm. *Locale:* Guatemala, Pacific slope, provenance unknown. *Style:* Toltec. *Period:* Early Postclassic, A.D. 900–1200.

This plumbate ware effigy jar shows a kneeling hunchback who is carrying a vessel. Figure 52.

30.3/2544

Chac Mool figurine, ceramic; head, leg, and one hand missing.

Length: 10.2 cm; *height:* 5.0 cm. *Locale:* Mexico, Chalco. *Style:* Toltec (?). *Period:* Early Postclassic, A.D. 900–1200.

Chac Mools, reclining figures with vessels on their torsos, are found in the form of stone sculpture at Tula, Chichén Itzá, and Tenochtitlán.

Aztec

30.3/2463

Applied head from flute, ceramic, paint on lip.

Length: 5.0 cm; *width:* 4.5 cm; *height:* 4.0 cm. *Locale:* Valley of Mexico, Culhuacán. *Style:* Aztec. *Period:* Postclassic, 1200–1520.

This small human head came from a flute (cf. 30.3/2468).

30.3/2464

Knife handle.

Length: 19.0 cm; *width:* 5.0. *Locale:* Central Mexico. *Style:* Aztec. *Period:* Postclassic, A.D. 1200–1520. Figure 54.

30.3/2465

Crouching figure knife handle, wood; resin partly covers face.

Length 18.0 cm; *width:* 6.0 cm. *Locale:* Central Mexico. *Style:* Aztec. *Period:* Postclassic, A.D. 1200–1520.

30.3/2466

Anthropomorphic knife handle, wood, badly preserved.

Length: 18.5 cm; *width:* 6.8 cm. *Locale:* Central Mexico. *Style:* Aztec. *Period:* Postclassic, A.D. 1200–1520.

30.3/2467

Inverted crouching figure knife handle, wood, blackened on left side of face and part of handle.

Length: 15.0 cm; *width:* 3.5 cm. *Locale:* Mexico, Guerrero, Teloloa. *Style:* Aztec. *Period:* Postclassic, A.D. 1200–1520.

30.3/2468

Flute, ending in ceramic, mold-made head.

Length: 14.0 cm; *height:* 4.0 cm. *Locale:* Valley of Mexico, Chalco. *Style:* Aztec. *Period:* Postclassic, A.D. 1200–1550.

This four-hole flute is decorated with a human head with sunken features, bulbous eyes, and two vertical projections from the top of the head.

30.3/2469

Flute, ceramic.

Length: 23.0 cm. *Locale:* Mexico. *Style:* Aztec. *Period:* Postclassic, A.D. 1200–1520.

The four-hole flute ends in a grotesque reptilian head with a recurved snout, two fangs, and a feathered or beaded collar; it may be identified as a *xiuhcoatl* (fire serpent).

30.3/2470

Vessel fragment, ceramic.

Length: 10.5 cm; *width:* 7.5 cm. *Locale:* Central Mexico. *Style:* Aztec. *Period:* Postclassic, A.D. 1200–1520.

The fragment shows Éhecatl-Quetzalcóatl, identifiable by the buccal mask and pectoral-shell ornament.

30.3/2471

Drum with dancer, wood.

Length: 59.0 cm; *height:* 20.0 cm; *diameter:* 17.5 cm. *Locale:* Mexico, used in Colima. *Style:* Aztec. *Period:* Postclassic, A.D. 1200–1600. Figure 53.

30.3/2472

Deer's head vessel, dull orange ceramic, thin walled.

Length: 8.0 cm; *height:* 7.5 cm. *Locale:* Valley of Mexico, Culhuacán. *Style:* Aztec (?). *Period:* Postclassic, A.D. 1200–1520.

30.3/2473

Figurine head of Xipe Totec, ceramic.

Height: 4.0 cm. *Locale:* Central Mexico. *Style:* Aztec (?). *Period:* Postclassic, A.D. 1200–1520.

30.3/2321

Fragment of paper, said to have been found in a cave.

Length: 22.8; *width:* 16.5 cm. *Locale:* Mexico, Tehuacán, Puebla. *Period:* Postclassic. A.D. 1200–1500 (?).

30.3/2322

Blue cloth with fringe, said to have been found in a cave. *Length:* 20.3 cm; *width:* 16.5 cm. *Locale:* Mexico, Puebla, Tehuacán.

30.3/2337

Blade flake, obsidian. *Length:* 16.0 cm; *width:* 1.5 cm. *Locale:* Mexico (?), provenance unknown.

OAXACA

30.3/2295

Monkey-head pendant, copper. *Length:* 4 cm. *Locale:* Mexico, Oaxaca. *Period:* Postclassic, A.D. 1200–1500.

30.3/2296

Bird ornament, gold. *Length:* 10.0 cm; *height:* 3.5 cm. *Locale:* Mexico, Oaxaca. *Period:* Postclassic, A.D. 1200–1500.

30.3/2297

Urn. *Width:* 13.0 cm; *height:* 22.0 cm. *Locale:* Mexico, Oaxaca. *Style:* Monte Albán. Figure 55.

30.3/2298

Jug, gray ceramic, false bottom. *Height:* 12.5 cm; *diameter:* 7.5 cm. *Locale:* Mexico. *Style:* Monte Albán (?).

30.3/2299

Jar. *Width:* 12.0 cm; *height:* 19.0 cm. *Locale:* Mexico, Oaxaca. *Style:* Monte Albán. Figure 56.

30.3/2300

Figurine, incense burner. *Width:* 38.0 cm; *height:* 56.0 cm. *Locale:* Mexico, Oaxaca. *Style:* Monte Albán. Figure 61.

30.3/2301A

Urn. *Width:* 29.0 cm; *height:* 38.0 cm. *Locale:* Mexico, Oaxaca. *Style:* Monte Albán. Figure 57.

30.3/2301B

Urn. *Length:* 17.0 cm; *width:* 12.5 cm. *Locale:* Mexico, Oaxaca. *Style:* Monte Albán. Figure 57.

30.3/2303

Labret. *Length:* 4.76 cm. *Locale:* Mexico, Oaxaca, Tututepec. *Style:* Mixtec. Figure 63.

30.3/2304

Bell. *Height:* 5.08 cm. *Locale:* Mexico, Oaxaca, Veracruz. *Style:* Mixtec. Figure 65.

30.3/2305

Bead, gold. *Diameter:* 0.95 cm. *Locale:* Mexico, Oaxaca–Puebla. *Style:* Mixtec.

30.3/2306

Ring, cast gold. *Height:* 1.3–1.9 cm; *diameter:* 1.9 cm. *Locale:* Mexico, Oaxaca–Puebla. *Style:* Mixtec. *Period:* Postclassic, A.D. 1200–1500. A ring with a human face with earring bells. (Published: Easby 1955:111.)

30.3/2307

Ear Spool. *Height:* 4.76 cm. *Locale:* Mexico, Oaxaca–Puebla. *Style:* Mixtec. Figure 64.

30.3/2308

Ear Spool. *Height:* 4.76 cm. *Locale:* Mexico, Oaxaca–Puebla. *Style:* Mixtec.

30.3/2309

Lip plug. *Length:* 1.75 cm. *Locale:* Mexico, Puebla, Tepeji el Viejo. *Style:* Mixtec. *Period:* Postclassic, A.D. 1200–1500. Lip plug decorated with open-work cast scrolls.

30.3/2310

Carved plaque, turtle bone; incomplete. *Locale:* Mexico, Oaxaca–Puebla. *Style:* Mixtec. *Period:* Postclassic, A.D. 1200–1500. Open-work carving of deity with buccal mask and serpent body.

30.3/2311

Pair of ear spools, obsidian and gold. *Diameter:* 3.81 cm. *Locale:* Mexico, Oaxaca–Puebla. *Style:* Mixtec. *Period:* Postclassic, A.D. 1200–1500. These ear spools have a shape characteristic of those carved from obsidian: on each end is a flat flange, the surfaces of which are continuous. The channel formed by these flanges is filled with sheet gold, and a circle of gold with a repoussé solar design fits over the opening of each spool.

30.3/2312

Bowl. *Height:* 9.0 cm; *diameter:* 21.0 cm. *Locale:* Mexico, Oaxaca–Puebla. *Style:* Mixtec. Figure 58.

30.3/2313

Bowl. *Height:* 14.0 cm; *diameter:* 17.0. *Locale:* Mexico, Oaxaca–Puebla. *Style:* Mixtec. Figure 59.

30.3/2314

Pendant. *Length:* 4.0; *width:* 3.0 cm. *Locale:* Mexico, Oaxaca–Puebla. *Style:* Mixtec. Figure 62.

30.3/2315

Turquoise mosaic ear spool, wood and stone; incomplete. *Diameter:* 3.49 cm. *Locale:* Mexico, Puebla. *Style:* Mixtec. *Period:* Postclassic, A.D. 1200–1500. Circular ear spool with open center and turquoise mosaic around edge.

30.3/2316

Fragment of a plate, polychrome ceramic. *Width:* 24.13 cm. *Locale:* Mexico, Oaxaca–Puebla, *Style:* Mixtec, Cholula polychrome. *Period:* Postclassic, A.D. 1200–1500. The fragment shows a single and nearly complete figure of a goddess.

30.3/2317

Plate. *Height:* 8.5 cm; *diameter:* 20.8 cm. *Locale:* Mexico, Oaxaca–Puebla. *Style:* Mixtec/Cholula/Tepeji el Viejo. Figure 60.

30.3/2318

Jaguar head, obsidian with metal tongue. *Length:* 2.4 cm; *width:* 8 cm. *Locale:* Valley of Mexico, Culhuacán. *Style:* Mixtec, *Period:* Postclassic, A.D. 1200–1500.

Saltillo Serapes

65/6036

Serape, patterned with central, predominately dark crimson and gold concentric diamond on a vertical mosaic field. Diagonal design borders. Polychrome with dark crimson predominating. Weft-faced tapestry weave. Cotton warps, handspun wool/wefts. Two loom products sewn together at side selvages. *Length:* 231 cm; *width:* 128 cm. *Locale:* Mexico, Saltillo town. *Period:* Classic Saltillo (18th c.)

65/6037

Fragment of serape with pattern of vertical mosaic field and diamond design end border. Polychrome with crimson predominating. Weft-faced tapestry weave. Cotton warps, handspun wool/wefts. *Length:* 27 cm; *width:* 19 cm. *Locale:* Mexico, Saltillo town. *Period:* Classic Saltillo (18th c.)

65/6032

Serape, patterned with central, crimson concentric diamond motif on a vertical mosaic field. Zig-zag design borders. Polychrome with crimson predominating. Weft-faced tapestry weave. Linen warps, handspun/wefts. Two loom products sewn together at side selvages. *Length:* 227 cm; *width:* 118 cm. *Locale:* Mexico, Saltillo town. *Period:* Classic Saltillo (18th c.)

65/6033

Serape, patterned with central, crimson concentric diamond motif on a vertical mosaic field. Zig-zag design borders. Polychrome with crimson predominating. Weft-faced tapestry weave. Linen warps, handspun wool/wefts. Two loom products sewn together at side selvages. *Length:* 244 cm; *width:* 134 cm. *Locale:* Mexico, Saltillo town. *Period:* Classic Saltillo (18th c.)

65/6034

Serape, patterned with central, blue and white concentric diamond motif on a field of small serrated diamonds. Diamond design borders. Light and dark blue on white. Weft-faced tapestry weave. Linen warps, handspun wool/wefts. Two loom products sewn together at side selvages, with evidence of original opening for head. *Length:* 240 cm; *width:* 140 cm. *Locale:* Mexico, Saltillo town. *Period:* Classic Saltillo (18th c.)

65/6035

Serape, patterned with central aggregate diamond motif on a vertical mosaic field. Diagonal design borders and weft-striped ends. Blue, brown, rust, and white. Two loom products sewn together at side selvages.
Length: 196 cm; *width:* 107 cm. *Locale:* Mexico, probably Saltillo town. *Period:* 19th c.

CENTRAL AMERICA

30.3/1257

Double figurine pendant, pale green stone.
Length: 6.0 cm; *width:* 3.5 cm. *Locale:* Costa Rica, Atlantic watershed, provenance unknown. *Period:* 300 B.C.–A.D. 500. Elizabeth Easby places the origin of this image of two figures connected end to end in the Atlantic watershed zone. It is based on the ax pendant form but, because of the shape, is worn horizontally as a bar pendant.

0.3/1258

Bird pendant with long angular beak, gray green jade.
Length: 6.0 cm. *Locale:* Costa Rica, Atlantic watershed, *Period:* A.D. 1–500, provenance unknown. The hooked-beak bird is among the most commonly depicted pendant forms in Costa Rica. It follows in its prominence after the ax-god and the plain celt pendant forms. Although the angled beak resembles a vulture more than an owl, it is probably conceptually associated with the avian aspect of the ax-god deity (Easby, 1969).

30.3/1259

Rectangular pendant with central bird (bat?) head motif, gray-green jade.
Width: 15.2 cm. *Locale:* Costa Rica, Atlantic watershed, provenance unknown. *Period:* A.D. 1–500. In addition to the pierced suspension holes, simultaneously construed as eyes, there are two raised circles delineating the wings on either side. This type of ornament, which is seen ranging from very abstract depictions to comparatively more naturalistic representations, is found in Central America, Venezuela, Colombia, and the Caribbean Islands and may represent some common belief systems (Easby, 1969:50).

30.3/1260

Anthropomorphic ax pendant, stone, surfaced with albite-jadite, delicately incised relief.
Length: 26.6 cm. *Locale:* Costa Rica, Nicoya Guanacaste (?), provenance unknown. *Period:* 300 B.C.–A.D. 500. A serpentlike tongue protrudes from the open mouth. Drilled holes on both sides of teeth are similar to those of the eyes and may allude to the existence of a second figure within it. The patterning and general shape have affinities with Olmec traditions and may predate other ax-god forms. The stylistic origin may be located further east, where such patterning is more prevalent (Easby 1969:17).

30.3/2224

Metate, stone with a relief of an animal accompanied by mano-marked "B" on the bottom.
Length: 23.0 cm; *width:* 19.0 cm; *height:* 9.5 cm. *Locale:* Costa Rica, provenance unknown.

30.3/2225

Club head, mottled brown stone.
Length: 10.5 cm; *height:* 4.5 cm. *Locale:* Costa Rica, provenance unknown. The feline form is a theme often manifested on Costa Rican clubs.

30.3/2226

Head-shaped ceremonial mace, stone, with circular relief elements emphasizing the eye sockets and a head crest.
Length: 10.5 cm; *height:* 8.5 cm. *Locale:* Costa Rica, Guanacaste–Nicoya, provenance unknown. *Period:* 300 B.C.–500 A.D.

30.3/2227

Ax pendant shaped as a human, light green jade, with one arm positioned over the head, patterning on right arm and legs, hands, feet, breasts and facial features delineated.
Length: 7.62 cm. *Locale:* Costa Rica, provenance unknown.

30.3/2228

Owl/human ax pendant, light bluish-green jade, with incised line patterning that emphasizes the owl's eyes. The body is human, and arms and hands are articulated.
Length: 10.6 cm. *Locale:* Costa Rica, provenance unknown. *Period:* 300 B.C.–A.D. 500.

30.3/2229

Avian ax pendant, dark green jade.
Length: 5.71 cm. *Locale:* Costa Rica, provenance unknown. *Period:* 300 B.C.–500 A.D. The simple rounded form of the head and pierced eyes is highly contrasted by the sharp, triangular form of the beak.

30.3/2230

Avian/anthropomorphic pendant, Green jade.
Length: 6.99 cm. *Locale:* Costa Rica, Atlantic watershed zone, provenance unknown. *Period:* A.D. 1–500. The bird form is clear in the figure's head. The figure depicted is in a squatting position with hands on its knees. It may represent either a bird who assumes human form or a costumed person.

30.3/2231

Ax pendant, bird form, speckled green jade.
Length: 17.78 cm. *Locale:* Costa Rica, Guanacaste–Nicoya zone, provenance unknown. *Period:* 300 B.C.–500 A.D. The roundness of the owl-like eyes is emphasized by incised lines.

30.3/2232

Avian ax pendant, light gray jade.
Length: 15.24 cm. *Locale:* Costa Rica, Guanacaste–Nicoya zone, provenance unknown. *Period:* 300 B.C.–A.D. 500. The figure surmounting this narrow pendant is highly rectilinear in its stylization.

30.3/2233

Bird's head ax pendant, green mottled jade.
Height: 6.35 cm. *Locale:* Costa Rica, Guanacaste–Nicoya zone, provenance unknown. *Period:* 300 B.C.–500 A.D. Incised facial patterning emphasizes the pierced eyes. The polished bottom indicates that this pieces exists in its entirety.

30.3/2234

Mace head in bird form, gray-brown stone with soft finish, carved.
Length: 16.0 cm; *width:* 6.0 cm; *height:* 7.8 cm. *Locale:* Costa Rica, Nicoya Peninsula, provenance unknown. *Period:* A.D. 1–500

30.3/2235

Bird celt, bluish-green jade.
Height: 7.30 cm. *Locale:* Costa Rica, Linea Vieja (?), provenance unknown. *Period:* 300 B.C.–A.D. 500. This highly polished figure with convex back is covered with flecks of white and imperial green. The shoulderlike forms below the head emphasize the anthropomorphic and avian imagery which are often merged within this type of figure (Easby, 1969:36).

30.3/2236

Anthropomorphic pendant, green jade, carved.
Height: 10.16 cm. *Locale:* Costa Rica, provenance unknown. Facial features are fully human; the triangular element below the mouth which so often makes a double allusion to a beak is clearly defined as a chin. The neck is pierced for suspension. String-sawing perforation runs along the bottom length of the pendant.

30.3/2237

Bird pendant, sea-green jade, finely variegated, carved.
Height: 4.13 cm. *Locale:* Costa Rica, provenance unknown. Careful attention has been given to the articulation of details of feet and wings (Easby, 1969:50).

30.3/2238

Anthropomorphic ax-god pendant, greenish jade.
Length: 13.34 cm. *Locale:* Costa Rica, Guanacaste–Nicoya zone, provenance unknown. *Period:* 300 B.C.–A.D. 500. Human characteristics are emphasized by the articulation of arms clasped tightly around the body and delineation of fingers and facial details.

30.3/2239

Mace head, brown stone.
Length: 8.0 cm; *height:* 6.5 cm. *Locale:* Costa Rica, provenance unknown. The large circular eyes may indicate that this form represents an owl.

30.3/2240

Tapir pendant, gold, with suspension loops formed by the front paws.
Length: 2.2 cm; *height:* 1.8 cm. *Locale:* Costa Rica, provenance unknown.

30.3/2254

Puma, copper with green patina.
Length: 4.5 cm; *height:* 2.5. *Locale:* Costa Rica, Cocle (?), provenance unknown. The puma is figured with its head turning over its body.

30.3/2242
Plaque, gold.
Length: 10.79 cm; *Locale:* Panama.
Style: Cocle.
The plaque consists of two figures holding axlike forms in both hands; it originally had danglers.

30.3/2244
Avian pendant, jade.
Length: 5.4 cm; *width:* 1.8 cm.
Locale: Provenance unknown.

30.3/2245
Cylindrical serpent bowl,
ceramic, figure in red paint on white background.
Height: 9.5 cm; *diameter:* 14.0 cm.
Locale: Provenance unknown.

30.3/2247
Pendant head, gray stone.
Height: 2.5 cm. *Style:* Olmec (?).

30.3/2248
Bowl, red ceramic, black, white, and brown design.
Height: 5.5 cm; *diameter:* 13.5 cm.
Locale: Panama. *Style:* Cocle.

30.3/2249
Plate, ceramic; black, red and orange design on buff ground, orange underside.
Height: 5.0 cm; *diameter:* 22.8 cm.
Locale: Panama. *Style:* Cocle.

30.3/2250
Jaguar jar, buff ceramic; black, red, and purple design.
Height: 11.0 cm; *diameter:* 15.5 cm.
Locale: Panama. *Style:* Cocle.

30.3/2251
Footed plate, buff ceramic, black, red, and buff design.
Height: 15.5 cm; *diameter:* 22.0 cm.
Locale: Panama. *Style:* Cocle.

30.3/2252
Dancing figure dish, ceramic, pedestal dish with polychrome decoration.
Height: 20.8 cm; *diameter:* 27.5 cm.
Locale: Panama. *Style:* Cocle.

30.3/2253
Bottle, ceramic; black and white decoration on neck.
Height: 16.0 cm; *diameter:* 6.5 cm.
Locale: Panama. *Style:* Cocle.

30.3/2336
Pendant, gold.
Width: 10.8 cm; *height:* 5.5 cm.
Locale: Panama, Toma, Veraguas.
Style: Cocle.
Gilded tumbaga pendant with two alligator gods surmounting bells and holding double-headed serpents.

SOUTH AMERICA: PERU

Chavin

41.2/8932
Textile fragment depicting a Chavin staff-bearing figure wearing a headdress. Plain weave 1x1 patterned with wrapped warp areas and discontinuous, complementary weft pattern; Z-spun cotton. Side selvages.
Length: 54 cm; *loom width:* 32 cm.
Locale: Peru. *Style:* Chavin. *Period:* 900–200 B.C.

Paracas

41.2/8933
Mantle with design of double-headed birds on borders. Plain weave 1x1 and embroidery on borders; Z-spun/S-plied camelid wool. Complete.
Length: 124 cm; *width:* 57 cm.
Locale: South Coast, Peru. *Style:* Paracas. *Period:* 800–100 B.C.

41.2/8934
Mantle with design of double-headed birds on central field and borders. Plain weave 1x1 and embroidered designs; Z-spun/S-plied camelid wool; originally two loom products (one now missing).
Length: 260 cm; *width (incomplete):* 102 cm. *Locale:* South Coast, Peru. *Style:* Paracas. *Period:* 800–100 B.C.

41.2/8935
Textile fragment with composite human and animal figure with mouth mask and forehead ornament. Embroidery on plain weave. Structures obscured by adhesive used in mounting. No selvages.
Length: 9.5 cm; *width:* 9 cm. *Locale:* South Coast, Peru. *Style:* Paracas. *Period:* 800–100 B.C.

41.2/8936
Turban strap with design created by the oblique interlacing of three multi-colored narrow woven bands. Plain weave and plaiting; Z-spun/S-plied camelid wool and possibly cotton.
Length (incomplete): ca. 200 cm; *width:* 2 cm. *Locale:* South Coast, Peru. *Style:* Paracas. *Period:* 800–100 B.C.

41.2/8937
Turban strap with design created by the oblique interlacing of differently colored yarn. Plaiting; Z-spun/S-plied camelid wool.
Length (incomplete): ca. 71 cm; *width:* 1.8 cm. *Locale:* South Coast, Peru. *Style:* Paracas. *Period:* 800–100 B.C.

41.2/8938
Turban strap fragment with design created by the oblique interlacing of differently colored yarn. Plaiting; Z-spun/S-plied camelid wool. *Length (incomplete):* ca. 35 cm; *width:* 2.5 cm. *Locale:* South Coast, Peru. *Style:* Paracas. *Period:* 800–100 B.C.

Nasca

41.2/8939
Tunic with animal figures contained in rectangular units. Embroidery on warp-dominant plain weave 1x1; warp fringe at bottom; Z-spun/S-plied camelid wool; two loom products. Complete.
Length: 47 cm; *width:* 67 cm. *Locale:* South Coast, Peru. *Style:* Nasca. *Period:* 100 B.C.–A.D. 700.

41.2/8941
Band with geometric pattern. Slit tapestry; Z-spun/S-plied cotton warp; Z-spun/S-plied camelid wool and cotton weft. Side selvages; one end selvage.
Length (incomplete): 52 cm; *width:* 3 cm. *Locale:* South Coast, Peru. *Style:* Nasca. *Period:* 100 B.C.–A.D. 700.

41.2/8942
Band with stepped diagonal design and three cords with fringe on one end. Slit tapestry; needlework-covered cords; Z-spun/S-plied camelid wool. Side selvages; one end complete.
Length (incomplete): 133 cm; *width:* 1.4 cm. *Locale:* South Coast, Peru. *Style:* Nasca. *Period:* 100 B.C.–A.D. 700.

41.2/8943
Band with animal and geometric motifs. Slit tapestry; Z-spun/S-plied /Z-replied and Z-spun/S-plied cotton warp; Z-spun/S-plied camelid wool weft. Side selvages.
Length (incomplete): 64 cm; *width:* 1.8 cm. *Locale:* South Coast, Peru. *Style:* Nasca. *Period:* 100 B.C.–A.D. 700.

41.2/8944
Textile fragment with tassel pendants applied in centers of repeated geometric motifs. Slit tapestry; Z-spun cotton warp; Z-spun camelid wool and cotton weft. No selvages.
Length: 17 cm; *width:* 25 cm. *Locale:* South Coast, Peru. *Style:* Nasca. *Period:* 100 B.C.–A.D. 700.

41.2/8945
Needlework edging fragment with fringe. Originally with tabs joined to main fabric (one tab remains). Probably crossed loop stitching; Z-spun/S-plied camelid wool.
Length: 11 cm; *width:* 6 cm. *Locale:* South Coast, Peru. *Style:* Nasca. *Period:* 100 B.C.–A.D. 700.

41.2/8946
Needlework edging fragment with geometric motifs and fringe. Probably crossed loop stitching; Z-spun/S-plied camelid wool; Z-spun/S-plied /Z-replied cotton structural cord.
Length (incomplete): 47 cm; *width:* 6 cm. *Locale:* South Coast, Peru. *Style:* Nasca. *Period:* 100 B.C.–A.D. 700.

41.2/8947
Tubular needlework strap fragments with geometric motifs. Probably crossed loop stitching; Z-spun/S-plied camelid wool. One end complete.
Length (incomplete): 27 and 20 cm; *width:* 1 cm. *Locale:* South Coast, Peru. *Style:* Nasca. *Period:* 100 B.C.–A.D. 700.

41.2/8948
Tubular strap with geometric motif. Complementary warp pattern; Z-spun/S-plied camelid wool.
Length (incomplete): 70 cm; *width:* 8 mm. *Locale:* South Coast, Peru. *Style:* Nasca. *Period:* 100 B.C.–A.D. 700.

41.2/9018
Double-spout ceramic bottle in the form of a couple engaged in intercourse. Burnished slip painted ceramic.
Length: 14.5 cm; *height:* 12.0 cm. *Locale:* South coast of Peru. *Style:* Nasca. *Period:* Early Intermediate 100 B.C.–A.D. 700. Both man and woman wear ornaments typical of their sex.

Moche

41.2/9019
Pair of inlaid wooden ear spools showing a warrior holding a club and shield.
Diameters: 5.5; *stems:* Lengths: 7.3 and 7.2 cm. *Locale:* North coast of Peru. *Style:* Moche. *Period:* Early Intermediate 200 B.C.–A.D. 800. The inlays (partially reconstructed) consist of iron pyrites, malachite, gilded copper alloy and spondylus shell; the metal rims are copper alloy.

Middle Horizon—Wari

41.2/8949

Tunic with design of steps and curves. Interlocked tapestry, Z-spun/S-plied cotton warp, Z-spun/S-plied camelid wool weft; two loom products. Complete.

Length: 110 cm; *width:* 102 cm. *Locale:* South Coast, Peru. *Style:* Wari. *Period:* A.D. 600–1000.

41.2/8950

Headband with human face design. Two segments of interlocked and slit tapestry sewn in the center to plain weave 1x1; S-spun/Z-plied cotton warp; Z-spun/S-plied camelid wool weft; plain weave: Z-spun/S-plied camelid wool. Two or three loom products. Side selvages.

Length or circumference (incomplete): 57.5 cm; *width:* 6.5 cm. *Locale:* probably North Coast, Peru. *Period:* Middle Horizon, A.D. 600–1000.

41.2/8951

Turban or sash with bird motifs and some geometric motifs on decorated ends and center. Undecorated plain weave 1x1. End with birds in rectangles: Double-face, discontinuous, supplementary weft; double-face, discontinuous (interlocked) complementary weft pattern on border between weft-faced weave stripes. Center and opposite end with birds in diamond grid: Double-face, continuous, supplementary weft pattern. Center might be embroidery. Border with frets and steps: Interlocked tapestry 2x1. Needlework finished edges on end decorated areas. Z-spun/S-plied cotton warp and weft of plain

weave and warp of complementary weft pattern, weft-faced weave, and tapestry. Z-spun/S-plied camelid wool pattern weft, weft in weft-faced stripes, and tapestry weft. Complete.

Length: 294 cm; *width:* 25 cm. *Locale:* South Coast, Peru. *Period:* Middle Horizon, A.D. 600–1000.

41.2/8952

Textile fragment with geometric pattern on central field and on border. Double-face, continuous, supplementary weft pattern or embroidery on plain weave 1x1 on central field; Border: Stripes of weft-faced plain weave 2x1, with double-face, discontinuous (interlocked), complementary weft pattern. Z-spun/S-plied cotton warp and weft on plain weave; Z-spun/S-plied camelid wool pattern weft; Z-spun camelid wool weft on weft-faced plain weave stripes. One side selvage and one end selvage.

Length: 18.5 cm; *width:* 17.5 cm. *Locale:* South Coast, Peru. *Period:* Middle Horizon, A.D. 600–1000.

41.2/8953

Textile corner fragment with geometric design in diamond grid and border with geometric design. Double-face, discontinuous, supplementary weft pattern on plain weave 1x1; Stripes of weft-faced plain weave and double-face, discontinuous (interlocked), complementary weft pattern on border; needlework edging; Z-spun/S-plied cotton warp and weft of plain weave and warp of border; Z-spun/S-plied camelid wool pattern weft and needlework yarn; Z-spun camelid wool weft of weft-faced stripes. One side selvage; one end selvage.

Length: 42 cm; *width:* 38 cm. *Locale:* South Coast, Peru. *Period:* Middle Horizon, A.D. 600–1000.

41.2/8954

Tassel with two pile covered cords with geometric designs. Z-spun/S-plied camelid wool; Z-spun/S-plied cotton.

Length: ca. 20 cm. *Locale:* South Coast, Peru. *Period:* Middle Horizon, A.D. 600–1000.

41.2/8955

Feather-covered hanging, with blue and yellow feathers in four rectangles. Strings of feathers attached by sewing to plain weave 1x1; Z-spun/S-plied cotton. Edging tape on top: Warp-faced plain weave 1x1; Z-spun/S-plied camelid wool. Camelid wool braids on sides. Macaw feathers, Complete. *Length:* 220 cm; *width:* 80 cm.

Locale: Hacienda Hispana, Churunga Valley, South Coast, Peru. *Period:* Middle Horizon, A.D. 600–1000.

Chimu

41.2/8956

Mantle, with interlocked bird design on central field and a row of monkey on each end; selvage border; applied fringes on side selvages. Slit tapestry; S-spun/Z-plied cotton warp; Z-spun/S-plied camelid wool and cotton weft and Z-spun cotton weft. 9 loom products (5 fringed edgings woven separately). Side selvages, one end selvage.

Length (incomplete): 154 cm; *width:* 115.5 cm. *Locale:* North Coast, Peru. *Style:* Chimu. *Period:* A.D. 1000–1460.

41.2/8957

Textile with painted design of dots and a band of stylized swimmer and wave motifs bordered by stepped triangles. Plain weave 2x1; S-spun cotton. Side selvages.

Length (incomplete): 206 cm; *width:* 70 cm. *Locale:* North Coast, Peru. *Style:* Chimu. *Period:* A.D. 1000–1460.

41.2/8958

Textile with birds in diamond grid on central loom product and animal motifs and geometric designs in diagonal bands on side loom products. Discontinuous supplementary, weft pattern on plain weave 2x1; Z-spun and some S-spun cotton warp; S-spun cotton weft and Z-spun/S-plied camelid wool pattern weft; three loom products. Side selvages and one end selvage.

Length (incomplete): 129 cm; *width:* ca. 72 cm. *Locale:* North Coast, Peru. *Style:* Chimu. *Period:* A.D. 1000–1460.

41.2/8959

Two fragments from a sash with monkey figure, stripe design and applied tassel with embroidered face and fringe. Single-face, continuous and discontinuous, supplementary weft pattern on plain weave 2x1; S-spun cotton warp and weft of plain weave; Z-spun/S-plied camelid wool pattern weft. Side selvages; one end.

Length: 73 cm and 31 cm; *width:* 7 cm. *Locale:* North Coast, Peru. *Style:* Chimu. *Period:* A.D. 1000–1460.

41.2/8960

Border fragment with geometric design. Single-face, continuous, supplementary weft pattern on plain weave 2x1; slit tapestry on edging; S-spun cotton warps; Z-spun cotton wefts on plain weave; S-spun/Z-plied cotton warp on tapestry edging; Z-spun/S-plied camelid wool pattern and tapestry weft. Two loom products (edging woven separately). One side selvage and one end selvage.

Length: 7 cm; *width:* 10.5 cm. *Locale:* North Coast, Peru. *Style:* Chimu. *Period:* A.D. 1000–1460.

41.2/8961

Textile fragment with bird figure. Single-face, supplementary weft pattern on plain weave 1x1; S-spun and Z-spun cotton warp and weft of plain weave; Z-spun/S-plied camelid wool pattern weft. No selvages.

Length: 15 cm; *width:* 24 cm. *Locale:* North Coast, Peru. *Style:* Chimu. *Period:* A.D. 1000–1460.

41.2/8962

Band with serrated fish and geometric motifs. Slit tapestry; S-spun/Z-plied cotton warp; S-spun/Z-plied and some S-spun camelid wool weft and S-spun/Z-plied cotton weft. S-spun cotton used as outline weft and slit closing yarn. Side selvages.

Length (incomplete): 164 cm; *width:* 4 cm. *Locale:* North Coast, Peru. *Style:* Chimu. *Period:* A.D. 1000–1460.

Chancay

41.2/8963

Tie-dyed textile fragment with geometric arrangement of rings of different colors. Plain weave 1x1; Z-spun/S-plied cotton. One side selvage.

Length: 61.5 cm; *width:* ca. 57.5 cm. *Locale:* Central Coast, Peru. *Style:* Chancay. *Period:* A.D. 1100–1476.

41.2/8964

Mantle with design of birds holding fish in their beaks and human figures distributed in a system of rectangles. Double cloth; Z-spun/S-plied cotton; three loom products. Side selvages.

Length (incomplete): 147 cm; *width:* 103.5 cm. *Locale:* Central Coast, Peru. *Style:* Chancay. *Period:* A.D. 1100–1476.

41.2/8965

Border fragment, with bird motif and stripes. Stripes of weft-faced plain weave 3x1; single-face, discontinuous, and continuous, complementary, weft pattern and plain weave 1x1; Z-spun/S-plied cotton warp; Z-spun/S-plied and Z-spun camelid wool weft; Z-spun cotton weft of plain weave 1x1; two loom products (fringe woven separately). Side selvages.

Length: 14 cm; *width:* 67 cm. *Locale:* Central Coast, Peru. *Style:* Chancay. *Period:* A.D. 1100–1476.

41.2/8966
Textile fragment with bird figure. Double-face, discontinuous supplementary weft pattern on warp-dominant plain weave 1x1; Z-spun/S-plied cotton warp and weft of plain weave; Z-spun/S-plied camelid wool pattern weft. No selvages.

Length: 12 cm; *width:* 12 cm. *Locale:* Central Coast, Peru. *Style:* Chancay. *Period:* A.D. 1100–1476.

41.2/8967
Border fragment with row of birds between stripes. Stripes of weft-faced, plain weave and single-face, continuous and discontinuous, complementary weft pattern; Z-spun/S-plied cotton warp; Z-spun/S-plied camelid wool and cotton weft. Side selvages and one end selvage.

Length: 4.5 cm; *width:* 40.5 cm. *Locale:* Central Coast, Peru. *Style:* Chancay. *Period:* A.D. 1100–1476.

41.2/8968
Border or band fragment with geometric pattern and stripes, sewn to fragment of undecorated plain weave. Stripes of warp-faced or weft-faced plain weave and single-face complementary warp pattern or weft pattern; Z-spun/S-plied cotton; (possibly some S-spun cotton pattern weft); Z-spun cotton warp of undecorated plain weave. Two loom products (undecorated plain weave woven separately). One selvage.

Length: 5.5 cm; *width:* 10 cm. *Locale:* Central Coast, Peru. *Style:* Chancay. *Period:* A.D. 1100–1476.

41.2/8969
Border or band fragment with row of pelicans between stripes. Stripes of warp-faced, or weft-faced plain weave and double-face, complementary warp pattern, or weft pattern; Z-spun/S-plied cotton. One selvage.

Length: 4.5 cm; *width:* 13 cm. *Locale:* Central Coast, Peru. *Style:* Chancay. *Period:* A.D. 1100–1476.

41.2/8970
Textile fragment with fish motif. Slit and eccentric tapestry 2x1 and plain weave 1x1; Z-spun/S-plied cotton. One side selvage.

Length: 7.5 cm; *width:* 20.5 cm. *Locale:* Central Coast, Peru. *Style:* Chancay. *Period:* A.D. 1100–1476.

41.2/8971
Border fragment with row of felines. Slit tapestry; Z-spun/S-plied cotton warp; Z-spun/S-plied camelid wool weft and Z-spun cotton weft. End selvages.

Length: 7.5 cm; *width:* 25 cm. *Locale:* Central Coast, Peru. *Style:* Chancay. *Period:* A.D. 1100–1476.

41.2/8972
Border fragment with two feline figures between wave motif stripes. Slit tapestry and open work; Z-spun/S-plied cotton warp; Z-spun/S-plied camelid wool weft. Three loom products (edgings with wave motif woven separately). End selvages; one side selvage.

Length: 38 cm; *width:* 17 cm. *Locale:* Central Coast, Peru. *Style:* Chancay. *Period:* A.D. 1100–1476.

41.2/8973
Textile with painted design of standing human figures and groups of six birds in alternating rectangles. Plain weave 1x1; Z-spun/S-plied cotton. Side selvages.

Length (incomplete): 143.5 cm; *width:* 96.5 cm. *Locale:* Central Coast, Peru. *Style:* Chancay. *Period:* A.D. 1100–1476.

41.2/8974
Bag with interlocked face motif, three tassels on braids and strap. Continuous, complementary weft pattern on bag; double-face, complementary warp pattern on strap; Z-spun/S-plied cotton warp; Z-spun/S-plied camelid wool pattern weft; Z-spun/S-plied camelid wool warp in strap; Z-spun/S-plied cotton in weft strap. Selvages sewn closed.

Length: 12.5 cm; *width:* 12 cm. *Locale:* Central Coast, Peru. *Style:* Chancay. *Period:* A.D. 1100–1476.

41.2/8975
Textile fragment with painted design in central loom product featuring birds, humans, double-headed snakes in rectangles with wave motif bands on either side. Bordering loom products are undecorated. Plain weave 1x1; Z-spun/S-plied cotton. Three loom products. Five side selvages.

Length: 55 cm; *width:* 42 cm; *loom width:* 14.5-16.5 cm. *Locale:* Central Coast, Peru. *Style:* Chancay. *Period:* A.D. 1100–1476.

Late Intermediate Period

41.2/5403
Loom with loom bars and 4 shed rods; weave features two bands of bird figures. Top band: Double-face, discontinuous, supplementary weft pattern on plain weave 1x1. Bottom band: Single-face, continuous, supplementary weft pattern on plain weave 1x1; S-spun cotton warp and Z-spun/S-plied cotton weft of plain weave; Z-spun/S-plied cotton pattern weft.

Length: 41 cm; *width:* 63 cm. *Woven area length:* 11 cm; *width:* 33 cm. *Locale:* North Coast or Central Coast, Peru. *Period:* Late Intermediate, A.D. 1000–1450, or Late Horizon, A.D. 1450–1532.

41.2/8977
Fur-wrapped cord with spiral strip design. Tassel at one end.

Length (incomplete): 194 cm; *circumference:* ca. 3.5 cm. *Locale:* Peru. *Period:* Late Intermediate, A.D. 1000–1450, or Late Horizon, A.D. 1450–1532.

41.2/8978
Textile fragment with design of birds in diagonal bands. Double cloth; Z-spun/S-plied cotton. Side selvages.

Length: 90 cm; *width:* 20 cm. *Locale:* Central Coast, Peru. *Period:* Late Intermediate, A.D. 1000–1450.

41.2/8979
Border fragment, with bird motif. Stripes of weft-faced, plain weave 3x1; single-face, continuous, complementary weft pattern and plain weave 1x1; S-spun cotton warp; Z-spun and Z-spun/S-plied cotton weft; Z-spun/S-plied camelid wool weft; three loom products (fringe woven separately). Three side selvages and one end selvage.

Length: 16 cm; *width:* 85 cm; *loom width:* 52 cm. *Locale:* Central Coast, Peru. *Period:* Late Intermediate, A.D. 1000–1450.

41.2/8980
Textile fragment with design of birds in grid of diamonds. Single-face, discontinuous, supplementary weft pattern on plain weave 1x1; Z-spun/S-plied cotton warp and weft of plain weave; Z-spun/S-plied camelid wool pattern weft. One end selvage.

Length: 22 cm; *width:* 22 cm. *Locale:* Central Coast, Peru. *Period:* Late Intermediate, A.D. 1000–1450.

41.2/8981
Border fragment, with design of birds in diamond grid between stripes. Stripes of weft-faced plain weave and double-face, continuous, supplementary weft pattern on plain weave 1x1; Z-spun/S-plied cotton warp and weft of plain weave; Z-spun/S-plied camelid wool weft. One tubular end selvage.

Length: 7.5 cm; *width:* 20.5 cm. *Locale:* Central Coast, Peru. *Period:* Late Intermediate, A.D. 1000–1450.

41.2/8982
Textile with design featuring rows of deer. Single-face, discontinuous supplementary weft pattern, or embroidery, on plain weave 1x1; Z-spun/S-plied cotton warp and weft of plain weave; Z-spun/S-plied camelid wool pattern weft. Four selvages.

Length: 26 cm; *width:* 24 cm. *Locale:* Central Coast, Peru. *Period:* Late Intermediate, A.D. 1000–1450.

41.2/8983
Border fragment with bird design in diamond grid, wave motif band, stripes and tab fringe. Double-face, continuous, complementary weft pattern for bird design; stripes of weft-faced plain weave; Z-spun/S-plied cotton warp; Z-spun/S-plied camelid wool weft. Single-face, continuous, supplementary weft pattern on plain weave 1x1; Z-spun/S-plied cotton warp and weft of plain weave; human hair supplementary pattern weft. Side selvages and one end selvage.

Length: 13 cm; *width:* 49 cm. *Locale:* Central Coast, Peru. *Period:* Late Intermediate, A.D. 1000–1450.

41.2/8984

Textile with stripe pattern. Warp-faced plain weave 1x1 with differently colored warp stripes; Z-spun/S-plied and Z-spun cotton. Complete.

Length: 28 cm; *width:* 24 cm. *Locale:* Central Coast, Peru. *Period:* Late Intermediate, A.D. 1000–1450.

41.2/8985

Border fragment with interlocked face design. Slit tapestry; Z-spun/S-plied cotton. Tubular edging on one end selvage.

Length: 6.5 cm; *width:* 23 cm. *Locale:* Central Coast, Peru. *Period:* Late Intermediate, A.D. 1000–1450.

41.2/8986

Two tassels with human faces and fringe. Plain weave and needlework; Z-spun and Z-spun/S-plied camelid wool; Z-spun cotton.

Length: 20 cm; *width:* 6.5 cm. *Locale:* Central Coast, Peru. *Period:* Late Intermediate, A.D. 1000–1450.

41.2/8987

Balance beam complete with suspension cord and net pouches with braided edging. Carved and incised bone beam with geometric motifs. Knotted netting pouches of Z-spun/S-plied fourcroya fiber with camelid wool braided edges. Cotton cords with shell and stone beads. Three bits of lead on one pouch to correct balance.

Beam width: 10 cm. *Locale:* Central or South Coast, Peru. *Period:* Late Intermediate, A.D. 1000–1450 or Late Horizon, A.D. 1450-1532.

41.2/8988

Textile fragment with design of birds in a diamond grid on central field and interlocking snakes (?) between stripes on border. Central field: Single-face, continuous supplementary weft pattern on plain weave 1x1. Border: Stripes of weft-faced plain weave and single-face, continuous, complementary weft pattern; Z-spun/S-plied cotton warp and weft of plain weave, Z-spun/S-plied and some Z-spun camelid wool weft. Side selvages and one end selvage.

Length: 29 cm; *width:* 44 cm. *Locale:* Central Coast, or South Coast, Peru. *Period:* Late Intermediate, A.D. 1000–1450.

41.2/8989

Textile fragment with design of interlocking snakes. Single-face, discontinuous, supplementary weft pattern on plain weave 1x1; Z-spun/S-plied cotton warp and weft of plain weave; Z-spun/S-plied camelid wool pattern weft. One end selvage.

Length: 15 cm; *width:* 23 cm. *Locale:* Central Coast or South Coast, Peru. *Period:* Late Intermediate, A.D. 1000–1450.

41.2/8990

Loom, complete with loom bars, heddle rod, shed rod, weaving sword and yoke; weave features geometric pattern. Double-face, continuous, complementary weft pattern and plain weave; Z-spun/S-plied cotton warp and weft of plain weave; Z-spun/S-plied camelid wool pattern weft. Yoke: double-face, complementary warp pattern; Z-spun/S-plied camelid wool.

Length: 30 cm; *width:* 20 cm; *woven area length:* 9.5 cm; *width:* 10 cm; *yoke length:* 116 cm; *width:* 2.5 cm. *Locale:* Central Coast or South Coast, Peru. *Period:* Late Intermediate, A.D. 1000–1450.

41.2/8991

Textile with geometrically-patterned stripes. Double-face, simple warp pattern; Z-spun/S-plied camelid wool and cotton warp; Z-spun/S-plied cotton weft. Complete.

Length: 30 cm; *width:* 21 cm. *Locale:* Coast of Peru. *Period:* Late Intermediate, A.D. 1000–1450, or Late Horizon, A.D. 1450–1532.

41.2/8992

Textile. No design. Plain weave 1x1; Z-spun/S-plied cotton. Side selvages; one end selvage.

Length (incomplete): 27 cm; *width:* 27 cm. *Locale:* Coast of Peru. *Period:* Late Intermediate, A.D. 1000–1450.

41.2/8993

Textile fragment with two rows of feline and other animal motifs. Single-face, complementary warp pattern and warp-faced plain weave; Z-spun/S-plied camelid wool. One end selvage.

Length: 21 cm; *width:* 15 cm. *Locale:* Probably Highlands, Peru. *Period:* Late Intermediate, A.D. 1000–1450, or Late Horizon, A.D. 1450–1532.

41.2/8994

Textile fragment with row of feline and other animal motifs (could be part of 41.2/8993). Single-face, complementary warp pattern and warp-faced plain weave; Z-spun/S-plied camelid wool. One side selvage.

Length: 10 cm; *width:* 9.5 cm. *Locale:* Probably Highlands, Peru. *Period:* Late Intermediate, A.D. 1000–1450, or Late Horizon, A.D. 1450–1532.

41.2/8995

Textile fragment with row of feline and other animal motifs (could be part of 41.2/8993 and 41.2/8994). Single-face, complementary warp pattern and warp-faced plain weave; Z-spun/S-plied camelid wool. One side selvage and one end selvage.

Length: 35 cm; *width:* 10 cm. *Locale:* Probably Highlands, Peru. *Period:* Late Intermediate, A.D. 1000–1450, or Late Horizon, A.D. 1450–1532.

41.2/8996

Textile with geometrically patterned stripes. Stripes of warp-faced plain weave, and double-face, simple warp pattern; Z-spun/S-plied camelid wool. End selvages; one side selvage.

Length: 29 cm; *width (incomplete):* 17 cm. *Locale:* Probably Highlands, Peru. *Period:* Late Intermediate, A.D. 1000–1450, or Late Horizon, A.D. 1450–1532.

41.2/8997

Border fragment with geometric pattern, and stripes. Stripes of weft-faced plain weave and double-face, continuous, complementary weft pattern; S-spun cotton warp; Z-spun cotton weft and Z-spun/S-plied camelid wool weft. Side selvages and one end selvage.

Length: 2.5 cm; *width:* 50 cm. *Locale:* North Coast, Peru. *Period:* Late Intermediate, A.D. 1000–1450.

41.2/8998

Textile fragment with four fish. Discontinuous, supplementary weft pattern or embroidery on plain weave 1x1; Z-spun/S-plied and S-spun cotton warp and weft of plain weave; Z-spun/S-plied camelid wool pattern weft or embroidery yarn. One side selvage and one end selvage.

Length: 26 cm; *width:* 37 cm. *Locale:* Probably Highlands, Peru. *Period:* Late Intermediate, A.D. 1000–1450, or Late Horizon, A.D. 1450–1532.

41.2/8999

Band fragment with birds between stripes. Stripes of warp-faced plain weave and single-face, complementary warp pattern. Z-spun/S-plied camelid wool warp and S-spun cotton warp; Z-spun/S-plied cotton weft. Side selvages.

Length: 68 cm; *width:* 10.5 cm. *Locale:* North Coast or Central Coast, Peru. *Period:* Late Intermediate, A.D. 1000–1450.

41.2/9000

Band fragment with bird and stripe design; tassels covered with pile at end of 2 tabs. Slit tapestry; S-spun/Z-plied cotton warp; Z-spun/S-plied camelid wool weft and Z-spun/S-plied or Z-spun cotton weft. Side selvages; one end complete.

Length: 58 cm; *width:* 4.8 cm. *Locale:* North Coast or Central Coast, Peru. *Period:* Late Intermediate, A.D. 1000–1450.

41.2/9001

Textile fragment with geometric design and animal motifs. Double cloth; Z-spun/S-plied cotton. Side selvages and one end selvage.

Length: 40.5 cm; *width:* 38 cm. *Locale:* South Coast, Peru. *Period:* Late Intermediate, A.D. 1000–1450.

41.2/9002

Textile fragment with bird figure, under serrated stripes. Dovetailed tapestry; Z-spun/S-plied/Z-replied cotton warp; Z-spun/S-plied camelid wool weft.

Length: 19 cm; *width:* 24 cm. *Locale:* South Coast, Peru. *Period:* Late Intermediate, A.D. 1000–1450.

41.2/9003

Feather-covered textile fragment with two human faces in upper half and three stepped design units in lower half. Strings of feathers attached by sewing to plain weave 1x1; Z-spun/S-plied cotton; probably mostly parrot feathers. One side selvage.

Length: 51.5 cm; *width:* 50 cm. *Locale:* South Coast, Peru. *Period:* Late Intermediate, A.D. 1000–1450, or Late Horizon, A.D. 1450–1532.

41.2/9004

Band or sash with row of birds between stripes. Stripes of warp-faced plain weave and single-face, complementary warp pattern; Z-spun/S-plied camelid wool warp; Z-spun/S-plied cotton weft. Complete.

Length: 102 cm; *width:* 5.5 cm. *Locale:* Central Coast, Peru. *Period:* Late Intermediate, A.D. 1000–1450.

41.2/9005

Band fragment with rows of birds and stepped frets between stripes. Stripes of warp-faced plain weave and double-face warp float pattern; Z-spun/S-plied cotton. Side selvages.

Length: 35 cm; *width:* 9 cm. *Locale:* Coast of Peru. *Period:* Late Intermediate, A.D. 1000–1450, or Late Horizon, A.D. 1450–1532.

41.2/8976

Tunic with pattern of steps around neck opening and design of stripes and rows of felines on the sides. Warp-faced weave with interlocked warps and complementary warp patterned stripes, Z-spun/S-plied camelid wool; two loom products. Complete.

Length: 81 cm; *width:* 127 cm. *Locale:* South Coast, Peru. *Style:* Ica. *Period:* A.D. 1000–1450.

Inca

41.2/9006

Tunic fragment, with bird motif in diagonal bands in stepped fret design and in rows on striped background. Embroidery and single-face, discontinuous, supplementary weft pattern units and/or embroidery on warp-faced plain weave 1x1 stripes; Z-spun/S-plied cotton warp and weft of plain weave; Z-spun/S-plied camelid wool pattern weft or embroidery yarn. Short strip of side selvage.

Length: 99 cm; *width:* 32 cm. *Locale:* South Coast, Peru. *Style:* Inca. *Period:* A.D. 1450–1532.

41.2/9007

Strap with geometric or stylized plant design. Double-face, complementary warp pattern with Z-spun/S-plied camelid wool. Two tubular side selvages, one end selvage.

Length (incomplete): 86 cm; *width:* 3 cm. *Locale:* Probably Highlands, Peru. *Style:* Inca. *Period:* A.D. 1450–1532.

41.2/9008

Edging fragment with row of birds. Warp-faced or weft-faced, plain weave and single-face, complementary warp or weft pattern Z-spun/S-plied cotton warp or weft; Z-spun/S-plied camelid wool and cotton warp or weft. No selvages.

Length: 43 cm; *width:* 2 cm. *Locale:* Coast of Peru. *Style:* Inca. *Period:* A.D. 1450–1532.

41.2/9009

Textile fragments (two) with geometrically-patterned stripes. Double-face, complementary warp pattern; paired weft; Z-spun/S-plied cotton. End selvages; one side selvage.

Length: 32 cm; *width (incomplete):* 25 cm and 6 cm. *Locale:* Coast of Peru. *Style:* Inca. *Period:* A.D. 1450–1532.

41.2/9010

Textile fragment with plaid design. Plain weave 1x1 with warp and weft stripes. S-spun cotton weft; Z-spun/S-plied and S-spun/Z-plied cotton warp. Two loom products. Side selvages; one end selvage.

Length: 55 cm; *width:* 79 cm; *loom width:* 64 cm. *Locale:* North Coast, Peru. *Style:* Inca. *Period:* A.D. 1450–1532.

41.2/9011

Tassel from coca bag with llama fur ends. Cord with geometric design: vertical wrapping on horizontal elements. Z-spun/S-plied camelid wool; Z-spun/S-plied and sometimes replied cotton horizontal elements.

Length: 32 cm. *Locale:* South Coast (Ocona-Acari valley), Peru. *Style:* Inca. *Period:* A.D. 1450–1532.

41.2/9012

Tassel from leather pouch bag with probably llama fur ends. Cords with diamond design: vertical wrapping on horizontal elements. Fringe strands: Differently-colored segments joined by interlocking S-spun/Z-plied camelid wool; Z-spun/S-plied and sometimes replied cotton.

Length: 46 cm. *Locale:* Coast of Peru. *Style:* Inca. *Period:* A.D. 1450–1532.

41.2/9013

Sling headband with diamond and chevron designs on braids. Cradle: Ribbed tapestry. Cords: Multiple strand braids. Probably S-spun and Z-spun/S-plied camelid wool.

Length: 226 cm; *width of cradle:* 3 cm. *Locale:* Peru. *Style:* Inca. *Period:* A.D. 1450–1532.

41.2/9016

Three ancient textile objects in modern combination to form a necklace: Nasca strap ends with three tassels at each end; Inca cylindrical tassel of coca bag; square braid probably from Nasca headband sling. Nasca strap ends: slit tapestry; Z-spun/S-plied camelid wool weft. Inca tassel: Vertical wrapping on horizontal elements; Z-spun/S-plied camelid wool. Nasca multiple strand square braid; Z-spun/S-plied, and S-spun/Z-plied camelid wool.

Locale: South Coast, Peru. *Style:* Nasca and Inca. *Period:* 100 B.C.–A.D. 700 and A.D. 1450–1532.

41.2/9017

Solid silver figurine in the form of a hunchbacked woman wearing necklace and cap.

Width: 2.9 cm; *height:* 5.9 cm. *Locale:* Peru. *Style:* Inca. *Period:* Late Horizon, A.D. 1450–1532. Perforations in the head may have held perishable ornaments.

Late Horizon

41.2/9014

Textile fragment with geometric motifs based on a diamond grid. Single-face, continuous, supplementary weft pattern on plain weave 1x1; Z-spun/S-plied cotton warp and weft of plain weave; Z-spun/S-plied camelid wool pattern weft. No selvages.

Length: 7 cm; *width:* 24.5 cm. *Locale:* Central Coast or South Coast, Peru. *Period:* Late Horizon, A.D. 1450–1532.

41.2/9015

Border fragment with interlocking bird and other animal motifs between stripes. Stripes of weft-faced plain weave and 3x1 or 4x1 and double-face, discontinuous, supplementary weft pattern on warp-dominant plain weave 1x1; Z-spun/S-plied cotton warp and weft of plain weave; Z-spun/S-plied camelid wool and Z-spun/S-plied cotton pattern weft and stripe weft. Two loom products (edging woven separately). One side selvage and one end selvage.

Length: 7.5 cm; *width:* 36.5 cm. *Locale:* Central Coast, Peru. *Period:* Late Horizon, A.D. 1450–1532.

Ethnographic

40.1/5179

Bag with geometric pattern. Coiled looping; plaited strap; palm fiber. *Length:* 28 cm; *top width:* 24.5 cm. *Strap length:* ca. 92 cm; *width:* 2 cm.

Locale: Northern Peru or Ecuador, Montaña area.

40.1/5180

Modern loom with loom bars, two heddle rods, two shed rods, and beater; weave of unfinished saddle bag features geometric motifs and two llamas. Single-face warp pattern with design details of discontinuous, supplementary weft. All commercial cotton and synthetic yarns.

Length: 89 cm; *width:* 64.5 cm; *Woven area length:* 36.5 cm; *width:* 36 cm.

Locale: Montesefu, Peru.

COLOMBIA

Tairona

41.2/9020

Bone finial carved in the form of a falcon or hawk atop a cylindrical shaft. An incised volute design covers the head, back, and wings. Bone objects are rarely preserved in the north highland regions.

Length: 4.3 cm. *Locale:* Tairona Region, Northern Colombia. *Period:* A.D. 800–1550.

NORTH AMERICA

Navaho blankets

50.2/6784

Chief blanket (Phase I), woman's, patterned with narrow white, dark blue, brown and orange weft stripes. Weft-faced tapestry weave. Handspun/wool warps and wefts.

Warp length: 107 cm; *wefts:* 141 cm. *Locale:* Navajo, Southwest U.S.A. *Period:* Late 19th c.

50.2/6785

Serape/Blanket, scarlet ground with blue and white diagonal cross-hatch lines enclosing small serrated and stepped motifs. Weft-faced tapestry weave. Handspun/wool warps. Commercial (4 ply) yarn, raveled and handspun/wool wefts.

Warp length: 127 cm; *wefts:* 85 cm. *Locale:* Navajo, Southwest U.S.A. *Period:* Late 19th c.

BIBLIOGRAPHY

Adams, Richard E.W. (1977). Prehistoric Mesoamerica. Little Brown and Company: Boston: MA.

Batres, Leopoldo. (1905). La lápida arqueológica de Tepatlaxco-Orizaba. Mexico.

Benson, Elizabeth (Ed.). (1981). Between continents/between seas: Pre-Columbian art of Costa Rica. Harry N. Abrams, Inc. (in association with the Detroit Institute of Arts): New York, NY.

Bernal, Ignacio. (1967). Museo Nacional de Antropología de México, Arqueología. Mexico, M. Aguilar S.A.

——— (1969). The Olmec world. Translated by Doris Heyden. University of California Press: Berkelev, CA.

Boos, Frank H. (1966). The ceramic sculptures of ancient Oaxaca. A.S. Barnes and Co.: South Brunswick, NJ.

Caso, Alfonso, and Bernal, Ignacio. (1952). Urnas de Oaxaca. Memorias del Instituto Nacional del Antropología e Historia 2. INAH: Mexico.

Clancy, Flora S., et al. (1985). Maya, treasures of an ancient civilization. Text [by] Flora S. Clancy, Clemency C. Coggins, T. Patrick Culbert, Charles Gallenkamp, Peter D. Harrison, and Jeremy A. Sabloff. Charles Gallenkamp and Regina Elise Johnson, general eds. Harry N. Abrams, Inc.: New York, NY.

Codex Ixtlilxochitl. (1976). Codex Ixtlilxochitl, Bibliothèque Nationale, Paris (Ms. Mex. 65–71). Akademische Druck-u. Verlagsanstalt: Graz, Austria.

Coe, Michael D. (1965). The jaguar's children: Pre-Classic Central Mexico. The Museum of Primitive Art: New York, NY.

——— (1973). The Maya scribe and his world. The Grolier Club: New York, NY.

——— (1978). Lords of the Underworld. Princeton University Press: Princeton, NJ.

——— (1980; 1966). Mexico. Praeger: New York, N.Y.

Corson, Christopher. (1976). "Maya anthropomorphic figurines from Jaina Island, Campeche." Ballena Press studies in Mesoamerican art, archaeology and ethnohistory, No. 1. Ballena Press: Ramona, CA.

Covarrubias, Miguel. (1957). Indian art of Mexico and Central America. Alfred A. Knopf: New York, NY.

Diehl, Richard A. (1983). Tula, the Toltec capital of Ancient Mexico. Thames and Hudson Ltd.: London, UK.

Easby, Dudley T., Jr. (1957). "Sahagún y los orfebres precolombinos." Anales del Instituto Nacional de Antropología e Historia, 9:85–117. Mexico.

——— (1964). "Fine metalwork in pre-Conquest Mexico." Essays in pre-Columbian art and archaeology. (Eds.) Samuel K. Lothrop et al. Harvard University Press: Cambridge, MA. pp. 35–42.

Easby, Elizabeth. (1969). Pre-Columbian jades from Costa Rica. André Emmerich publication.

——— and Scott, John F. (1970). Before Cortés, sculpture of Middle America. Metropolitan Museum of Art: New York, NY.

Edward H. Merrin Gallery. (1969). Fifty figures from Veracruz. Exhibition: New York, NY.

Ekholm, Gordon F. (1970). Ancient Mexico and Central America. Introduction by Gordon F. Ekholm. Caption material prepared by Gordon F. Ekholm, Marguerite W. Ekholm, and Jon Holstein. The American Museum of Natural History: New York, NY.

——— (1973). "The Eastern Gulf Coast," The iconography of Middle American sculpture. (Eds.) Ignacio Bernal et al. Metropolitan Museum of Art: New York, NY. pp. 40–51.

Emmerich, André. (1963). Art before Columbus. New York, NY.

——— (1965). Sweat of the sun and tears of the moon: Gold and silver in Pre-Columbian art. University of Washington Press: Seattle, WA.

Flannery, Kent V., and Marcus, Joyce. (1983). The Cloud people, divergent evolution of the Zapótec and Mixtec civilizations. Academic Press: New York, NY.

Franco, José-Luis. (1971). "Musical instruments from Central Veracruz in Classic times." Ancient art

of Veracruz. The Ethnic Arts Council of Los Angeles: Los Angeles, CA.

Furst, Peter T. (1965). "West Mexican tomb sculpture as evidence for shamanism in prehispanic Mesoamerica." Antropologica no. 15:29–80. (1968).

———— "The Olmec were-jaguar motif in the light of ethnographic reality." Dumbarton Oaks Conference on the Olmec, (Ed.) Elizabeth P. Benson. Dumbarton Oaks: Washington, DC. pp. 143–74.

García Payón, José. (1971). "Archaeology of Central Veracruz." Handbook of Middle American Indians. (Eds.) Robert Wauchope, Gordon F. Ekholm, and Ignacio Bernal. University of Texas Press: Austin, TX. 11:505–42.

Gay, Carlo T. (1967). Mezcala stone sculpture: the human figure. Museum of Primitive Art Studies 5: New York, NY.

Graulich, Michel, and Crocker-Deletaille, Lin. (1985). Rediscovered masterpieces of Mesoamerica: Mexico–Guatemala–Honduras. Editions Arts: Boulogne, France.

Groth-Kimball, Irmgard, and Feuchtwanger, Franz. (1954). The art of ancient Mexico. Thames and Hudson: New York and London.

Hammer, Olga. (1971). "Ancient art of Veracruz." The Ethnic Arts Council of Los Angeles: Los Angeles, CA.

Heyden, Doris. (1971). "A new interpretation of the smiling figures." Ancient Art of Veracruz. The Ethnic Arts Council of Los Angeles: Los Angeles, CA.

Jones, Julie. (1987). Houses for the hereafter: funerary temples from Guerrero, Mexico. The Metropolitan Museum of Art, New York, NY.

Joralemon, P. David. (1976). "The Olmec dragon: A study in Pre-Columbian iconography." In H.B. Nicholson, ed., Origins of religious art and iconography in Preclassic Mesoamerica. UCLA Latin American Center and Ethnic Arts Council: Los Angeles, CA. pp. 27–71.

Kampen, Michael E. (1972). The Sculptures of El Tajín, Veracruz, Mexico. University of Florida Press: Gainesville, FL.

Kurbjuhn, Kornelia. (1985). "Busts in flowers: A singular theme in Jaina figurines." Fourth Palenque Round Table, 1980. VI:221–34. Pre-Columbian Art Research Institute, San Francisco, CA.

Leigh, Howard. (1966). "The evolution of the Zapotec glyph C," In Paddock 1966, pp. 256–69.

Lifschitz, Edward A. A stylistic seriation of the smiling figures of Veracruz. Unpublished masters thesis, Columbia University: New York, NY.

McBride, Harold W. (1971). "Figurine types of central and southern Veracruz." In Ancient art of Veracruz. The Ethnic Arts Council of Los Angeles: Los Angeles, CA.

Médioni, Gilbert, and Pinto, Marie-Therese. (1941). Art in ancient Mexico. Selected and photographed from the collection of Diego Rivera. Oxford University Press: New York, NY.

Medellín Zenil, Alfonso. (1960). Cerámicas del Totonacapán: Exploraciones arqueológicas en el centro de Veracruz. Universidad Veracruzana: Xalapa, Veracruz.

Miller, Arthur G. (1973). The mural painting of Teotihuacán. Dumbarton Oaks: Washington, DC.

Millon, Rene F. (1973). Urbanization at Teotihuacán, Mexico. Vol. 1. The Teotihuacán map. University of Texas: Austin, TX.

Morley, Sylvanus G.; Brainerd, George W.; and Sharer, Robert J. (1983). The ancient Maya. Fourth edition. Stanford University Press: Stanford, CA.

Nicholson, H.B. (1971). "The iconography of classic central Veracruz." In Ancient art of Veracruz. The Ethnic Arts Council of Los Angeles: Los Angeles, CA.

Nicholson, H.B., and Cordy-Collins, Alana. (1979). Pre-Columbian art from the Land Collection. California Academy of Sciences: San Francisco, CA.

Paddock, John, (ed.). (1966). Ancient Oaxaca: Discoveries in Mexican archaeology and history. Stanford University Press: Stanford, CA.

Parsons, Lee A. (1980). Pre-Columbian art, the Morton D. May and the Saint Louis Art Museum collections. Harper and Row: New York, NY.

Paz, Octavio, and Medellín Zenil, Alfonso (1962). Magia de la risa. Universidad Veracruzana: Xalapa, Mexico.

Pasztory, Esther. (1974). "The iconography of the Teotihuacán Tlaloc," Dumbarton Oaks studies in Pre-Columbian art and archaeology. Dumbarton Oaks, Washington, DC.

———. (1976) The murals of Tepantitla, Teotihuacán. Garland Press: New York, NY.

——— (1983). Aztec art. Harry N. Abrams, Inc.: New York, NY.

Proskouriakoff, Tatiana. (1971). "Classic art of central Veracruz," Handbook of Middle American Indians. (Eds.) Robert Wauchope, Gordon F. Ekholm, and Ignacio Bernal. 11:558–72. University of Texas Press: Austin, TX.

——— (1954). "Varieties of Classic central Veracruz sculpture." Contributions to American anthropology and history, No. 58. Carnegie Institution of Washington, DC.

Rands, Robert. (1965). "Jades of the Maya Lowlands," Handbook of Middle American Indians 3:561–580. University of Texas Press: Austin, TX.

———, and Rands, Barbara C. (1965). "Pottery figurines of the Maya Lowlands," Handbook of Middle American Indians 2:535–560. University of Texas Press: Austin, TX.

———; Bishop, Ronald L.; and Harbottle, Garman. (1979). "Thematic and compositional variation in Palenque region incensarios." In (Eds.) Merle Greene Robertson and Donnan C. Jeffers. Third Palenque round table, Vol. IV. Pre-Columbian Art Research Center: Monterey, CA.

Robertson, Donald. (1959). Mexican manuscript painting of the early colonial period. Yale University Press: New York, NY.

Robertson, Merle Greene. (1983–87). The sculpture of Palenque. Vol. 1, The Temple of the Inscription; Vol. 2, Early buildings of the palace and the wall painting; Vol. 3, The late buildings of the palace. Princeton University Press: Princeton, NJ.

Sahagún, Bernardino de (1950–86). The Florentine Codex, or general history of the things of New Spain. Arthur J.O. Anderson & Charles E. Dibble, trans. 13 vols. University of Utah Press: Salt Lake.

Saville, Marshall. Turquoise mosaic art in Ancient Mexico. Museum of the American Indian, Heye Foundation: New York, NY.

Schele, Linda, and Miller, Mary Ellen. (1986). The blood of kings: dynasty and ritual in Maya art. George Braziller, Inc.: New York, NY.

Schiff, Bennett. (1970). "A great new display of Pre-Columbian art." Natural History 1/5:36–41.

Sotheby's. (1987). Pre-Columbian art. Catalog 5635. Sotheby's: New York, NY.

Soustelle, Jacques. (1967). Mexico. Translated by James Hogarth. Nagel Publishers: Geneva, Switzerland.

Stendahl, Alfred. (1968). Pre-Columbian art of Mexico and Central America. Harry N. Abrams, Inc.: New York, NY.

Spence, Lewis. (1923). The Gods of Mexico. Frederick A. Stokes: New York, NY.

Spinden, Herbert J. (1913). A study of Maya art. Memoirs of the Peabody Museum 6. Harvard University: Cambridge, MA.

Spratling, William. (1960). More human than divine: an intimate and lively self-portrait in clay of a smiling people from ancient Veracruz. Universidad Nacional de México.

Stern, Theodore. (1949). The rubber-ball games of the Americas. Monographs of the American Ethnological Society 17. University of Washington Press: Seattle, WA.

Tedlock, Dennis (Trans.). (1985). Popol Vuh, the definitive edition of the Mayan book of the dawn of life and the glories of gods and kings. Simon and Schuster: New York, NY.

Vaillant, George C. (1935). Excavations at El Arbolillo. Anthropological Papers, American Museum of Natural History, Vol. 35, Pt. 2. New York, NY.

Von Winning, Hasso. (1974). The shaft tomb figures of West Mexico. Southwest Museum Papers, 24. Southwest Museum: Los Angeles, CA.

——— and Hammer, Olga. (1972). Anecdotal sculpture of ancient West Mexico. The Ethnic Arts Council: Los Angeles, CA.

Weaver, Muriel Porter. (1972). The Aztecs, Maya, and their predecessors: archaeology of Mesoamerica. Seminar Press: New York, NY.

Weigand, Phil C. (1985). "Evidence for complex societies during the Western Mesoamerican Classic period." In The archaeology of western and northwestern Mesoamerica. Eds. Michael Foster and Phil Weigand. Westview Press and Frederick Praeger. London, pp. 47–93.

Wilkerson, Jeffrey S. (1980). "Man's eighty centuries in Veracruz," National Geographic. August. pp. 203–31.